讓空間留白

參與式建築設計

王建明 梁皓晴 陸明敏 著

Contents 目錄

序

設計和人的價值

今時今日，很多設計還是由設計師主導，人們以為一切都是設計師創作的物件，那就是設計。

其實設計不只關於一個物件，甚至是一間房屋，它們最終都有使用者，也就是用家。但是用家是否有參與設計的權利呢？

參與式設計正是由用家主導，讓他們把自己的想法及喜好與設計師分享，雙方運用合作的方式，共同構思設計的概念，一起製作，再一起享受成果。

我在大學畢業後成為執業建築師，但是在工作中，我常常反思如何能夠令用家參與設計的過程，以及能夠在設計時聆聽及引進用家的聲音。在工作了五年後，我毅然放棄全職工作，隻身到英國修讀城市發展規劃，而當中的經驗令我大開眼界。他們所推廣的設計理念，正是讓用家可以由設計開初就參與其中，直到他們看到成果為止，這種設計方式正正能夠讓設計師與用家聯繫起來。而當中的過程並不容易，全賴用家對設計師的信賴，以及設計師放下身段並願意聆聽用家的聲音，所做出來的成果。

回到香港後，我全力發展參與式設計，而手上第一個項目正是改裝一間由智障人士運作的咖啡室。在改裝的過程中，我邀請了智障人士、他們的家人，以及一群有心的設計師參與，期間大家由不理解到互相明白彼此的意念，這一切一切，讓我們能夠成功把咖啡室改裝的成果呈現出來。我印象最深刻的正是其中一位智障朋友與家人說的話，他

指著咖啡廳牆上的小掛畫裝飾，說：「這是我的設計。」因為這一句話，令我更加明白為何要在設計過程引進用家的聲音，以至於令他們參與其中的重要。

後來我與團隊努力研究這種由下而上的設計參與模式，讓不同背景的人也可以參與設計過程，包括本書提及的長者及青少年，透過設計，他們得以發揮創意及想像。設計師亦在過程中更深刻地了解到長者及年輕人的需要，讓設計更到位；更重要的是，設計成為了設計師與他們的溝通工具。原來設計是可以拉近人與人之間的關係的。

我們的團隊除了在本地積極發展不同的參與式設計項目，還希望把這個概念推廣到世界各地，所以自二〇〇九年起，我們便到一些較為落後的地區，例如柬埔寨、尼泊爾及印度，發展參與式設計項目。本書第三章收錄了我們在這幾個地方開展的項目，利用參與式設計讓當地的居民及學生可以與設計師及義工一起建造他們理想的居住或學習環境。

在這個過程中，我發現設計能拉近不同種族、不同文化、不同背景的人之間的距離。而我深深地感受到設計的魔力，這種人與人之間的關係是無價的。

至於在設計專業上，參與項目的設計師變得更主動，去學習了解設計媒介，把複雜的設計概念變得更親切。而在使用者方面，他們不再會覺得設計遙不可及，反而覺得設計是有趣的玩意，在生活中也可以欣賞設計、探索設計。

本書以「留白」為主題，通過不同個案與讀者互動，希望大家在書中空白處動筆思考、發表，從而感受設計、體驗設計，走進設計的魔力中。

王建明

Chapter

01

理論

Theory

THEORY 01

建築與公民參與的理念及理論

讓公眾參與改變生活環境

參與式設計（Participatory Design），或曰共同創造（Co-creation）、共同設計（Co-design），是一種試圖讓所有持份者積極參與設計過程的設計方法，以便更好地解決問題並創造更大的公共價值。

參與式設計起源於一九六〇年代，從最初的倡議手段，漸漸發展成可應用於各個學科的研究方法，尤其是於建築和城市規劃領域。而在這本書中的參與式設計理念，與讓社區參與建築和城市設計過程的理念相關。

傳統上，建築師、設計師、工程師各專業人士主要被認為是服務提供者，其主要職責是滿足客戶需求和期望。而在參與式設計中，包含的社區成員更廣泛，從直接受項目影響的最終使用者到項目周邊的公眾，都是持份者，應該要讓他們參與設計過程。

這套讓公眾於城市發展過程中參與的理念，已獲得廣泛認同，有越來越多研究可產生正面的影響，他們了解自己的需要，民眾會在這個過程中不斷產生深刻見解和知識。01

1.1 何謂參與式設計？

> "By 2030,
> enhance inclusive and
> sustainable urbanization and
> capacity for participatory,
> integrated and
> sustainable human settlement
> planning and management
> in all countries."

早在二〇一五年，聯合國已將「建設包容、安全、有抵禦災害能力和可持續的城市和人類住區」定義為十七個可持續發展目標之一，在 #Envision2030 [02] 的「目標11：可持續城市和社區」中提到：

到二〇三〇年，在所有國家加強包容和可持續的城市建設，加強參與、融合和可持續的人類住區規劃和管理的能力。

參與式設計的方法不僅僅是將設計視為單向的專業服務，而是將建築和規劃的力量擴展至社會工程（Social Engineering）和共融（Inclusion），所得出的結果是專業人士和公眾之間協作的成果。

1.2 參與式設計在建築領域的緣起和發展

「現代建築於一九七二年七月十五日下午三時三十三分（大約）已於密蘇里州聖路易斯市死亡，當臭名昭著的普魯伊特—伊戈公寓（Pruitt-Igoe）計劃，或者說計劃中的幾座標準長形大廈，被炸藥給予致命一擊的時候。」建築評論家 Charles Jencks 的名言，標誌着建築後現代主義的開始。[03]

在這場批判現代建築的運動中，關於參與的論述漸漸發展起來，與後現代時期並肩而行。這種論述希望尋找一種替代方法，來創建能夠滿足社會各階層需求的建築。

● 從精英主義到行動主義

參照建築和城市規劃學者 Nan Ellin 提出的後現代都市主義,自一九六〇年代以來的建築理論,可以被理解為解決建築師所面臨的實踐、藝術和道德困境的一系列努力。一九六〇年代的不同市民參與和社會運動時期,代表了他們對社會及政府有了不同的期望和變化。

在二戰後全球化加速發展的背景下,對西方社會的意見不外乎是「失去歸屬感」,以及對於「我們所失去的世界」深深的憧憬。在環境建造領域,這些意見表現為對現代建築和城市規劃作品的普遍不滿,包括全世界都在破壞現有的城市肌理、在開放空間中建造孤立的建築架構和大量生產的倒模式住宅區。[04]

在著名的 The Death and Life of Great American Cities 一書中,作者 Jane Jacobs 攻擊了正統城市規劃和重建。她在分析社區構成後,認為社區應回歸至日常人類互動和公民積極參與的本質。[05]

缺乏完善而大規模的社會房屋項目,特別是

一九七二年美國清拆公營住宅系統後,更令人質疑精英主義對於專業所提出的假設。美國社區行動者和政治理論學者 Saul David Alinsky 認為,該系統的主要問題是政治機構對民眾漠不關心,而民眾亦由於官僚化、集權化和信息操縱而被排斥在外。[06]

Paul Davidoff 在論文 "Advocacy and Puralism in Planning"(一九六五)中,呼籲規劃者推行參與式和積極的改變。「規劃者應尋求擴大所有人的選擇和機會,認識到為有需要人士及弱勢社群的需求而進行規劃的社會責任,並應敦促改變有礙這些目標的政策、制度和決定」。[07]

倡議式規劃(Advocacy Planning)是第一種將設計和規劃專業人士與公眾聯繫起來的公眾參與形式,社區設計中心(Community Design Centers, CDCs)則成為專業人士代表被剝奪權利的社區團體利益的舞台。

倡議式規劃的後續影響十分廣泛。各大機構隨之修訂其專業職責,譬如在一九六七年,美國規劃師協會(American Institute of Planners)修訂了其宗旨,將規劃師的職權範圍從僅僅實體規劃,擴

大至包括社會、經濟和環境議題。以至於其他領域和跨學科的發展，如使用後研究、環境心理學、環境保護主義城市設計理論等專業理論中，也出現了反思性的轉變及自我評價。根據這種自我完善的角度，城市規劃及設計項目可以賦予人們更多改善社區和環境的參與機會。[08]

● 從保守到開放

雖然參與的理論和實踐始於美國的倡議行動，但在西歐也有類似的趨勢，建築師試圖通過讓設計更加透明和開放，來找到與用家互動的方法。

新古典主義和新理性主義傾向尋找前工業化的城市景觀作為靈感和正當性來源，歐洲建築師和規劃師採用了另外一種方法，他們試圖通過回應建築生產模式和產品的單一化，來應對現代主義方案所產生的多元化。

開放式建築的方法是在設計過程中納入潛在用家，或者為他們提供可以輕鬆轉化成符合他們需求和品味的結構。[09] 比利時建築師 Lucien Kroll 是

先驅之一，他最著名的參與式作品是一九六九年比利時新魯汶醫學院教學樓（Louvain-la-Neuve）。Kroll 在建築設計上給予用家極大參與機會，他開發了一套模組建築系統，預測基本技術設計，並以該系統為基礎，讓用家完成最終設計。

荷蘭建築師 Herman Hertzberger 提出了類似但沒那麼激進的想法——「多功能空間」的設計，提供允許個人詮釋和挪用的原型。一九七四年，他在其 Centraal Beheer 保險辦公大樓中實現了這個想法。鼓勵居民介入的目標，進一步導致了合租運動和另類社會住屋形式。

英國建築師和規劃師 Ralph Erskine 於一九六八年重建位於泰恩河畔紐卡素（Newcastle upon Tyne）的 Byker Wall 屋邨的項目，是英國社區建築運動的先驅。為了在重建過程保持與社區的聯繫，用家最初通過與建築師事務所溝通，該事務所實行開放政策，允許居民與建築師對話交流。這個項目建立了正式組織、聯絡委員會和社區發展項目以促進討論，並得到區內居民支持。[10]

另一個賦予用家參與的嘗試，是建築師

Walter Segal 在倫敦路易咸區（Lewisham，一九六〇至一九七〇年代）的社會房屋自建指導計劃。Segal 的方法是將建築的設計和施工簡化為說明書，讓沒有經驗的施工人員和居民也可以低成本來建造房屋。11

與社區建築運動中的基層行動主義不同，Erskine 和 Segal 都展示了在政府主導的社會房屋和規劃項目中，結合社會工程和居民參與的可能。

二戰後的一段時期社會出現大量關於未來走向的爭論，是設計行業也在反思他們在社會中的角色和目的。在經歷了許多慘痛的錯誤和教訓後，參與式設計為專業人士提供了另一種方式，強調在構建開放社會時聆聽及理解公眾的聲音，了解用家的生活需要，而非以專制的方式來決定甚麼設計最適合他們。

1.3

參與的不同可能性及程度

自一九六〇年代以來，積極公民（Active Citizenship）的概念愈加普及，參與已被規範化，既是我們在城市發展時的責任，也是權利。參與有兩種不同的哲學基礎立場：一種認為參與是受某個過程影響的人的基本權利，另一種認為參與具有工具價值。第一個立場不排除第二個立場，但第二個立場並不包含第一個立場。12

在管理或行政上，參與減少了用家的匿名感，讓他們感受到較多的關注。當用家積極參與發展過程，就會把實體環境維護得更好，社區也會有更強的公共精神、更高的用家滿意度，節省下來的開支也更可觀。現時，公共和私人利益團體普遍從項目開始時就尋求社區參與和援助。然而，參與的定義對不同持份者來說可能會有很大差異。

參與的形式和程度

第一個參與理論框架是由美國學者 Sherry Arnstein 提出的參與階梯（Ladder of Participation，一九六九），她以公民權力級別來衡量參與程度。對於 Arnstein 來說，最佳的參與水平是解放（Emancipation），在這種情況下，公眾可以完全控制他們的社區。[13]

1	2	3	4	5	6	7	8
操縱	教化	通知	諮詢	安撫	合作關係	委派	公民掌控

非參與式　　　象徵主義　　　公民掌控

公民參與的程度
改良自 Arnstein 的參與階梯（一九六九）

而根據學術界開發的其他框架，一般來說，我們可以將參與分為兩種不同的類型：由管理層掌握項目控制權的屬偽參與（Pseudo-Participation），當人們有權控制所採取的行動時，才會出現真正的參與。

但是，由於參與是根據發展脈絡而決定的雙向關係，會視乎行動者的不同情況而產生不同的意義，而參與者也偏好根據情況以不同的方式參與。

參考英國學者 Sarah White 提出的喜好分類（Typology of Interest，一九九五），可以找到以下參與的形式和動機：[14]

參與的形式	從執行機構的利益出發	從接收者的利益出發	參與的功能
名義上的	正當	包容	展示：包括通知、教化和操控
實用的	效率	代價	達到既定目標的一種手段：通常在項目實行中能有效利用社區成員的技能和知識
有代表性的	可持續	影響力	讓社區成員在影響他們的項目或政策的決策和實施過程中發表意見
變革性的	充權	充權	無論是作為手段還是目的，都擁有持續的動力。

Sarah White 的參與者喜好分類法（一九九五）

參與形式之間的區別同樣重要，因為在整個過程中需要仔細考慮溝通模式，以實現所有參與者的知識共享和學習。

除了區分各種參與形式，將參與的方式概念化，還意味着要詢問「誰」（Who）、「甚麼」（What）、「在哪裡」（Where）、「如何」（How）和「何時」（When）的問題。建築學者 Paul Jenkins 在 "Concepts of Participation in Architecture" 一文中，展示了自己創建的一個三維圖像，來說明更大範圍的建築生產參與框架，其中包括：[15]

Ⓞ **誰**　參與者的性質（客戶、用家和公眾）

Ⓦ **如何**　參與的形式（通知、諮詢和決策）

Ⓝ **何時**　建築過程的各個階段（設計、施工和完工後）

由於每個項目的性質不同，有關「如何」的問題將在下一篇第 2.2 節「在項目中實施參與式設計的原則」討論。

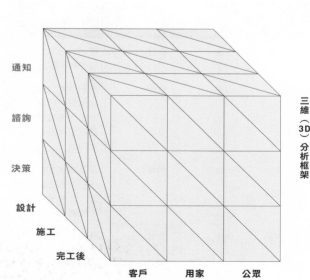

三維（3D）分析框架

通知
諮詢
決策

設計
施工
完工後

客戶　用家　公眾

Jenkins P. & Forsyth L. 的建築生產參與框架（二〇一〇）

結合 Sarah White 之前建立的框架，我們可以得出在建築界實踐參與式設計的不同方式，建築師和客戶（建築項目發起人或發展商）從而可以決定設計過程不同階段的參與形式和程度。而事實上，設計專業人士和外行人之間的互動，是當今城市規劃和設計工作取得成功的重要組成部份。

1.4

建築師和公眾

建築具有內在的政治特質，因為它是空間生產的一部份，而這種政治特質顯然會影響社會關係。16

意大利建築學者 Giancarlo De Carlo 在 "Architecture's Public"（一九六九年）17 一文中，陳述了建築的政治特質和透過參與為用家賦予權力的必要。他批評，在所有時代，無論建築師這個角色如何重要，他們都需要受制於當權者的世界觀。他批評道：「隨着資產階級專業主義的興起，建築被推入了專業化的領域，在那裏只有『如何』的問題是重要的，因為『為甚麼』的問題被認為是已一勞永逸地解決了。」18

現代建築師與經濟和政治權力結盟，並與公眾保持距離，比起用家，他們更靠近客戶。強調專家的重要，伴隨而來的就是對社會責任的壓制，這也是為甚麼設計通常被認為是從屬審美選擇的領域。幾個世紀以來，建築師一直根據古羅馬建築師維特魯威（Vitruvius）的優秀建築原則《建築十書》（De architectura）學習，即強調堅固、實用和美觀。19然而，如果建築師只是識別客戶的需求，而不是用家的真正需求，那麼建築又怎能真正實用呢？

不管怎樣，當建築師與客戶或用家之間無法有效溝通時，實用原則就會遭到破壞，建築師會認為，他們比用家更了解用家自己的需求。20

● **建立對等關係 以更好地理解用家知識和專業知識之間的平衡**

參考巴西教育家 Paulo Freire 在其著作 *Pedagogy of the Oppressed*（一九六八年）中的觀點，Freire 將傳統教學法稱為「囤積式教育」（Banking Model of Education），因為它將學生視為一個空的容器，就像一個錢罌般填入知識，但他認為教育應該將學習者視為知識的共同創造者。[21]

參與式設計的本質是認同用家的知識，並賦予他們與研究人員一起建立新知識的權力。因此，根據 De Carlo 的說法，建築師認同用家的需求並不意味着「為」他們設計，而是「與」他們一起設計。

建築師應識和用家攜手合作，在得出設計結果之前，雙方應該以各自的知識一起討論空間和架構的模樣，而非把公眾視作空的容器，等待專業人士將其填滿。建築師和公眾之間對等的關係是參與式設計的成功基礎。

 註

01 Rachael Luck, "Dialogue in Participatory Design." *Design studies* 24, no. 6 (2003): 523-535.

02 "#Envision 2030 Goal 11: Sustainable Cities and Communities" , United Nations, Department of Economic and Social Affairs, Disability, accessed 29 Nov 2022.
https://www.un.org/development/desa/disabilities/envision2030-goal11.html

03 Charles Jencks, *The Language of Post-Modern Architecture*. 6th ed. London: Academy Editions, 1991.

04 Nan Ellin, *Postmodern Urbanism*. Cambridge, Mass: Blackwell Publisher, 1996, p.1-8.

05 Jane Jacobs, *The Death and Life of Great American Cities*, Harmondsworth: Penguin in association with Cape, 1964.

06 Henry Sanoff, *Community Participation Methods in Design and Planning*, New York: J. Wiley & Sons, 2000, p.1-3.

07 同上。

08 Nan Ellin, *Postmodern Urbanism*. Cambridge, Mass: Blackwell Publisher, 1996, p.44, 48-54.

09 同上，p.9-10, 26.

10 Natasha Vall, "Social Engineering and Participation in Anglo-Swedish Housing 1945-1976: Ralph Erskine's Vernacular Plan." *Planning Perspectives* 28, no. 2 (2013): 223-245.

11 Mateusz Gierszon, "Architect-Activist. The Socio-Political Attitude Based on the Works of Walter Segal." *Journal of Architecture and Urbanism* 38, no. 1 (2014): 54-62.

12 Paul Jenkins and Leslie Forsyth, *Architecture, Participation and Society*, London: Routledge, 2010, p.14.

13 Sherry R. Arnstein, "A Ladder of Citizen Participation." *Journal of the American Planning Association* 85, no. 1 (2019): 24-34.

14 Sarah C. White, "Depoliticising Development: The Uses and Abuses of Participation." *Development in Practice* 6, no. 1 (1996): 6-15.

15 Paul Jenkins and Leslie Forsyth, *Architecture, Participation and Society*. London: Routledge, 2010, p.9-22.

16 Nishat Awan, Tatjana Schneider, and Jeremy Till. *Spatial Agency : Other Ways of Doing Architecture*. Abingdon, Oxon [England]: Routledge, 2011, p.38.

17 Giancarlo De Carlo, "Architecture's public" (1969). Peter Blundell Jones, Jeremy Till, and Doina Petrescu. *Architecture and Participation*. Taylor and Francis, 2013: chapter 1.

18 同上。

19 Vitruvius Pollio, Frank Granger, and Vitruvius Pollio, *On Architecture*, Translated by Frank Granger, Cambridge, MA: Harvard University Press, 1931.

20 Susanne Hofmann, Susie Hondl, and Inez Templeton, *Architecture Is Participation : Die Baupiloten – Methods and Projects*, Translated by Susie Hondl and Inez Templeton, Berlin: Jovis, 2014, p.11.

21 Paulo Freire, *Pedagogy of the Oppressed*, London: Penguin Books, 1972.

02

THEORY

參與式設計

關於了解和溝通

一九六〇年代末至一九七〇年代初,在設計界裏,有一場關於如何通過建立系統,令設計方法學更容易被非設計專業人士理解的討論。[01] 設計界試圖讓設計變得更「科學」,追求想法的客觀性和高度合理性,摒棄主觀、情感和直覺因素,讓設計更容易被行外人理解。

最早關於理性設計和創意方法的書籍也在這時期出現,包括建築師兼設計理論學者 Christopher Alexander 的 *Pattern Language Method*、設計師 John Chris Jones 的 *Design Methods*,以及後來建築學者 Peter Rowe 的 *Design Thinking*。

而由 Christopher Alexander、John Chris Jones、工程設計師 Bruce Archer 和德國設計理論家 Horst Rittel 於一九六〇年代初創立的「設計方法運動」(Design Methods Movement),則是於系統規劃過程開始納入民眾參與的重要嘗試。

2.1

設計思維和建築設計的關係與聯繫

● 從設計透明化到設計思維

Rittel 批判早期發展設計方法時的純粹理性方向，並提出了「棘手問題」（Wicked Problems）[02] 的概念——複雜的、開放式的、模稜兩可的、不能輕易判斷對錯的問題。這使得「設計方法運動」中的一部份人捨棄了將設計理性化的方向，從而轉投視能夠整合用家需求的設計——即設計師與持份者（客戶、顧客、用家、社區）合作的設計。這種以人為本的問題解決方法其後引發了參與式設計、以用家為中心的設計，以及後來的設計思維（Design Thinking）。

一九九一年，設計公司 IDEO 成立，其突破之處在於很大程度上借鑒了史丹福大學課程，[03] 並公開展示了其設計過程。人們普遍認同 IDEO 是為將設計思維帶入主流的公司之一。在二〇〇五年，史丹福大學 d.school 開始在課程中將設計思維列為正統方法。

現時設計思維已成為受歡迎的創意解難方法，除了在傳統設計行業被廣泛採用，也被許多其他行業，特別是商業和政府部門所採用。隨着設計師不斷發展設計模式，設計思維成為了那些未曾受過設計訓練的人之橋樑，協助他們將設計方法應用於其所屬領域，作為創新的解決問題方法。

● 設計思維方法和典型設計方法

設計方法的發展與設計過程系統化有着密切的關係。系統化的設計過程（典型設計）主要包括四個階段：發現（洞察問題）、定義（重點領域）、開發（潛在解決方案）、交付（解決方案）。參考建築和工程項目的工作階段，或任何設計領域，包括概念設計、方案設計和細節設計，均是採用類似的模式。

雖然設計思維較少關注硬件，而更加關注軟件和用家體驗，但亦可分為以下步驟，幫助設計人員了解最終用家的需求：

設計思維階段	典型設計階段
同理心	發現
定義	定義
構思	開發概念
原型	深化概念
測試	交付

❶ 感同身受
❷ 定義
❸ 構思
❹ 原型
❺ 測試
❻ 重新開始並盡量重複流程

以下圖表顯示了設計思維工作流程與典型設計工作流程的關聯，以及進一步闡釋不同的設計思維階段：

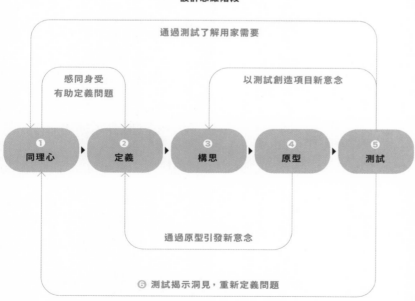

設計思維階段

通過測試了解用家需要

感同身受
有助定義問題

以測試創造項目新意念

❶ 同理心　▸　❷ 定義　▸　❸ 構思　▸　❹ 原型　▸　❺ 測試

通過原型引發新意念

❻ 測試揭示洞見，重新定義問題

2.2 在項目中實踐參與式設計的原則

● 參與式設計是設計研究

與設計思維類似，參與式設計有許多方法以確保過程中能考慮到參與者的想法和需要。設計理論學者 Clay Spinuzzi 在其論文 "The Methodology of Participatory Design" 中描述，參與式設計是一種研究，儘管有時它僅僅被視為一種設計方法，但他強調，這種方法既關乎設計（以生產包括人工製品、系統、組織以及實用或隱性知識），也關乎研究。

參與式設計經常採用人誌學研究（Ethnographic Research）的工具，如實地觀察、訪談、文物分析和個案分析的方法常被重複用作建構新設計，而這意味着由設計師（研究人員）與設計的最終用家共同詮釋的新設計，也能同時構成和引申出的研究結果。04

參與式設計項目的設計成果不是預先確定的任務，它一方面是支持創新的實際工作，另一方面是系統的數據收集和分析，是設計師（研究人員）和參與者之間合作的研究成果。

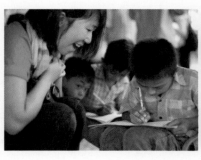
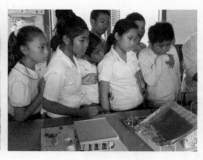

● 參與式設計的工作階段和方法

大部份參與式設計研究都可分為五個階段：

工作階段	可行的方法
◎ 第一階段：初步探索 設計師與用家會面，並熟悉用家的處境。	此階段涉及脈絡查查，以諸如實地觀察、訪談、調查、演練和檢查等的人誌學研究方法，有助了解用家的行為及其身處的環境。
◎ 第二階段：發現過程 設計師和用家使用各種技術來理解和闡述目標，並設想期望的結果。	有別於傳統的人誌學，這個階段需要設計師和用家進行大量互動，包括：小組互動、投票、角色扮演遊戲等，目標是讓用家想像他們的偏好和背後的原因。
◎ 第三階段：原型設計 設計師和用家持續發展符合第二階段目標的設計原型。	這個階段涉及各種技術，以重複地塑造設計，像是樣板、比例模型、實體紙板均有助用家對設計給予意見及回應。
◎ 第四階段：建造及施工 在項目工程時期及安全容許下，設計師可考慮與參與設計的用家代表一同到施工地盤，參觀了解進度，實地向用家解釋一些重點及標誌性設計，讓他們一同參與。	設計師在視察前應與用家代表清楚表達參觀的目的及限制，以免出現不同的理解而產生誤會。
◎ 第五階段：完工及分享成果 在參與式設計項目完工後，建議設計師及參與設計的用家邀請其他用家及朋友參加分享會，大家一同欣賞設計成果。	曾參與設計的用家亦可充當「設計師」的身份，向其他用家介紹設計概念和特色。

參與式設計項目必須因應個別項目的需要及期望，在初期便定下不同階段及相關細節，讓設計師、用家及有關的持份者達成共識。

超越設計及生產流程
建築由大家共同創造

儘管建築設計的技術要求很高，但用家的參與仍可出現在建築製作的各個階段，特別是早期設計和後期完成階段。在建築師、設計師開發項目的同時，每個階段讓用家參與，可以檢查並驗證設計成效。

以下的工作流程圖總結了建築生產、參與式設計和設計思維如何提高效率和相互的關聯。

結合行動研究方法的設計，可以令建築師、設計師等專業人士和用家之間產生積極的改變與互動。建築師可以向用家學習他們在社區內的隱性知識，以設計更好的建築環境，而用家可以向建築師、設計師學習他們的專業知識。因此，建築設計不只是解決問題和提供服務，而是賦予大家機會去了解設計、欣賞設計、學習設計。

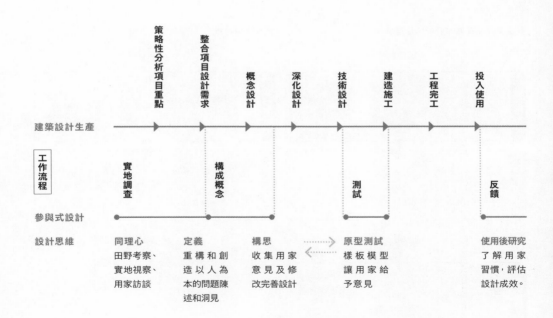

	策略性分析項目重點	整合項目設計需求	概念設計	深化設計	技術設計	建造施工	工程完工	投入使用
建築設計生產								
工作流程	實地調查	構成概念			測試			反饋
參與式設計								
設計思維	同理心 田野考察、實地視察、用家訪談	定義 重構和創造以人為本的問題陳述和洞見	構思 收集用家意見及修改完善設計		原型測試 樣板模型讓用家給予意見			使用後研究 了解用家習慣，評估設計成效。

● 促進者的角色：
建築師和以人為本的專業人士之合作

在 *Architecture, Participation and Society* 一書中，建築學者 Paul Jenkins 和 Leslie Forsyth 討論了建築設計過程，以及建築師與不同持份者的關係。除了典型的建築生產模式，他們還提出了一個社會參與度更高的設計和建造過程（Design-and-build Process）。05

在典型的建築過程，建築師是作為關鍵協調者與其他專業人士合作，提出可以滿足客戶需求和監管機構要求的設計方案。而在社會參與度更高的模式中，建築師、設計師和其他專業人士共同努力，促進與客戶和與建築物用家的有效溝通，同時仍然履行專業職責，滿足監管要求。

一般的建築師或設計師培訓側重於技術知識，在傳統的設計教育中，溝通技巧和其他軟性技能（Soft Skills）可能會被忽視。設計專業人士和行外人的互動，是成功的設計成果之重要組成部份，由此，建築師如能和其他以人為本的專業人士（例如社工、教師、治療師等）協作，對於取得更深入的參與成果將至關重

社會參與度更高的設計和建造過程　　　　**典型建築過程**

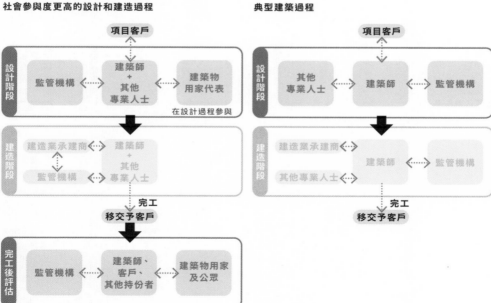

024

在參與式設計中社會服務提供者的角色

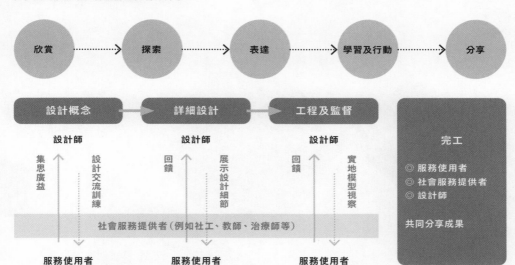

註 01 Susanne Hofmann, Susie Hondl, and Inez Templeton, *Architecture Is Participation : Die Baupiloten – Methods and Projects*, Translated by Susie Hondl and Inez Templeton, Berlin: Jovis, 2014, p.11-12.

02 Horst W. J. Rittel, and Melvin M. Webber, "Dilemmas in a General Theory of Planning." *Policy Sciences* 4, no. 2 (1973): 155-169.

03 "Design Thinking Defined", IDEO, accessed 29 Nov 2022. https://designthinking.ideo.com

04 Clay Spinuzzi, "The Methodology of Participatory Design." *Technical Communication* (Washington) 52, no. 2 (2005): 163-174.

05 Paul Jenkins, and Leslie Forsyth, *Architecture, Participation and Society*. London: Routledge, 2010, 9-22.

要。在大多數情況下，與當地社區密切合作的社會服務提供者，將在公共項目中擔當設計師和社區之間重要的促進者角色。

在社會服務提供者的幫助下，設計師可於事先更好地了解社區；在設計工作坊中，社會服務提供者可以充當溝通橋樑，積極鼓勵用家參與、發表他們對環境的需要及對設計概念的意見，促進設計師與用家之間的建設性互動及協作。

在接下來的章節中，我們將介紹為甚麼不同持份者會對參與式設計的方法感興趣，以及提供不同的案例研究，這些方法和案例研究展示了各持份者如何合作，以獲得參與式結果。

chapter
02
專業
思考
業
考

Expert idea

EXPERT IDEAS

01

從政策桎梏打開缺口

吳永順：「還港於民」的實踐式參與實驗

引入用家參與設計的建築項目少之又少，更不要說在社會政策層面可以有何突破。海濱事務委員會主席吳永順（Vincent），二○○四年至今持續投身海濱發展項目。他將海濱項目轉化成實踐式參與實驗，矢志要「還港於民」，讓人們通過身體力行，令海濱空間不斷進化。

Vincent 從事建築設計和城市設計超過三十年，商業和公共建築作品超過百項，包括：中環街市活化計劃、香港理工大學創新樓等。他深明在傳統建築設計上引入使用者的參與，是多麼困難的事——尤其在公共項目中。這不只關乎建築團隊是否有心，更要「過五關、斬六將」，面對政府各部門的掣肘。「這的確困難，牽涉的持份者太多，一項政策除了視乎市民的需要，還有很多方面牽涉到政府架構問題，要打通不同的政府部門，符合不同的需求，當中面對重重障礙，足以令你放棄。」

作為建築師，他認為建築設計必須有用家參與。在中環街市項目中，他邀請居民前來給予意見，「漂浮綠洲」方案中有不少是市民的心願：保留建築外貌，加建綠化空間、泳池等。「由將來的用家參與設計的好處，第一、可以讓建築師及早了解使用者的需要，第二、成果更貼近最終使用者的需要，使用者對空間會有歸屬感和『自己有份設計』的滿足感，比起閉門造車式的設計更能產生正面效果。」

● 期間限定裝置修正預期

二〇〇四年，Vincent 代表香港建築師學會加入海濱事務委員會（前身為共建維港委員會），展開為期二十四年的海濱優化項目，目標在二〇二八年前將維港海濱長廊延長至三十四公里，並在維港兩岸提供約三十五公頃休憩用地。自二〇一八年起，Vincent 擔任海濱事務委員會主席，念茲在茲的心願始終是「還港於民」。

從建築師到成為政策制定者，公共建築更需得到公眾的認受性，畢竟這是全香港七百五十萬人的事。不過，相較以往單一建築項目，對於二十年起跳的大型持續項目，他不諱言公眾參與的形式要相應地作出改變。

「公眾參與，從來都沒有離開過我的腦海。」Vincent 說。在他心目中，海濱項目是一個巨大的實驗場，是以往公眾參與項目的進化版，他稱這種實驗模式為「實踐式公眾參與」。相較過往諮詢市民，他提倡「先駁通，再優化」的理念，即一些海濱基礎設施落成後，就會立刻開放給市民使用，委員會同步收集市民的使用意見，再將場地相應調整和進化。「相比起讓市民一起去傾規劃和設計，我們是先行動再調整。場地陸續推出一些期間限定的裝置，作用是收集市民的意見，我們持續觀察他們怎樣使用，再逐一修正。」

舉個例，在卑路乍灣海濱長廊的項目中，團隊本來構思以涼亭作為市民表演的場地，但後來發現其使用率很低，反而在疫情下，人們沒有地方吃飯，於是團隊趕緊在一個月內於全部涼亭設置餐枱，因而吸引很多市民買外賣到涼亭大快朵頤，反應正面。反應如此迅速，需要精簡管理架構。海濱項目裏有些場地直接由發展局管理，靈活性很高，例如容許市民遛狗、踩單車、踩滾軸溜冰、踩滑板、釣魚等，Vincent 希望可以做到「段段有特色」：卑路乍灣的椅子是可任市民移動的沙灘椅，荃灣有首個採用無欄桿設計、以增加親水性的海濱，灣仔至銅鑼灣有水上活動主題區，西營盤有以渠筒設計的「捐山窿公園」……

Vincent 以烹飪作為比喻，解釋實踐式公眾參與的好處：「過去建築師策劃的公眾參與項目，倘

若是「即叫即蒸」，便很快看到成果。但在大型項目和規劃上，公眾參與的過程實在太漫長了，當你點完菜，十年後才上菜，昔日的使用者群可能已經改變了，新的使用者便會覺得：你沒有問過我啊？當中就會出現矛盾，所以我們決定在現場與市民互動。」

● 公眾參與才能回應時代

不斷有新的使用者加入，與空間交織互動，從而產生更大的可能，這個空間就會變成一個開放式的有機空間，並會自我更新和完善，當進化到一定程度，或許不再需要粗暴的管理。Vincent 認為，互動的過程會為市民和機構帶來更新的動力，這個動力是源於雙方不斷出現知識的碰撞。「建築師往往覺得自己懂得很多，但每當接觸用家後才恍然大悟：原來對方想要的是這樣。而對於用家來說，建築師的講解也擴闊了他們的想像空間，在共同創作的過程中，雙方可以增進知識和視野，這亦是充權（Empowerment）的過程。」

雖然實驗充滿了未知之數，可能行得通，可能行不通，可能做對了，也有很大機會出錯，但這個世界之所以能夠進化，不啻是由一連串實驗的錯誤貫穿而成，正所謂「有危就有機」。「只要一直運作，自然會啟發更多人，投入 IDEA，項目就會一直進化；機構也要同步回應一直改變的社會環境，這就是公眾參與的精神。而我們現在做的，就

是通過實驗打開缺口，測試過去的規條是否仍然適用，要創新就必須要這樣做，否則我們只會永遠於現在的環境實踐過去的規條，再規劃將來，這只會墨守成規，毫無進步。嘗試就是必須要冒險。」他頓了頓，又說：「建築只是一種工具，如果你有熱誠，你會願意為人們冒一些險。」

缺口一旦打開，就會一發不可收拾，準會招來不少齟齬，或禁止或質疑，最常見的是「有市民投訴」，彷彿解釋了宇宙原理一樣。如果說和諧是一百種不同的聲音能互相尊重，那麼也可以是同一空間中，人們能尊重不同類型的活動共存，這是每個人都需要學習的包容精神。當然，大前提是不能傷害別人，但如何不會傷害別人？又是一個大課題。Vincent 說：「人們需要從中學習，即使踩單車、踩滾軸溜冰都不會撞到人。我們想做一個實驗，去破除這些既有框架，證明某些部門過去的憂慮是不必要的。政府只設立投訴熱線，是無法得到全面的意見的，尤其是正面的反饋。根據我們的初步調查顯示，超過八成人覺得這個我們的運作是 OK 的，這就可以給予政

府信心，嘗試新的管理模式。」

　但政策制定者是否能夠容納一個不斷改變的環境——或稱之為「留白」、讓公眾參與的位置，才是關鍵。「不論是決策者還是領導層，『留白』都不是容易的事。當一個人到了決策的位置，可能會有完全掌控一切的慾望，或因過於害怕出錯而不敢放手。要讓無法預計的東西出現，真的需要勇氣和胸襟。」

● 支持參與式設計項目

Vincent 曾於二〇一〇年擔任香港建築師學會青年會員事務委員會主席，撥款資助 IDEA 柬埔寨項目。該委員會設立的其中一個目標，是透過青年建築師項目基金支持年輕建築師實踐心願，譬如第一屆基金就資助了建築師為劏房家庭改善居住環境。那年芸芸眾多項目中，學會經篩選後決定批出款項予 IDEA 到柬埔寨興建學校建築物和小型圖書館。現在他回想，直呼：「這是正確到不能再正確的決定！」

「我們都想不到，當日埋下小小的種子，今天竟有那麼多人在 IDEA 參與式設計項目中參與和受惠。一方面，從象牙塔訓練出來的建築師可以更直接去接觸社會的需要，不會再做一些自以為是、空中樓閣的事情，這個對於建築師的訓練本身已經有很大價值。另一方面，參與者從創造中正面影響了其他人的生命，令人更關注社會弱勢社群，是很難得的事。」Vincent 回想起，仍然驚訝於 IDEA 團隊多年來堅持不懈的毅力和熱誠。

思想裏激盪：
留白是如何產生的？

與劉鳳霞博士對談

有人問，為何我們無法參與自己家樓下的公園設計？答案顯然易見：在滴水不漏的政府管理中，根本沒有用家介入的餘地。即使有政府部門嘗試在公共項目設計中加入用家參與的元素，也需經過其他部門重重審批，先不要說最後會否獲批，單是行政處理工作的難度之高，已足以令有心人卻步。

不過，總有個別成功的例子。康樂及文化事務署藝術推廣辦事處為慶祝香港特別行政區成立二十周年，推出「城市藝裳計劃：樂坐其中」（City Dress Up: Seats · Together）公共藝術項目，卻成功留下了一些「留白」的空間，讓摩士公園裏的「老友記・設計師」項目得以實行，長者也能設計自己喜愛的座椅（詳見另文《老友記・設計師　爆發小宇宙　設計老幼共融公園座椅》）。

然而，如何塑造這個留白的空間是一大學問。藝術推廣辦事處總監劉鳳霞博士與「老友記・設計師」項目設計團隊成員王建明、梁皓晴，一起訴說在座椅設計以外的「凳＋」願景。

 梁
 王
 劉

劉——藝術推廣辦事處總監
劉鳳霞博士
Dr. Lesley Lau

王——IDEA創辦人
王建明
Robert Wong

梁——香港大學建築系導師
梁皓晴
Rosalia Leung

● 劉 參與式設計，這個概念對我們來說很有意思。藝術推廣辦事處並沒有特別將「參與」元素放進系統，長久以來，我們都在集中思考怎樣塑造一個平台，將藝術推廣滲入不同環節，同時配合時代發展方向所需要的創作和創意，讓藝術家、創作人，也包括建築師、設計師，可以透過我們的支援，找到他們發揮的空間，而非單純只是一個辦展覽的機構。但居然可以從這個平台裏發展出參與式設計項目，這就是有趣的地方。

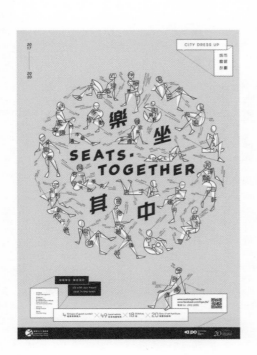

● 王

我是建築師，修讀過設計思維相關科目，但因為不是藝術背景出身，始終會覺得和藝術有段距離。「城市藝裳計劃：樂坐其中」利用公園座椅的功能，拉近了設計、藝術和社區的關係，各方面都多走了一步，達致三贏局面。

● 劉

這也是藝術推廣辦事處做過前所未有最大型的項目。當日我們收到的任務是在全香港「擺放一些有設計特色的公共座椅」，除此以外，也沒有定明的項目細節。如果要做得簡單，我們大可以找一位藝術家設計一款座椅，放在十八區的公園裏，但這樣便會浪費大好機會。我們作為使用公帑的政府部門，一定要思考項目如何能更符合社會需要。加上難得有這筆資源，打着二十周年的旗號，又可令各部門稍微開綠燈，沒理由不趁機做些甚麼吧？

於是我們找了二十組藝術家，為全港二十個公園設計二十款座椅，在設計上沒有硬性規定，唯一要求是要能坐。除此以外，我們還有個小小的願景：可以達到「凳＋」，但到底「＋」甚麼呢？就要由創作人發揮想像力。你們（IDEA團隊）就加入長者參與的部份，有的組別則加入表演小舞台，有的組別加入後續活動，增加市民對空間的想像。

● 空間留白　產生更多可能

● 王

王：要做「＋」的東西，或者我稱之為「留白」的地方，實在不容易。像我們團隊裏的社工同事帶着一群「老友記」到戶外實地考察，已是難關重重；要不熟悉設計的社工同事向「老友記」解釋如何參與設計，更是大挑戰；項目完結後，當然最重要還要有康文署放行，我到美國建築師學會、聯合國人居署、世界衛生組織分享，在場聽眾很驚訝為何我們可以做到「與長者共同設計公共家具」，各國政府也想做，但不知怎樣做。其實我覺得只要有一些「留白」，不論是系統「留白」還是設計「留白」，就可以令很多可能性出現。以公園項目為例，預留十分之一的部份由建築署以外的機構或人參與設計，留下一些可能性，在不改變預算的情況下，已經可以令整個項目更加「有機」（Organic）。

● 劉

劉：我想舉一個例子。不知道你們有沒有受到公園同事「招呼」（笑），曾經有些組別在過程中遇到場地困難，結果找了我一起開會「壓場」（笑）。我和創作團隊一到公園，同事客氣又老實地解釋說：「其實我們不需要更多的凳子。」意思就是：「其實我們不太需要你們。」通常這個時候藝術家可能會沉着臉走人，但這個團隊很正面，反而認

真思考不多做一張椅子的做法，結果他們拆走原有座椅的椅背和扶手，再「僭建」成一張張沙灘椅、連小几的椅子等，這個作品 *Hack-a-bench* 更接連取得

IDA國際設計大獎2018（金獎）、DFA亞洲最具影響力設計大獎2018（優異獎）和 2020 Good Design Award。公園同事很開心，原本這些設計應該於二○二○年七月拆除，結果他們到現在都捨不得拆掉。這個項目也為康文署內部帶來了正面迴響。

我想帶出的訊息是，即便有「留白」的空間，都要小心拿捏細節。不同合作及負責單位會因為不同的考慮及想法而提出「改良」意見，結果有時反而會抹殺了最初的精彩之處。曾經見過有些獲獎的計劃書，在接受了很多「善意」意見後，結果反而變得最沒趣味，作品做出來的效果也不好。所以要能成事，很視乎各個參與者是否掌握項目的共同理念

及細節，創作團隊又是否可以捉緊每個契機，當中做得好的話，觀眾的眼睛總是雪亮的，好的東西最終都會感動人心。

視乎脈絡的公眾參與模式

● 王　我覺得設計不只是一個解決方法，更是一個凝聚了很多人共識的手段。

● 梁　一個項目要讓公眾參與，尤其是建築或公共空間，好多時候在政策或行政方面，應該已經要有參與式的思維方式。一張凳子的形成，往往並不是凳子要怎樣設計，而是整個項目的設計，從概念到執行、行政工作的流程，然後設計師怎樣入場，最後才是公眾怎樣去參與這個設計。

● 劉　其實牽涉到公共空間的設計是十分複雜的，不能漠視公眾、社區、空間的發展

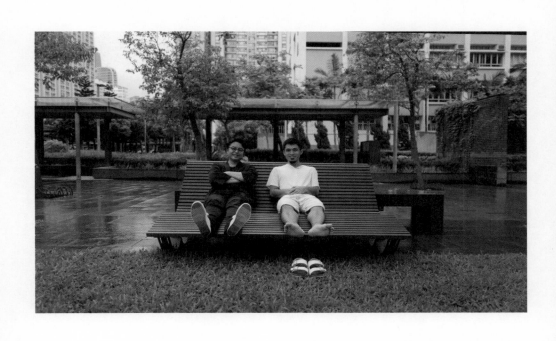

和歷史；不能偷懶、抱殘守缺。態度過

份小心翼翼、不積極面對世界的快速發

展，就不能與時並進，特別是創意相關

領域真的發展得很快，否則最終可能連

一般市民也會作出批評。我覺得大家在

自己的專業界別中工作多年，真的要以

自己的專業去做對應現代社會適合的

事，這是基本點。

話說回來，現在流行講「社區參與」，

但甚麼叫做合適的參與？有時魔鬼在細

節。油街實現現正進行一個擴建工程，

作為政府項目，必須要做到社區參與，

若果我們不向市民及持份者諮詢，那就

「死得了」（笑）。以往一般的公眾諮

詢會，可能在一個會堂裏「正正經經」

地舉行──主持人在台上作簡報，然後

回答台下觀眾的問題。我不是說這樣做

不行，但我們作為藝術創意界別，理應

表現出一點新意，用更好玩有趣的方法

● 梁

參與也可以分為不同程度——徵詢意見是否參與？還是「落手落腳」去做才是參與？對我來說，參與是很 contextual（脈絡化）的，根據不同情境，需要不

進行諮詢，效果可能更令人驚喜。我傾向使用香港建築師學會與油街實現合辦的「玩轉『油』樂場」模式（詳見後文的《從玩開始　從小做起　陳翠兒：讓參與成為改變世界的第一步》），用一系列工作坊收集公眾意見。

同的公眾參與程度和方式，很難有單一定義。有時候，參與也可能會出現事與願違的效果，因為在某些情境下，那一種參與方式未必有用，可能問了公眾的意見，反而令事情更加糟糕。

社區裏的創意實驗

● 劉

你們有一道問題，是關於我怎樣看社群藝術（Community Art）這個概念。我覺得這些字眼令人感覺很正面和良好，大家一般都喜歡。但何謂社群藝術呢？坊間沒有清晰的定義，而我們最簡單的說法是透過藝術營造社群。那要怎樣做呢？在公園裏上演一齣人人耳熟能詳的經典粵劇《帝女花》，雖然應該很容易吸引大量觀眾，但我們更希望做的，是透過尋找社區需要甚麼創作和創意，再去開展一個項目，這樣不論是社群還是藝術，都會有向前發展的機會。

● 王

你們和我的背景不一樣，你們是建築師，我是藝術策展人，但有些東西大家是近似的，就是我們都在連繫人、情、事，在中間扮演着重要的角色，貢獻自己的資源和知識。

你所說的人、情、事相當重要，一件作品或一個項目帶來的不只是視覺上的賞心悅目，更重要的是帶有人的詮釋。若果每個人都帶着好奇心，嘗試跨出第一步，做社區實驗的機構又能將參與式設計帶進公共項目中，大家抱持着建設性的互相學習精神，所產生的影響會很大。我自己對此是抱着傳教般的心態，可能人們未準備好了參與進來，但只要不放棄，一有機會就在項目或活動中滲入一些參與式設計的概念，就可以繼續走下去。

EXPERT IDEAS

03

從玩開始 從小做起

陳翠兒：讓參與成為改變世界的第一步

在一個小小的房間裏，佈滿了與俄羅斯方塊一模一樣的粉紅色海綿磚，人們可以隨意躺臥、嬉戲或移動磚塊，建構出他們理想又或是超乎想像的居所。房間內洋溢着歡笑聲，大人小孩子都玩得十分高興。這是「玩轉『油』樂場」（PLAY to CHANGE）其中一個展覽「玩轉——活：逼活油街」（PLAY to Live），要從「玩」拓闊觀眾對空間的想像。「玩」，是一股神秘的力量，香港建築師學會副會長、香港建築中心主席（二〇一五至二〇一九）陳翠兒（Corrin）認為，從「玩」所產生的想像力和創造力，是改變社會不可缺少的推動元素。

在二〇一七至二〇一九年間，香港建築中心連同香港建築師學會與油街實現共同策劃「玩轉『油』樂場」項目，兩年間舉行了十多個由青年建築師團隊打造的展覽和活動，當中所有節目必須包含「玩」和公眾參與的元素，「玩轉『油』樂場」後來更榮獲日本「優良設計獎二〇一七」殊榮。

與建築師予人嚴肅的形象相反，項目以「玩」作為主題，嘗試透過各種展覽和創作探討社會空間議題，例如劏房、街道招牌、舊區老舖等。這對慣常投身於商業項目的建築師來說，也能透過輕鬆活潑的藝術創作，重回以建築連結人與社區的初心──這是項目的目標之一。「用『玩』作為切入點，另一方面亦想鼓勵大家用輕鬆的心情面對逆境。而且『玩』其實好重要，兒童都是透過『玩』的體驗去學習，『玩』不是輕率的『玩玩吓』，而是透過自在放鬆的心態去做實驗，帶來創意和快樂。」Corrin 解釋。

展覽內容相當多元化，有以巨型康樂棋介紹北角舊建築和街道，將首屆香港小姐選舉場地麗池夜總會的故事娓娓道來；有流動繪圖木頭車帶着街

坊遊走舊區作城市寫生，畫出不一樣的風景；也有探尋城市空間的體驗導賞團，重新發掘社區為數眾多的閒置土地。比起別的展覽和活動，這更像是為大眾舉行了一場想像的實驗──這也是項目的目標之二。Corrin 指：「每一隊建築師都有自己的想像，想城市有甚麼改變，就算不能在短時間改變世界，至少希望參與者從自身出發，有所改變。」

陳翠兒認為，以「玩」作為切入點，能讓人輕鬆地發揮創意、獲得快樂。

玩轉「油」樂場
PLAY to CHANGE
playtochange.oil/

● 透過「玩」閱讀大眾的心

想要改變，先要學會聆聽。團隊也藉着「玩」閱讀公眾的心，而這絕非居民大會或聽證會可比擬的，Corrin說：「不是每個人都可以在公共場合自在地講出自己的心聲，所以團隊要以另一種方法去聆聽大眾的需要。」在展覽「玩轉——諒・繪・望・賞」（PLAY to Understand）中，團隊邀請青少年在膠盆上畫出對城市發展的願景，然後掛起來成為裝置藝術品。有人想要有更多水，有人想要有更多樹木，有人想要陽光充沛，也有人覺得更多圖書館可以給予心靈上的空間，原來人們最想要的，不過這麼簡單。

又如在展覽「玩轉——互：社區百繪集」（PLAY to Interact）中，團隊帶領參與者遊走北角老區，讓他們藉由寫生的方式反思社區發展，過程中他們也會被社區的細微之處改變既定印象。「公眾寫生的作品啟發了我們怎樣去看城市，有時我們會對身旁事物視而不見，我們以為看到了，但原來看不到，又或者不知道是否看得到。但當看到他們的畫作，着眼於最細微的景觀和感覺，就能夠閱讀他們的內心，了解對他們來說甚麼才是重要的。人們選擇閱讀這個城市的甚麼，再在畫筆之下重組這個城市，其實就是一個創造的過程，這是很重要的體驗。」

有一點必須提及的是，建築師往往習慣在偌大的空間裏發揮才華，面對油街實現小

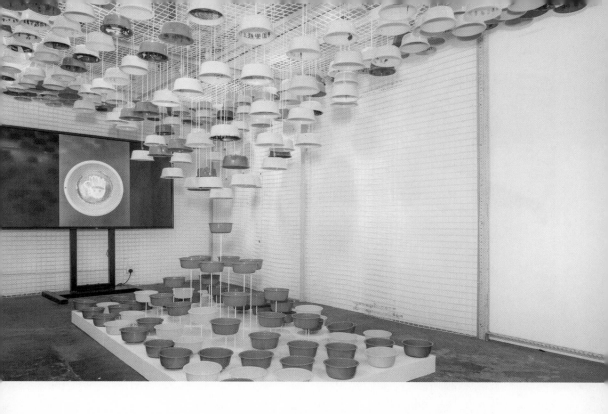

小的活動室，想必困難重重，但空間的限制反而激發起建築師的小宇宙。Corrin 笑言他們用的是油街實現最小的一個展覽廳，但她卻珍而重之：「大展覽廳當然容易做，但小房間卻令我們要花更多心思，下定決心作出改變，不受空間限制。」小小的房間也可以包含深遠的願景：「為社會帶來改變。」

在展覽「玩轉——連∴空擴」（PLAY to Connect）中，房間掛滿各種顏色的絲帶，參與的觀眾可以把絲帶剪下來，然後掛到房間外的雕塑上。將減去了的再加起來，猶如將一個負空間（Negative Space）重新創造成正空間（Positive Space），而這兩個空間都是因為市民的參與而出現的、流動的結果。「變化是一個定律，這個世界無時無刻都在改變，可能會變好或變壞，但只有讓有持份者不斷參與，才會令這個城市有更可持續的發展，因為城市是屬於所有人的。」未來的社會會走一條怎樣的路，就在每個人把意念轉換成行動或不行動之中。

045

● 民間力量是重要資源

中國思想家老子在《道德經》中曾經說過：

「天下難事，必作於易；天下大事，必作於細。」

改變社會，不妨先在日常生活中從改變小社區做起。「空間使用者無論如何都已經介入了空間，但到底可以怎樣參與？不妨先着手思考小社區中有何可改善的，譬如在後巷種花、畫畫美化環境，也可以思考如何減少街道垃圾，而政府在政策上亦應下放資源給作為市民代表的區議會，來完善社區設施和城市設計。」

記得當日深水埗主教山羅馬式蓄水池就慘遭橫手，葬身於推土機下嗎？幸好一位在主教山做運動十多年的街坊芳姐隻身抵擋推土機，才成功叫停工程。Corrin 當日到場視察，發現除了蓄水池，山上原來還有個小小的「健身專區」，擺放了不同種類的運動器材，如乒乓球枱、單車機、拉繩裝置、沙包等，全是由深水埗街坊、嚴重急性呼吸系統綜合症（SARS）康復者蘇先生親手打造。他還建造了設有扶手的小山徑，方便街坊上落，比起

046

千篇一律的康文署公園更得民心。這便是從小社區做起的一個好例子：想當日，蘇先生為了強身健體而建設了健身專區，誰又料到這個小社區居然吸引了一眾街坊前來，而其中一位街坊又成功改變了蓄水池的命運。

Corrin 不禁大嘆「智慧在民間」：「由上而下思考，一定不及由下而上所能給予我們那麼豐富的資源。對芳姐來說那裏就是她的家園，眼見要毀掉那個地方，當然不肯放過它！」民間的後續力量龐大，一聽到要拆毀這個百年歷史建築，全民一呼百應，短短一天內就把背後故事挖掘出來，攝影師航拍相片和影片，建築師做3D模擬圖，還有人查出其真實建造年份。她接着說：「從這件事可以看出來，社區是我們重要的資源，市民，尤其是學生和年輕人不是社會的對立者，他們的力量會令我們的城市變得更好，這就是為甚麼空間使用者的參與那麼重要——因為我們是 Together As One，不是由一小撮人決定我們的未來，決定甚麼是對、甚麼是錯。教育應該是啟發生命的平台，給我們下一代帶來發揮創意和潛能的機會。」

● 建築即建立關係

她想起香港建築中心主辦「十築香港」學生建築大使的活動期間，其中一位學生分享感受時說：「經歷了今次參與，我發現建築不是在我外面，而是在我裏面。」

此話一出，叫全場人士驚訝，對 Corrin 來說更是印象深刻，想不到學生年紀小小，居然會有如此有力量而且深層次的體會：「他說得很好，真正的體驗不是外界給你的，因為真正的發現是由自己尋找到的，而且只屬於自己。人是身體和情感的結合體，當我們參與的時候，就會產生一個無形的、情感上的連結。建築不只是硬件，更重要是與人建立的關係。」

人們常把集體回憶掛在嘴邊，猶記起當年皇后碼頭清拆，不少市民上街反對。它不一定最有歷

史價值，也未必是最美，但它和大眾生活息息相關：那些年和女朋友在碼頭散步看海，那些年人們每天返工放工，最舒適是海風吹拂。記憶是一種推動力，也是一種凝聚的動力。「市民出來維護的，不只是單純的建築物，背後是一種對空間的愛與牽掛，裏面有香港人的價值。」

即使與舊建築相距多年的年輕人，對於這些昔日的美好仍有強烈執着，因為他們相信其中的價值，不論是歷史價值，還是精神價值。要明白這種堅持，便需要聆聽對方的心，這正是現時社會最缺乏的。

● 參與帶來連結和快樂

擔任建築師超過二十年的 Corrin，過往曾負責不少社區項目，尤其明白聆聽的重要。以其中一個重新設計精神病康復者社區中心的項目為例，起初她所接洽的都是中心負責人和社工，但思前想後卻發現自己對精神病康復者一無所知，因而提出，不如為他們舉辦工作坊？負責人滿腦子疑惑：「你覺得問他們有用嗎？」Corrin 搖搖頭答道：「不知道。」接着緩緩說道：「正是因為不知道，所以我想知道。」

後來她果真為康復者舉辦工作坊，讓這些使用者透過接觸各種物料和顏色，來了解他們的喜好。她憶述，有位叔叔提議她不要使用紅色，因為紅色過於刺激，會令他們產生強烈的反應，他們偏好使用粉色調、木質感之類比較溫暖的素材。翻新完成後，所有持份者在使用時更開心了，中心負責人和義工才驚覺：原來工作坊真的有用！

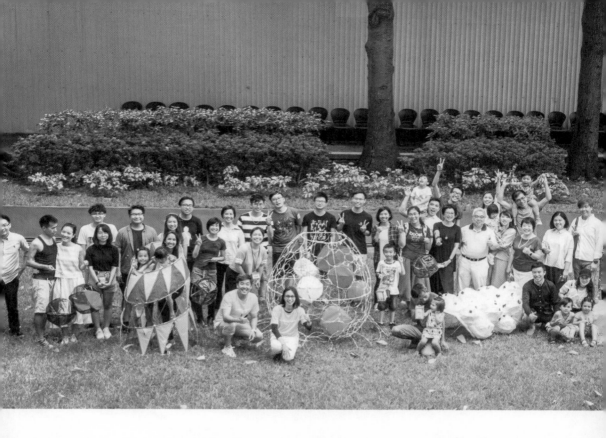

「最重要是聆聽。」Corrin 說。「被人聆聽，是一件很奇妙的事，會帶來療癒和快樂。」現在人們常說的歸屬感，其實不過就是生活在其中的人，可以聆聽和被聆聽，繼而參與。「歸屬感就是，你在創造過程中有份參與，我們常說地方營造（Placemaking），不是去營造地方，而是人去營造人與地方，以及人與人之間的連結。你在這個世界有參與感，覺得自己是一份子，自然會更加開心。」

Corrin 認為，世界劃分了不同的國家，不是為了擁有和統治，而是要人們作為其中的一份子，去好好照顧正在生活的地方。「我們不需要所謂又便宜、興建時間又短，『倒模式』的建築物，一個城市不只是數字上的滿足，而不追求實素。回頭看，為甚麼我們要有城市、建築？都是因為我們想活得更好。城市設計作為工具，無非是為了增加人與人之間的聯繫和快樂。若果在城市設計和發展時，包括教育制度、環境保護等方方面面，都和市民一起去做，我們一定會更加好。」

Chapter
03

項目介紹

Case Study

老友記·設計師　爆發小宇宙
老幼共融公園座椅

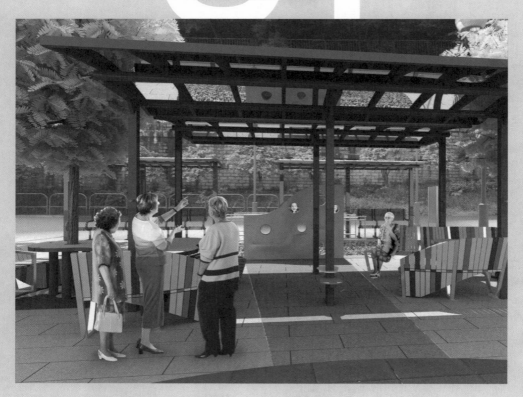

在社會既定印象裏，長者總被認為是需要被照顧的一群，但其實只要有發揮的機會，他們絕對能積極參與並改善社區事務。就如在二○一七年，十八位長者於摩士公園構思出符合老幼共融、長者友善的公共家具，流線形設計兼顧美學與互動功能。作為輔助的設計團隊王建明（Robert）、梁皓晴（Rosalia）、曹智明（Chiling）和陳詠琳（Gwyneth）與大家分享項目緣起和過程點滴。

項目的契機源於二〇一七年時，康文署藝術推廣辦事處為慶祝香港特別行政區成立二十周年，特別推出「城市藝裳計劃：樂坐其中」（City Dress Up: Seats · Together）公共藝術項目，在全港十八區共二十個康樂及文化事務署（康文署）轄下的公園、海濱長廊、休憩用地及遊樂場所，設置二十組別具創意的城市家具，作為城市美化之用，展期至二〇二〇年七月。

計劃策展人之一的劉栢堅，以「長者公共傢俬」為主題，邀請 Robert 負責重新設計摩士公園場地中約十二個位置的椅子。曾擔任香港聖公會福利協會助理總幹事的 Robert，其實早已在福利協會轄下長者中心裝修和翻新的過程中，加入長者參與的元素，這次正好有機會帶同一群長者走進社區，共同設計符合長者友善、長幼共融原則的公共設施。

設計團隊從聖公會福利協會於西環、黃大仙、土瓜灣和紅磡的四個長者中心裏，邀請了十八名較為活躍的長者參與，他們同屬長者中心長者友善關注組成員，平日會思考如何令社區裏的公共設施對長者更友善，並經社工將意見向政府部門及區議員反映。他們早已有社區參與的經驗，但是要親力親為、從無到有去設計公共家具，還是第一次。

看了外國的座椅參考照片後，「老友記」對自己心中理想的公園座椅也有了更具體的想法。

● 從零開始體驗設計師工作

項目總共有兩次設計工作坊，團隊希望讓長者從零開始體驗設計師平日的工作，一步一步真正成為「老友記・設計師」。第一次工作坊分為兩部份，團隊先向長者簡介項目背景，然後一行人便到摩士公園實地考察。團隊預先設計了引導問題，例如留意座椅的長闊高、怎樣為之舒適的戶外椅子、對戶外空間的概念等等。「老友記」第一次親身量度場地尺寸，均興奮不已，同時又細心地在紙上記下自己的想法。

當日下午，一行人回到長者中心展開繪圖環節。一眾「老友記」被分成三組，團隊首先向他們派發外國公園座椅的參考照片，試着打開他們的想像空間，也讓團隊了解「老友記」對於椅子類型和物料的喜好。Robert 指，這些照片都是世界上最美的非標準設計。「為何在外國可以，在香港就不行？這是一個很好的機會，讓非設計背景的『老友記』接觸比較具有藝術特質的東西，一下子就將他們的接受程度擴大了。其實美的東西沒有人不喜歡，這也是我們後來學習到的。」

團隊又給予「老友記」小模型，讓他們更具像地呈現心目中的空間。一開始「老友記」們戰戰兢兢，不敢在設計師畫草稿用的黃色牛油紙上動筆，其中一位婆婆更向社工索取白紙作草稿用，設計師們頓時深深感受到專業人士和普通民眾之間的鴻溝。但經過這些微小的接觸，或許就能帶來一些改變：敢在牛油紙上繪圖，對「老友記」來說已經是朝設計走出了一大步。

長者對於康文署一式一樣的公園座椅早已不甚滿意，他們認為那些座椅設計單調、功能單一、唯一的用途就只是讓人坐下來休息，期望可以有更多功能。Rosalia 指出，「老友記」希望能在公園享受天倫之樂：「康文署的設施通常以年齡劃分，長者有長者的空間，兒童有兒童的空間，但老人家往往需要照顧孫兒孫女，兒童空間裏卻沒有符合他們需要的設備。」在公園裏也可以與家人圍坐在一起，野餐、閒聊、聚會，是他們最想達成的願望。

● 特殊掛鈎方便掛放物品

團隊原以為「老友記」在設計上會偏向保守，偏好方方正正的座椅，卻萬料不到他們的想像力遠比團隊以為的豐富得多。Gwyneth 憶述，其中一組長者做了一張高科技彩虹凳，可以放 iPad、電腦。「我們常以為長者只會下棋，但其實他們很追得上潮流步伐，想有個舒適的座椅享受上網樂

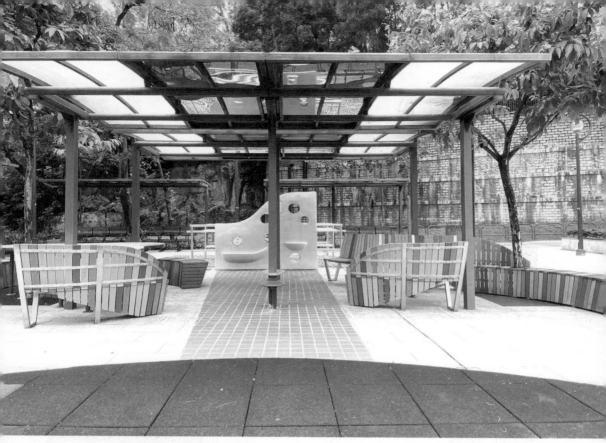

眾人齊心合力，完成了流線形、長幼共融的新座椅。

趣。他們又會想要很多『打卡位』，想與自己的兒孫留下美好的一刻。」

完成繪圖後，「老友記」就要像設計師般在眾人面前報告設計概念。在參加工作坊之前，他們對於設計概念還很陌生，三小時後，就要向人們解釋自己的設計概念和想法，無疑是一項大挑戰。

接着設計師根據報告所得出的設計概要（Design Brief），整合各人意見和喜好，再以電腦製圖，大致上得出兩個要點：一、傾向採用流線形而非死板的設計；二、長幼共融。

於是得出了這樣的設計：帶有部份靠背、相對並排的波浪形長凳設計，中間是一張貫穿兩棵樹的大桌子——「老友記」認為公園座椅往往只能讓他們「排排坐」，不能面對面交流，現在則可以和兒孫各坐在一邊，面對面傾談；有了大桌子，也可以和家人聚餐，就像在樹蔭下進行小型野餐一樣。最特別的設計

是座椅扶手和桌邊設有小孔和凹入去的掛鈎，以及方便長者用來掛常用物品的S形掛鈎孔，以便掛雨傘、枴杖和購物袋。這個設計由「老友記」提出，他們平時在一般的公園座椅上坐下來時，需要把東西掛放在椅背，但經常忘記拿走；若果掛在眼前，就可以減少遺漏的機會。團隊還特別做了一幅波浪形打卡牆，牆身設有洞口，可讓兒童湊上前，充滿童趣。

為了將「老友記」的設計實體化，Rosalia和Chiling花了兩星期時間做了一個一比一的樣板模型（Mock Up）。場地的限制不少，譬如康文署只容許團隊在早上拆除原有的椅子，下午六點前要還原場地，期間團隊要在場地鋪上白紙量度位置、裝嵌預先剪裁好的瓦通紙。到了第二個工作坊，團隊的任務就是帶「老友記」再一次來到現場，為Mock Up提出意見。這個過程相當重要，對於不習慣憑空想像的「老友記」來說，這樣可以讓他們更清楚自己想要甚麼，深化和微調設計細節。Robert表示：「最記得那時他們遠遠看到模型座椅，就興奮又驚訝地嚷着…『那個波浪真的做出來了！』」

團隊也做了七彩繽紛的顏色條，讓他們選擇設計作品的色彩。「老友記」左挑右選，卻一種顏色也定不下來。

Robert 對此笑言…「雖然他們嘴上沒有說不喜歡，不過卻一直吱吱喳喳…『唔好睇呀，咁似幼稚園！』後來我們留意到他們覺得自然木色很好看，最後就用了較柔和的木色。」不過，對於兒童的玩樂設施，「老友記」就選了藍色、黃色等較鮮艷的顏色。雖說是「設計初哥」，但已經能

團隊做了一個一比一的樣板模型，將「老友記」的設計實體化並作測試。

像設計師那樣，因應物品功能來挑選顏色，而不單是看自己的喜好。

開幕當日，一行人到場辦了個小型派對，嘗試使用這個空間。Gwyneth憶述，當日有個年紀很大的婆婆一到場，便指着桌邊和座椅扶手處的掛鈎，興奮大叫：「這個是我設計的！」簡簡單單的一句話，就已經帶出了項目的意義。

後來，項目分別獲邀到世界衛生組織（World Health Organization）、聯合國人居署（UN-Habitat）、美國建築師學會（Amercian Institute of Architects）等國際組織舉辦的關於人口老化的論

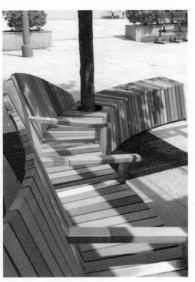

最終成品：座椅扶手都配置了凹位掛鈎

壇上，與國際學者、各國的政策制定者分享這個項目，獲得一致好評，認為是長者融入和參與社區事務的優秀例子。Robert說：「與會者都很驚訝，為何我們可以完成這個項目，他們都在尋找一種框架，如何吸引更多長者走進社區。我認為，只要政府部門能夠留一點空白的位置讓公眾實驗，就能帶出更多可能。」

Robert參與世界衛生組織舉辦的長者友善城市論壇，介紹長者如何參與設計項目。

● 結合參與者想法的設計美學

設計師把「老友記」的設計概念以設計美學的手法來表達。為了讓長者友善的公共家具更吸引用家，設計師把不同的功能以流線形連貫起來，波浪形長凳帶有深

調的不鏽鋼告示板改為波浪形告示板的想法，既能沿用團隊特別為孩子做的波浪形打卡牆的設計手法，也能為公園增加活潑的元素。但美中不足的是，康文署的這些告示板需符合政府一定的設計標準，不能輕易改變。設計師團隊希望政府部門將來可以為這些不鏽鋼告示板加入更活潑、更有吸引力的設計元素，令公園更有趣味，多點繽紛。

淺不同的自然木色，不完全整齊的靠背設計生動活潑、不單調；流線形桌子把公園的不同地方連接起來，以原本的水泥面作為桌面，既耐用，亦有點「型格」。團隊與康文署商討後，還在公園入口處的花圃種上小型植物，並在旁邊加設更多座椅，形成一個具吸引力、老幼皆宜的公園。

在原來的整體設計中，還有把長者運動區單

參與設計的長者在完工後回到公園，並帶孫兒到公園玩耍。

INFO·BOX

老友記‧設計師

時期	二〇一六至二〇一八年
地點	香港黃大仙摩士公園
合作機構	香港康樂及文化事務署 藝術推廣辦事處
設計團隊	王建明（Robert）、梁皓晴（Rosalia）、曹智明（Chiling）、陳詠琳（Gwyneth）
其他參與者	香港聖公會福利協會轄下四間長者中心的十八位長者（分別來自：香港聖公會黃大仙長者綜合服務中心、香港聖公會西環長者綜合服務中心、聖公會聖匠堂長者地區中心、香港聖公會樂民郭鳳軒綜合服務中心）

入口改造-指示牌 X 花槽 X 坐椅
Signage x Planter x Seating

參考：坐椅 X 指示牌
Reference: Seating x Signage

Reference: Seating x Planter

指示牌 2
Signage 2

Information

五大因素
促成項目
讓長者
走進社區

世界衛生組織在二〇〇五年推行「全球長者友善城市及社區」概念，其後於二〇一〇年成立「全球長者友善城市及社區網絡」，以「長者友善」、「長者參與」及「適合長者」的原則，指出能夠令長者擁有更健康晚年生活的八個關鍵範疇，包括：室外空間和建築、交通、房屋、社會參與、尊重和社會包容、公民參與和就業、訊息交流、社區支援和健康服務。而是次項目與「室外空間和建築」及「社會參與」相關。不過，要鼓勵長者行動，以及令項目順暢地運作，全靠各方面的因素配合才得以成事。

❶ 目標對象明確

帶領「老友記」外出實地考察，聽起來好像很簡單，但事前準備工夫不少，例如：買保險、租旅遊巴、

預計時間等，當中的人數分配也有講究。若果只招募一個長者中心的「老友記」（約十八人），人數太多，未必可以說服長者中心點頭；但若果分散成四個長者中心，每個中心招募數名長者參與，相對會容易得多。獲邀的「老友記」都比較熱衷於社區事務，令他們在參與設計活動時，遇到的難題又會再少一點。

❷ 活動名稱令長者放下戒心

雖說這些參與項目的「老友記」都是長者友善關注組成員，較習慣參與社區事務，但若果一開始就拋出「參與式設計」之類的字眼，恐會嚇怕不少人。團隊用了「長者友善空間探索之旅」作為活動名稱，看起來就像社區中心平時的活動一樣，對「老友記」來說也會更吸引。

「老友記」積極參與討論，給予了寶貴的意見。

③ 社工擔當輔助角色

社工的角色是不可或缺的，尤其是已經與長者建立一定互信關係的社工。在很多活動細節上，團隊未必能說服「老友記」參與其中，例如「老友記」或不敢站在眾人面前報告設計概念，這時社工從旁鼓勵，就能令他們更有信心。社工也會為「老友記」和設計師互相傳達意見，令他們能更清晰了解彼此的想法。

④ 尊重長者的作息時間

「城市藝裳計劃：樂坐其中」項目的官方開始時間為二〇一七年七月，「老友記‧設計師」這個項目卻要待到年末才進行，最大的原因是項目涉及實地考察，團隊曾被社工告知，若果在夏天進行，會令長者卻步；同時長者體力有限，活動時間也不能太長，到中午十二時左右就要吃午飯，五時半就要吃晚飯。經過提點，項目時間能控制得更好。

⑤ 康文署一定程度的鬆綁

作為場地管理者的康文署，若不在一些「細節上」「鬆綁」，項目便很難進行下去。例如團隊在進行重要的一比一 Mock Up 展示時，若果無法得到康文署允許拆除原本的座椅，就無法將概念實體化，讓長者能深化和微調設計細節。拆除座椅需要經過重重審批，更有可能招致投訴，在這個環節，康文署算是很勇敢，也令項目得以順利完成。

「能參與當然好開心」

九十歲的新晉設計師

任何人都可以發揮潛能，長者也不例外。人們總以為長者思想古板、落伍，對改善社區並不感興趣，其實，從摩士公園的例子可以看到，這些刻板印象絕對是錯誤而且不必要的。年逾九十的趙婆婆，樣子看起來仍相當精靈，她高興地指着座椅扶手和桌子邊的凹位掛鈎說：「這就是我設計的！」

這個凹位掛鈎是相當出色的設計，不用另外增加配件，不用添加建築設計費用，只需少許改動，就能達到一物三用的效果：掛雨傘、掛枴杖、掛購物袋。座椅扶手還有一個 S 形掛鈎孔，也能方便「老友記」掛着物品。雖然設計很微小，

但正因為微小，所以是平日不常到公園的人無法想像出來的設計。

作為黃大仙街坊，趙婆婆很高興看到自己設計的座椅成為了區內特色設施：「完成後覺得很特別，其他公園都沒有的！」她笑着說，說時一臉自豪。趙婆婆是長者友善關注組的活躍成員，平日會在區內發掘不夠長者友善的設施，向關注組匯報。

她還是活躍義工，在二○一八年於社會福利署頒發的香港義工嘉許中獲二十年長期服務獎，可說十分厲害。

● 信任和尊重 無分老與少

一般人覺得長者能有個地方坐下休息下就足夠了，殊不知在小小的公園內，「老友記」也有維繫社交和家庭關係的需求，希望公園可以成為共享天倫的地方。「我的理想是又能湊孫又能玩，以前在公園沒有地方和孫兒一起玩。」項目中的流線形大桌子，正是為了長者與親朋好友聚餐而設。

問及她對於成為設計師有何想法，她豎起大拇指，說：「自己能參與當然好開心，我們（長者）都懂得做的，年輕時沒機會嘗試的東西現在都有了，幾十歲了還可以做設計。」她慨嘆，平時年輕人覺得長者落伍，所以不肯聽他們的意見，這次能獲得尊重，意見被接納並具體呈現出來，當然能產生滿足感。

讓「老友記」成為設計師，不單是要給他們進行「職業培訓」，更重要的是相信「老友記」有能力做到，這是一份信任和尊重。無論是三歲還是八十歲，都有備受肯定的需要，任何人，只要有適合的平台，定能發揮所長。至於設計師能否將學到的設計知識、能力和視野帶給不同的人，長遠而言令各區都可以有機地發展，就是一個值得研究和探討的大議題了。

CASE STUDY 02

印度流浪街童學校

將創意融入傳統大改造

印度街童問題嚴重，全國有超過一千八百萬名兒童流浪街頭，數量居全球之冠。

走在印度街上，放眼盡是賣藝、販售小商品，甚至乞討的貧窮兒童，小小年紀已要為謀生勞碌，過着危險艱苦的生活，許多人往往因此誤入歧途。在二〇一二年，IDEA 團隊與扎根印度南部城市 Pondicherry（本地治里市）的社會福利機構 Kalki Welfare Society（Kalki）合作，透過參與式設計，給為街童提供緊急援助和學習機會的街童中心進行大翻新，以吸引更多街童上學。

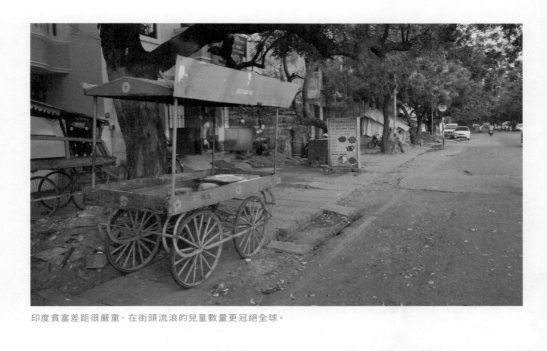

印度貧富差距很嚴重，在街頭流浪的兒童數量更冠絕全球。

Kalki 於二〇〇八年由商界和學術機構成立，目的是應對城市中流浪兒童數量不斷增加的情況。

Kalki 在當地設立了街童庇護中心，為身處危險情況下的兒童提供緊急援助，如日常食物、保健、教育、娛樂活動等，最終希望使他們脫離流浪生活，擁有更美好的將來。現時約有一百名街童於中心接受援助，年齡遍及三至十七歲。

項目中，IDEA 團隊分為三路人馬，各司其職：設計組負責為香港義工舉辦設計工作坊，並以參與式設計與當地人合作改善中心環境和配套；教育組研究在中心引入已發展國家的教學方法，如互動式小班教學，並為當地教師製作包含遊戲和學習法的教學手冊；而世界公民組則着眼於將公民意識和平等世界觀帶給當地兒童，同時也帶義工到當地貧民窟實地考察，了解更多發展中國家所遇到的困境。

早在項目進行前半年，團隊核心成員已到當地實地考察，然而，在落後地區實行項目，往往有着許多未知因素。當一行三十人凌晨落機，再轉三小時車程抵達位於印度南部的本地治里市，到達目的

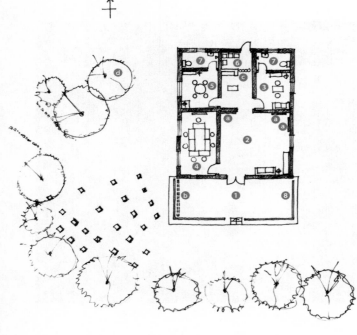

Kalki 街童學校平面圖

室內佈局

❶ 門廊 Porch（孩子有室外活動地方）
❷ 活動大堂（室內）
❸ 社工房
❹ 課室
❺ 小組活動房
❻ 輔導室
❼ 洗手間 / 浴室
❽ 欄杆

設計項目

ⓐ 由孩子拍攝的照片組成的照片牆
ⓑ 帶有 Kalki 標誌及 Kolam 印度圖案的百葉簾（能遮擋西面日照）
ⓒ 輔導室的布簾由學生設計
ⓓ 小型室外劇場設有石凳

地正式開展服務團之際，卻被眼前的景象嚇到：原先計劃中要翻新的街童中心竟然關閉了！該如何是好？團隊匆忙聯絡 Kalki 負責人，決定將目標轉往另一村落的街童庇護學校，將原有建築物翻新。

這個街童學校共有兩棟建築物，一是活動中心連廚房和員工辦公室，二是暫住宿舍。在視察環境及諮詢老師和社工的意見後，團隊立即因應實際需要，構思四大設計任務，包括：一、創造結合印度傳統圖案 Kolam（米繪）的百葉簾，在露台打造全新的表演舞台；二、粉飾內牆，街童走進社區，使用菲林相機拍攝，製成獨一無二的照片牆，以及製作掛牆圓鐘；三、將縫紉室重新設計成遊戲治療室和輔導室；四、將戶外空間轉換為多用途遊樂園和景觀座位。

● 製百葉簾上的多彩創意與信仰

學校設計非常平實，絲毫沒有歡樂氣氛，如果有更豐富的視覺和空間元素，想必會吸引更多街童逗留。學校入口有個偌大的空置露台，團隊想到利用百葉簾作為空間切割，將空間更妥善地用於活動教學。百葉簾除了

可遮擋熾熱的午後陽光，亦可作為帷幕，將原本平平無奇的露台變為表演舞台。

團隊希望百葉簾的設計可與當地文化接軌，因此將主題設定為印度人人都會畫的 Kolam 圖案。米繪在印度南部稱為 Kolam，在北部稱為 Rangoli，是印度重要的傳統文化習俗，也是精緻的地畫藝術。每天早上，家家戶戶的婦女都會利用米粒、米粉、麵粉等食材，在家門前繪上對稱的圖案，以吸引昆蟲、雀鳥來進食，寓意豐衣足食。到大時大節，更會使用染色的食材，繪上色彩斑斕的圖案，迎接神的來臨，冀望來年闔家平安，健康幸福。由此可見，Kolam 代表了當地人的身份認同，也是他們的精神信仰所在。

原先還害羞遲遲不敢下筆的孩子，知道要畫熟悉的 Kolam 後都十分雀躍，甚至反過來教義工怎樣畫。團隊先是帶領兒童熟悉基本的圖形設計方法，然後鼓勵他們大膽地在傳統圖案上加入創新的畫法，例如將圓形的 Kolam 畫成四分之一的扇面。起初他們有些疑惑，後來也漸漸跳出框架，嘗試在傳統圖案上加入自己的詮釋，讓各種創意大放異彩。

IDEA 設計團隊很希望讓兒童覺得自己也參與了學校百葉簾的設計，因此會向他們分發單行紙，讓孩子設計。兒童完成圖案後，只需要把單行紙沿着橫線一行一行摺起來，就能形成拉摺式的紙百葉扇——同時是學校百葉簾的一比十模型，他們還可以拿着紙百葉簾模型與家人朋友分享。

● 以攝影連接社區

除了添加裝飾美化環境，團隊也希望街童可以走出學校、接觸社區，於是其中一位攝影師義工黃君諾（Kenrick）提出，讓孩子以菲林相機紀錄他們居住的城市和生活。兒童先利用紙框學習構圖

街童學校學生的 Kolam 草圖

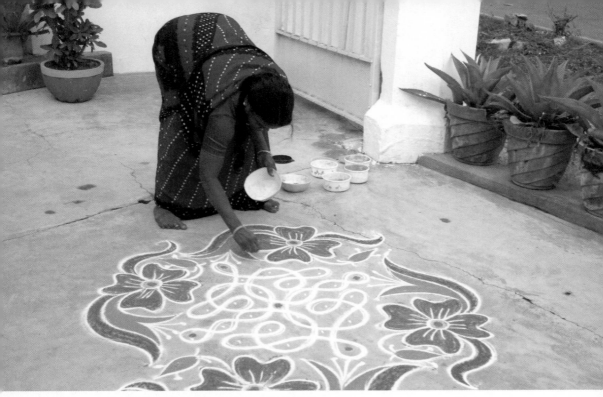

繪畫 Kolam 帶有對美好生活的期盼，也是當地人的精神信仰。

和了解攝影，然後才按下快門捕捉喜愛的畫面。他們走在街道上，透過不同視角和框架發掘有趣的事物，從日常生活中嘗試探索自己的美學。

義工鄭家揚（Calvin）說，這個活動某程度上是希望帶動社區互動和連結：「留在學校的街童普遍自信心較低，不太願意接觸外界，團隊希望這群兒童與社區互動，一來他們可以更認識身處的社區，二來外界也能了解到所謂街童只是普通孩子。」千里之行，始於足下，願意踏出第一步，其實已是融合的開端。作為被城市排擠的一群，街童也有了進入社區的新方法，構建他們對社區的集體記憶。

拍好的照片沖曬後會貼在學校內牆上，猶如小小的展覽，孩子看到照片牆，走來走去，找到自己拍攝的照片，熱烈地與同學介紹分享，又興奮地拉着義工，指認牆上自己拍攝的照片。IDEA 設計團隊在照片牆中添加了一些有英文字句的厚板，令把照片牆看起

來不只是整整齊齊的照片，更是一個充滿美感的藝術作品。學校的一角形成了小型展覽廳，讓美感欣賞成為街童學校的重要部份。孩子參與其中，雖不肯定他們會否因此而愛上攝影，但可以肯定的是，攝影為他們帶來了新視野，是難得的感官式學習體驗。

另一方面，六至九歲的兒童會留在教室裏，利用彩色紙、羽毛、棉球和塑膠板等物料，製作獨一無二的圓鐘，過程中他們學習到基本的顏色理論，得到擴展想像力和創造力的機會。

● 一針一線改造遊戲輔導室

學校教師和社工向團隊提出，兒童在成長階段有着各種煩惱，需要與人傾訴，然而，在原有校舍內，並無高隱私度空間作輔導學生之用。有見及此，團隊便計劃將位處縫紉室內的小小儲物室翻新成輔導室。這個輔導室除了作諮詢用途，也兼具存儲和休閒角的功能。

團隊將懸掛式儲物架掛於輔導室入口，分隔縫紉室和輔導室的空間，增加私隱度。輔導室內擺放了儲物盒存放大型玩具，方便教師和義工取用作遊戲輔導，同時可根據需求靈活地佈置成書桌。房間的一角安放了象徵樹屋的葉子形頂篷，與室外的自然環境互相呼應。

孩子們的創意作品

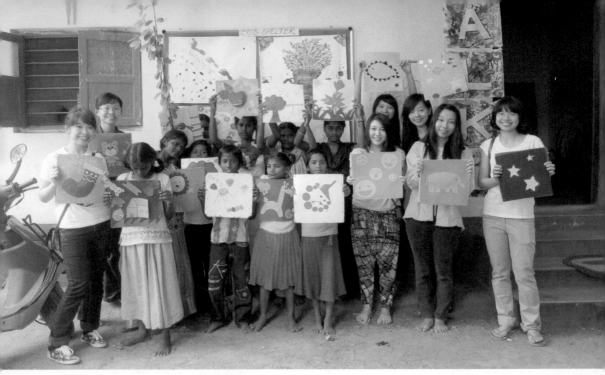

穿針引線的樂趣吸引了大朋友和小朋友一同參與其中

另外，團隊利用窗簾修飾輔導室外的櫥櫃，並邀請較年長的十二至十六歲青少年，利用彩色布料和針線，在窗簾上穿針引線，設計圖案。他們先在紙上畫草稿，再在不同顏色的布料上切割圖案，縫製成為方包形織物，用針線連接形成窗簾。

最初這些小少年們面面相覷，推說自己不會做，活動負責義工建築師劉蔚茵（Sofia）認為，先從簡單小任務做起，輔以示範和引導，便能引起他們的積極性。後來果然大家都一步一步上手，反應更是熱烈。針黹需要一定的手藝，原本活動的目標對象是年紀稍大的青少年，不過後來因為活動太有趣，不少幼童也被吸引過來，並在年長成員指導下學習基本的針線活。餘下的布料也被孩子用以製作飾物，更有人縫製小禮物送給義工。

Sofia說：「他們視你為朋友般禮尚往來，你教會他們新事物，他們就用自己擅長的手作回饋給你，雖然雙方語言不通，但感受到他們很真誠。」

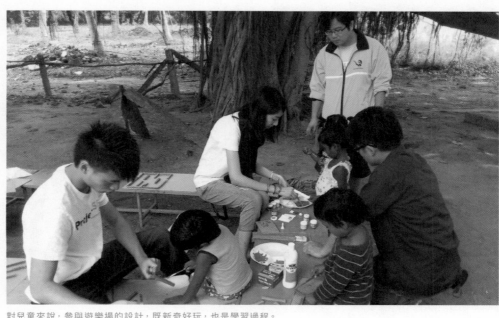

對兒童來說，參與遊樂場的設計，既新奇好玩，也是學習過程。

● 童心打造多功能遊樂場

在露台的表演舞台另一邊，有一片可容納四十名兒童的空地，團隊計劃讓三至六歲的兒童分組進行翻新。他們為每組兒童提供十五條硬紙板，用作設計室外景觀椅的圖案，並透過樹枝、石頭和顏色去劃分不同空間，將空地轉換成多功能互動遊樂場。期間他們需要戴着手套清潔場地，又要學習使用捲尺在現場進行測量，並使用三種顏色在石頭上繪畫圖案。

年紀這麼小的兒童是否有能力去設計？答案是肯定的。不過，面對幼童就要花特別的心思。活動負責義工曹智明（Chiling）認為：「策劃者需要思考他們的理解能力，將任務細分成不同項目。另一方面，即使語言不通也不要緊，對幼童來說，身體語言、玩樂和體驗元素反而更重要，因為兒童都是透過玩去學習新事物，而且無論成品如何，都要肯定他們的付出和努力，這才能提升他們的參與度。」雖然幼童未必能夠理解設計，但

> 怎樣去維持氣候公義，
> 是每個人都應該要做的事情。

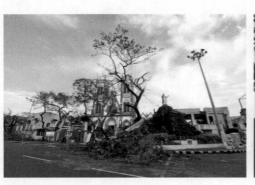

颱風過後，滿目瘡痍。

也能在過程中品味到所謂設計，而在觸感、視覺上的體驗，亦是幼兒學習事物的重要途徑。

「其實他們才是設計師，只是缺乏工具和機會表達自己的想法，我不過是促進者（Facilitator），在過程中幫助他們一把。」Chiling 笑說。

● 成長過程中建立自信

印度為人詬病的種姓制度，會依姓氏、血統來劃分社會地位。雖說現時種姓制度的法律地位已被廢除，但在社會運作上仍存有歧視。街童學校收留的流浪兒童，處身於社會制度的最底層，打從出生起便只能靠行乞和犯罪謀生。

項目負責人之一的義工馬家兒（Carol），在與當地社工傾談過後，亦感受到一股隱約的無力感。她對此有所反思：「在這個制度下，流浪街童要得到資源有很大限制，甚至當遇上颱風這類天災，如果沒有這些中心，他們就會很危險。我們這個項目未必可以回應這麼大的需求，但寶貴的是，義工可以從中得到經驗，重新看待譬如氣候貧窮（Climate-

poverty）這類議題，怎樣去維持氣候公義，是每個人都應該要做的事情。」

雖然工作坊未必能為流浪兒童帶來制度和物質上的改變，但可以想像的是，這至少為他們帶來一絲希望，知道仍有其他國家的人在乎他們，在工作坊中累積的知識也能幫助他們建立自信。Carol 說：「當我們說設計賦權（Design Empowerment），會希望先處理他們的日常生活，令他們對社區和生活環境有歸屬感，並在成長過程中建立健康的自尊（Self-esteem）。」

Sofia 亦認同，雖然在十天內可以做的事情有限，但每個項目都是在參與者的生命中埋下一顆種子：「尤其這群兒童並不是幸運的孩子，他們可能會藉此機會發掘到自己的天賦，或者對他們的將來有些幫助。如何讓不幸的人有參與的機會，還有很多可以做的事情，我們應該對此有更多的思考。」

旅程的末段發生了一段小插曲：一行人竟遇上印度三十年一遇的颱風，電話網絡中斷，居住的地方因水浸要半夜撤離，城市停電，團隊更差點斷糧。幸好其中一位印度義工 Dinesh 不辭勞苦，騎着電單車載着 Robert 衝風冒雨四處買飯盒。Calvin 有感而發：「義工去當地不是單方面幫助他人，因為我們也很脆弱，遇到困難都要靠當地人協助，這讓我了解到生命其實很平等，互相幫忙很重要。」

INFO·BOX

街童學校室內翻新

時期	二〇一一至二〇一二年
地點	印度南部城市本地治里
合作機構	印度社福機構 Kalki 街童學校
設計團隊	IDEA 印度項目設計團隊：馬家兒（Carol）、鄭家揚（Calvin）、曹智明（Chiling）、王建明（Robert）、劉蔚茵（Sofia）及各義工 來自本地治里的街童
其他參與者	印度街童 Kalki 福利協會老師及社工 IDEA 項目義工

孜孜不倦 授人以漁

印度社工改善婦女兒童困境

IDEA 印度項目中的街童庇護學校，是由扎根 Pondicherry 的社會福利機構 Kalki Welfare Society 負責營運。其中一手促成項目的社工 Amaladevi Vaithianathan（Amala）自是功不可沒。

Amala 本身也是奇女子，她成長於 Pondicherry 農村，在男尊女卑的社會下修得社工碩士專業資格，還擔任義工多年，在自己家鄉先後創辦多間非政府組織和公司，改善當地孩童和婦女生活。

Amala 獲 Kalki 負責人邀請加入機構後，開始着手不同的項目。為了更廣泛地接觸街童和貧民窟兒童，她開展了流動玩樂圖書車項目，每天定時到達各個地點，讓貧困兒童能夠暫時忘卻生活煩憂，獲得短暫的童年時光。這個項目漸為當地街童和其家長熟悉，吸引有需要兒童到庇護學校獲取食物和教育。

項目起先聚焦於幼童，後來 Amala 認為，成人，尤其是女性，也應該得到關注。因此，她又開展了關注童婚、低收入婦女

Amaladevi Vaithianathan 是一手促成 IDEA 印度項目街童庇護學校的社工

和強迫賣淫問題等的項目，最終目標是讓女性能重返校園，或得到更好的工作。

● 打開街童心扉

IDEA 印度項目是 Kalki 其中一個援助街童的合作項目。在許多人心目中，參與式設計工作坊或許只是「眾多工作坊中的一個」，但對於長期受排擠的弱勢街童來說，原來其意義非凡。自己有份重新設計理想中的校舍，固然令他們無比興奮；因而獲得的關注，原來也能令他們打開心扉。Amala 指出：「這對街童來說是接觸社會的好機會。即便他們在學校找到容身之所，也不過是封閉在圈子內。這次卻有機會接觸來自世界各地的人，互相分享經驗。這也是我數年來第一次見到孩子們如此樂在其中。」

校舍裏的孩子有各種遭遇，Amala 憶述，其中有一位女孩子長期遭受到父親性虐待，雖然幸運地獲救並寄宿校舍，但一直無法走出傷痛。Amala 曾經嘗試引導對方表達情緒，可終究無效，直至女

孩參加了參與式設計工作坊。

「工作坊完結後的某一天，這位女孩突然來找我，說想跟我談談；後來她便將自己的遭遇一五一十地說出來。曾經受過嚴重傷害而變得敏感脆弱的孩子，很難去表達自己，對着社工也只是一直哭，一直哭，我們只能不斷安撫，卻也沒法令他們打開心扉。這次透過藝術活動，讓他們選擇自

Aalam's Creative 聘用當地婦女以天然材料製成可持續的手工藝品和玩具

己喜愛的圖案和顏色，學習一點一點地嘗試表達自己，令我們與孩子在輔導室進行輔導時也更順利。對我們社工來說，工作坊是很好的途徑去了解這些孩子和他們的內在感受。」

在工作坊舉辦後的六個月間，Kalki 社工都有定時觀察孩子的學習和成長是否因此而有所不同。而 Amala 觀察到，這些孩子都有很正面的轉變。「這些孩子來我們中心，原先只是為了安全考慮，但後來他們認識到，這裏是屬於他們的、非常漂亮的家，在這裏他們可以走出過往經歷，重建（Rehabilitate）自我和聚焦未來。孩子們更愛上學，甚至完成學業。這是一件令人鼓舞的事。」Amala 樂見很多街童後來重回主流學校，擁有了不一樣的人生。

● 聘用農村婦女製作工藝品

後來她離開了 Kalki，自立門戶成立了另一扎根 Pondicherry 的社會福利機構 Deshna Foundation，繼續為改善兒童、青年和社區的福利而努力，譬如為孩子提供資訊科技課程、為農村婦女進行衛生巾教育、在學校和社區開展植樹造林項目等。「農村的孩子很需要幫忙，當他們遭受肢體、情感，甚至是性暴力時，他們會傾向隱藏起來，也不知道要對誰說。我的家也在距離 Pondicherry 市中心二十五公里的農村內，我希望幫助故鄉的孩子獲得生活技能、接受教育和養成創新精神。」至今該機構已幫助超過七百個家庭。

Amala 始終馬不停蹄，自二〇一六年起，她在五間機構任義工，後又於二〇二〇年成立 Aalam's Creative 社會企業，聘用當地婦女以天然黃麻、小麥、甘蔗、竹子、黏土和稻殼製成可持續的手工藝品和玩具，希望讓婦女有一技之長，同時亦有助改善環境。這些擁有非凡手藝的婦女會開班授課，教導當地孩子藝術和設計，將技能承傳下去。「授人以魚，不如授人以漁。在我們公司，所有婦女的地位都是平等的，將融合現代和當代藝術的手作工藝品如花瓶、籃子、首飾等銷售至當地市場和外國市場，讓她們有能力改善生活質素。」Amala 獲得義工獎項無數，最近更獲頒發名

Amala 獲頒發名譽博士學位

這些手作工藝品融合現代和當代藝術，十分精緻。

譽博士學位，以表揚她在社會工作方面的成就。

二○二○至二○二一年，二○一九冠狀病毒病（COVID-19）肆虐全球，印度疫情尤其嚴重，Amala 也曾不幸染疫，幸而迅速康復，但 Amala 的親人卻因感染去世。更不幸的是，很多孩童因家長及親人感染去世，成為了孤兒，或成了單親家庭。事態緊急，Amala 向國際籌款，協助這些受影響的家庭張羅二十五日的糧食，讓孩子不至失去營養。「在封鎖期間，他們很難獲得糧食，我們持續為這些家庭每天提供兩至三餐。」孜孜不倦、不求回報的付出，滋潤着不幸者的心。

這次世紀災難更對落後國家及貧窮地區孩子的教育帶來嚴重影響。Amala 康復後便與 IDEA 商討未來數年的災後重建項目，以設計及藝術為媒介，通過國際間非政府組織的合作，以參與式設計推動社區參與，凝聚社群共建家園，為孩子教育及成長努力，更為貧窮家庭種下愛與盼望。

印度科學家任義工服務街童

「先讓孩子願意上學!」

在印度項目中,擔任居中協調重責的是來自當地 Pondicherry 的義工——印度海洋生物學家 Dinesh Ram 博士(Dr. Dineshram Ramadoss)。

他認為,街童在成長過程中,每天只能為三餐勞碌,不會意識到教育的重要。「但我想讓他們了解,教育可以改變他們的未來。」這是他希望為自己家鄉盡的一點心力。

曾於印度海洋研究所(National Institute of Oceanography, India)擔任海洋生物學家的 Dinesh 與香港很有淵源,他於二○一○年獲獎學金於香港大學攻讀博士學位並任博士後研究員長達七年半,專門研究香港蠔如何受氣候變化影響。

在港大就讀期間,有天他經過學校餐廳時,發

印度海洋生物學家 Dineshram Ramadoss 博士在印度項目擔任居中協調的重責

現牆上貼有 IDEA 招募義工到 Pondicherry 為街童學校進行翻新的海報，得知有團體為自己家鄉的學童提供教育服務，感到既驚訝又興奮，馬上就報名參加。

● 以設計帶動教育

儘管 Dinesh 出身於良好家庭環境，卻一直關注印度的貧窮問題，尤其對於兒童失學問題感到痛心：「或許是家庭背景和成長經歷的緣故，這些貧窮兒童對於上學接受教育不感興趣，輟學率很高，即使來到學校都只是為了日常食物，他們的父母每天賺錢養家餬口，也不願意或沒有能力在孩子學習方面花費更多。」而 IDEA 的印度項目或許正是一個很好的切入點：能否發掘到一種方法，令貧窮兒童了解到教育的重要，從而吸引他們上學？

帶着這個疑問，他與團隊一起構思工作坊。雖然 Dinesh 不擅長設計，但在設計時，大家會一起摸索和思考。「即便是普通的物件，大家也會共同思考如何令其更吸引，就如建築師會想建築怎樣能

更吸引一樣，設計師也嘗試將設計習慣傳達給對設計不熟悉的人，所以我學到很多。」他笑說，以往傾向將實驗道具如小型水族館交給別人製作，現在倒是會嘗試自己動手做，將學習到的設計知識應用在日常生活中。

成長於 Pondicherry 又久居於香港的 Dinesh，無疑是擔任項目促進者（Facilitator）的最佳人選。

humanityfocus.org www.ideaproject.org.hk

IDEA INDIA PROJECT
ART EMPOWERMENT PROGRAMME

HERE IS A UNIQUE CHRISTMAS GIFT IDEA FOR YOU. HUMANITY IN FOCUS (HIF) AND SHOWER TALENT EXCLUDE PREJUDICE (STEP) DESIGN TEAM ARE GOING TO ORGANIZE AN IDEA INDIA PROJECT - ART EMPOWERMENT PROGRAMME. YOU WILL BE ABLE TO USE DESIGN AS A CATALYST FOR EMPOWERMENT OF THE STREET CHILDREN IN PONDICHERRY, INDIA AND INVOLVE THEM IN THE DESIGN PROCESS. IT WOULD BE A REWARDING DESIGN SERVICE EXPERIENCE.

就是這張海報，讓當時身處香港的 Dinesh 也能為遠在印度家鄉的兒童提供幫助。

Dinesh 曾於香港大學攻讀博士學位，並任博士後研究員，在這裏生活了七年半。

他在項目中主要作為 IDEA 團隊和當地老師、學生、社工雙方的翻譯，譬如為小朋友講解設計任務的每個步驟。不要以為這種翻譯只是語言上的轉換，實際上，兩地文化如此不同，正需要促進者作出文化詮釋並正確地表達出來，才能在極短時間內縮短大家的距離。「最重要是我知道香港義工想要傳達甚麼訊息，這就可以讓大家沒有阻礙地理解對方。」

他稱讚香港是個多元文化和充滿活力的地方，接納來自世界各地努力工作和成長的人。「在教育、努力、堅持和尊敬長者等方面，亞洲各地有着共同的價值觀，由於我們來自相似的文化，因此印度義工更容易與具有相似思路的香港夥伴打成一片！」

● 可持續發展需要就地取材

Dinesh 和小朋友一起去城市的不同角落拍照，一起利用校園隨處可見的石頭打造多功能遊樂場，一起學習將傳統 Kolam 藝術現代化。「任何年紀的小朋友都能夠學習到設計技巧、知識和工具，並利用身邊的東西去完成任務。可能在某些人的眼裏，這些不過是課外活動，但對這些孩子來說，已經是基本的學習 ── 至少在創造力和智能思維的層面，活動鼓勵了他們從多方面思考，給了他們教育的概念。這是很重要的，可能因為這些活動，而

令到他們的教育得以延續下去。」

另一方面，他認為從他和義工們以身作則的示範中，也會改變小朋友不上學的想法：若想像義工般有機會到世界各地擴闊眼界，就應該去上學。

「我們嘗試傳遞這個訊息：教育是生命中最重要的部份。我們希望，即使他們在日常生活中遇到甚麼困難，都會願意上學，利用學習到的知識改善將來的生活，這樣他們就能得到賦權的機會了。」

參與式設計，談論的不只是設計，而是以設計作為一種手段，可以怎樣鼓勵人們參與、怎樣可以令所有參與者都得到個人成長的機會，甚至啟發他人。

就如 Dinesh 那樣，參與印度項目後也不斷思考如何為有需要的人提供協助，因而開展了一些類似的公益項目，為落後地區的村校提供資源。

「IDEA 項目是可持續和具有成本效益的，這給了我很大的啟發：可持續發展的生活模式不一定要花費大量金錢──這對印度貧窮階層來說也是不可能的；反而如何從日常生活環境的有限資源中取材，嘗試去建立一些除了金錢以外的東西，

正是我們要思考的事情。」

印度在二〇一九冠狀病毒病疫情下，感染及死亡個案居高不下，Dinesh 的親人亦因染病而去世。他祝願：「在未來數年的災後重建，我們可否使用參與式設計，一方面重建學校及社區設施，更重要是凝聚社群共建家園，為小孩種下愛與盼望。」

Dinesh 在參與印度項目後開展了一些類似的公益項目，為有需要的人提供協助。

083

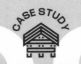

尼泊爾村民親建防震未來之村

在危難中重拾希望

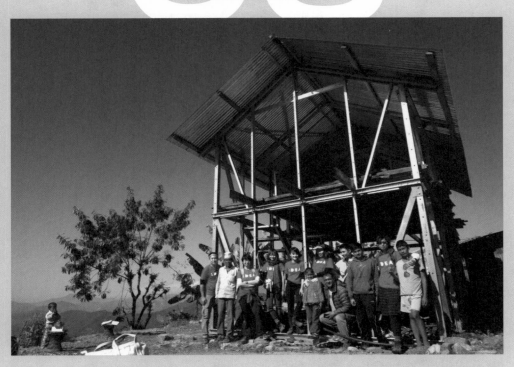

二〇一五年四月二十五日，尼泊爾發生七點八級大地震，造成近九千人喪生，逾二萬人受傷，是該國自一九三四年以來最嚴重的地震。由於當地大部份建築物均沒有抗震設計，首都加德滿都很多建築物都被摧毀，大多數人無家可歸。

IDEA 和扎根尼泊爾的非政府組織 Future Village 攜手開展「築。動未來」項目，進行以社區為本的災後重建計劃，並與當地災民合作興建防震房屋。這個計劃成為了尼泊爾其他社區和未來災後重建計劃的模範，也填補了政府及國際組織一向着重災後緊急援助，卻忽略了漫長的重建過程和資助個人住屋需要的缺口。

Katunge 村位於地震震央附近，受到的影響最為嚴重。

● 社區為本的重建大計

扎根該村第九區的 Future Village（未來之村），由香港人類學者林黎明博士（Dr. Christie Lam）與村民 Dambar Adhikari 於二〇〇四年共同成立。大地震後，當時正身處日本大阪大學任教的 Christie 亦重返 Katunge 村，協調救災工作。她憶述，大部

大地震震央位於加德滿都西北約八十公里，屬於淺層地震，所造成的傷害比深層地震還要巨大。禍不單行，在不足一個月內，尼泊爾再次發生七點三級大地震，零散的餘震持續出現。可幸的是，國際機構紛紛迅速行動，向尼泊爾災民提供緊急人道援助，大城市的救援進行得如火如荼。然而，位處震央附近的山區農村，受到地震的影響最為嚴重，卻得到較少關注──這個位於加德滿都以北約一百公里 Dhading 區的 Katunge 村，災後一片頹垣敗瓦，所有村民失去棲身之所。

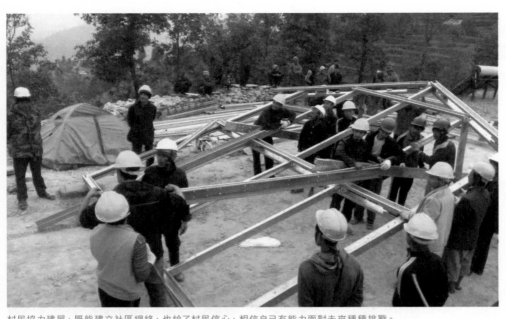

村民協力建屋，既能建立社區網絡，也給了村民信心，相信自己有能力面對未來種種挑戰。

份村民從來未真正經歷過地震，對未來感到徬徨無助，即使想重建家園也不知從何入手。

團隊以「社區為本」作為救援理念，透過和當地人緊密溝通，讓有限的資源真正抵達最有需要的人手中。Christie 舉例，災後最緊急的便是為村民籌措雨衣，但此舉卻令其他救援組織大惑不解。然而「村民在五六月便要開始籌備在六七月的雨季耕種稻米，該區一年只有一個季節適合種植稻米，一件雨衣可以令他們不會失去唯一的耕種機會，否則未來一年都需要依靠外界幫助以獲得糧食。」其他工作包括建社區中心、修補山路等也是一樣，最重要的是切合當地人的真正需要。

在緊急救援之後，Future Village 開始思考 Katunge 村第九區的重建大計。該區約有一百個家庭，在災後一個月，家家戶戶利用當地資源和群眾的智慧，齊心協力自發搭建臨時鐵皮屋，一個月內所有村民已有臨時棲身之所。但長遠而言，村民仍需要一個可於地震重臨時減少傷害和損失的防震居所，而且在心理上和實際上，他們亦覺得一定要「有瓦遮頭」，才可計劃將來。雖想興建更好的房

常民建築鋼架施工立體圖，以簡單圖像讓村民容易了解建造過程。

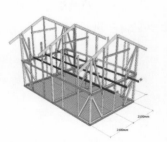

❶　在圖示位置安裝兩層檁條

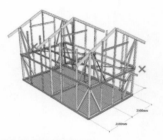

❷　在圖示位置安裝兩層拉杆

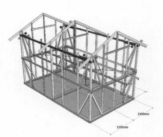

❸　安裝閣樓層次樑，並用螺栓鎖住。

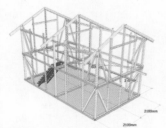

❹　組裝樓梯

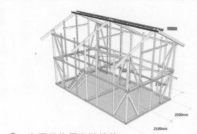

❺　在圖示位置安裝檁條

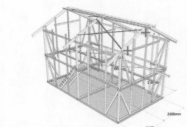

❻　在圖示位置安裝屋面拉杆

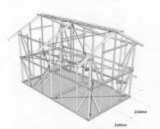

❼　校正鋼架：A＝B，並將所有螺栓鎖緊。

子，惟村民因技術問題而苦無頭緒。後來在機緣巧合下，Future Village 得以與 IDEA 團隊合作，雙方理念一拍即合，於是開展了「築。動未來」項目。

Future Village 與 IDEA 團隊看到大地震摧毀了當地的社區網絡，他們均認為，除了建屋，如何令村民重拾信心、參與社區事務，以達到充權和自主，也是首要任務之一。「築。動未來」項目有四大目標：一、通過參與式設計與共同財務承擔，使村民從單純的受助者成為重建項目主導者；二、協助村民重建於災害中失去的信心，以自己的力量去克服生活困難；三、鼓勵村民自主參與社區，包括項目的決策過程，讓他們與社區重新連接，並發展社會資本；四、建立互信互助的社區網絡。

整個項目從二○一五年持續至翌年，共分為三個階段。首先，團隊到當地向村民諮詢，聆聽他們的房屋需求，再選用適合的社區參與式建築模型。到了第二階段，團隊在香港招募義工，開展學習服務之旅，到當地協助村民準備建屋材料，以及為村內兒童舉辦具教育意義的參與式設計工作坊、粉飾 Future Village 的學習中心。最後一個階段，則是協助村民興建房屋。

團隊選用了由台灣建築師謝英俊及團隊常民建築所開發的「輕鋼架協力造屋」，特點是成本低、抗震能力高和易於組裝，哪怕是普通人也能合作組裝建造。二○一五年十一月，為了解這個如積木般、不用焊接的鋼架結構設計，IDEA 和 Future Village 一行五人出發前往內地成都，與設計及生產鋼結構的常民建築會面，商討如何落實房屋設計細節，同時親身體驗，共同協力把鋼鐵柱樑搭建成立體的鋼結構骨架。其中，擁有豐富建築經驗的工程師潘詠姿 (Gigi) 及錢可欣 (Jenny) 分享道：「從事工程多年，這是我們第一次親手把結構柱樑安裝起來，與單純在圖紙上設計相比，是畢生難忘的體驗。」這樣一來，IDEA 團隊既能了解協力建屋的運作方式，亦能在招募義工人手時作出更好的規劃。

● 為災民帶來盼望　為義工重塑人生

那年除夕，IDEA 建築師王建明 (Robert) 與設計師黃千宸 (Jackie) 又前往 Katunge 村實地考察，

並與常民建築的駐村印度建築師 Naga Venkata Sai Kumar Manapragada 商討施工細節。

Naga 作為一名印度建築師，為何選擇來到尼泊爾參與重建工作？他表示：「當我在中國成都的常民建築學習時，有機會和謝英俊建築師一同到雲南參與重建項目。在那裏我了解到，工地施工時的情況，遠比我們在圖紙上的手繪設計複雜棘手。我一直想了解如何把協力建屋的建築概念傳達給大地震後尼泊爾偏遠村落的村民。他們以前對建築施工沒有任何了解，手頭上也沒有工具，以便他們在搭建輕質密度鋼結構時能達到建築所需的精準度。」

抵達尼泊爾後，Naga 通過印地語（Hindi Language）與村民交流，運用自己建築知識提供協助。他更十分感恩：「我感到很高興和幸福。正如印度神話所說：『受到濕婆神祝福的人才能來到尼泊爾的聖地』，參與重建項目不但有助我實踐所學，還給我提供了很多機會，把我塑造成為今天的我。」

Naga 和 Robert、Jackie 一起，用非常基礎的方法平整地面。他們以塑膠水管作為平水尺（即水

為了解常民建築的輕鋼架設計之施工可行性，未來之村及 IDEA 的代表到成都的生產廠房視察及作測試。

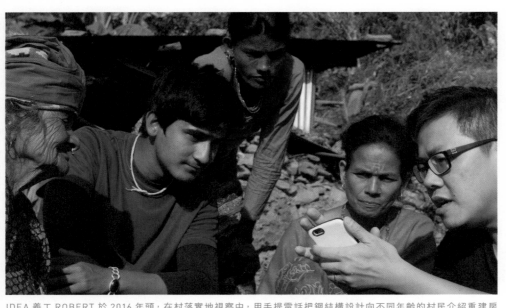

IDEA 義工 ROBERT 於 2016 年頭，在村落實地視察中，用手提電話把鋼結構設計向不同年齡的村民介紹重建房屋的設計。

平尺、水平儀），以測量並確定地面的基礎水平。

了解到當地貨車長度較短，難以運載過長的鋼架跨越崎嶇的山路，設計團隊隨即修改結構支柱長度，以方便運輸。

另一方面，團隊開始向村民介紹設計方案。由於大地震後村內大部份成年男性都到了首都工作，以增加家庭收入，村內只剩下老弱婦孺。Robert 便拿着智能電話，指着屏幕上的設計方案，一一向他們介紹重建房屋設計，譬如鋼結構、房間分佈室等，讓他們對新房屋有基本認識，了解重建方案的細節，為他們重燃對生活的盼望。

二〇一六年底，IDEA 團隊在香港招募了三十多名來自不同專業背景的義工，參與「築。動未來」項目，到尼泊爾山區服務，其中重點環節是協助村民興建房屋。Jenny 和 Gigi 也在義工團隊當中，她們花了數天整理和檢測散亂的鋼架，再根據施工圖，為每間房屋分配所需的鋼架，並向村民介紹如何根據施工圖把鋼架分類，為協力建屋作準備。

建築師義工俞俊安（Edgar）則和 Robert 一起，聯同村民把每套房屋的鋼架搬運到重建工地

上，並按照施工圖將鋼架放在不同位置，再向村民工頭解釋鋼架的不同組合方式及組裝的先後次序。接着，十多位義工與村民一起，一步一步搭起鋼架，組裝成一間房屋的抗震鋼架。村民和義工都是第一次親手搭建房屋，眾人齊心協作，對於參與式設計有了更深刻的體會。Edgar 說：「沒想過自己用電腦繪圖設計的房子，利用鋼架就能在兩天內組裝完成，是我從事建築十多年來最難忘的經驗之一。協力建屋更是凝聚社群的有效媒介，讓尼泊爾村民與香港義工打成一片！」

● 勞動互惠鞏固社區關係

其實，教導村民自己建造房屋，比起由建築師、工程師全權負責，需要更多時間和耐性。無論是資源分配的方式，還是具體的建造工序，都要得到村

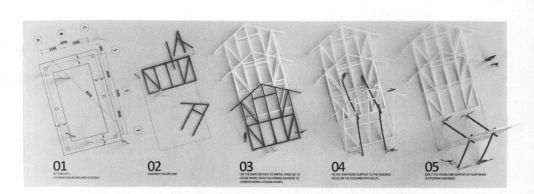

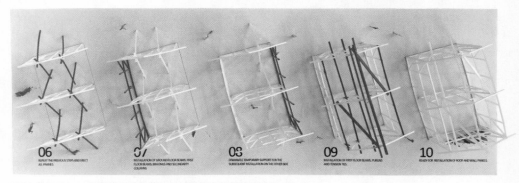

IDEA 義工 Edgar 用模型向其他義工及村民展示鋼架結構的施工次序

民理解和認同，才能一切順利。

重建整條村落、約一百間防震房屋需要約二百萬港元，平均每戶需要約一萬八千港元。項目強調村民團結協作、自主參與重建工程，因此與一般慈善機構單向資助的

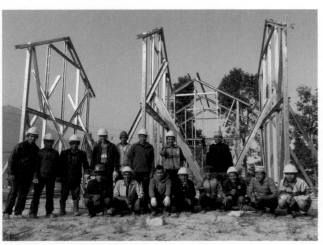

在建造期間，義工學懂放手讓村民嘗試，村民也發揮創意，打造更適合自己生活習慣的居所。

方式不同，其中約三成費用由村民負擔，餘下七成由 IDEA 和 Future Village 籌款資助；而建屋時所需的勞動力也由村民共同承擔。

組裝「輕鋼架協力造屋」十分容易，積木般的鋼架及牆身都可由村民齊心協力組裝建造。這種傳統的勞動互惠模式（Labour Reciprocity Practice）在村內實行良久，在日常生活中，不管是播種、翻土、收集肥料、修補房子等，村民都會互相借助勞動力，受惠家庭將來亦一定會以努力補償幫助了他們的人。這樣的方式不但有助鞏固農村社區關係，亦能彌補勞動力短缺的問題，有愈多村民參與建造房屋，所節省的人力成本便愈顯著。

一開始，村民興致勃勃，紛紛表示願意參與，不過沒多久，團隊就遭遇了最大的障礙──尼泊爾政府實施災後建屋津貼計劃，分三期發放三千美元（約兩萬三千港元）資助予災民，建造政府指定的抗震房屋。不少村民想要現金，因此最後只有約三十戶村民參與「築‧動未來」項目。Christie 說：「那個資助計劃並不是以社區為本，不要求當地人作出貢獻，我們的項目重點則在於讓村民在重建過程中重拾信心和學習技能，並能互相扶持。可是，三千美元對很多村民來說極為吸引，因為很多人當時的年收入未必有這麼多，我們也曾解釋，若計算

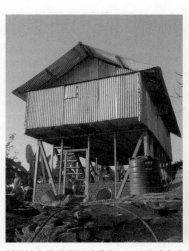
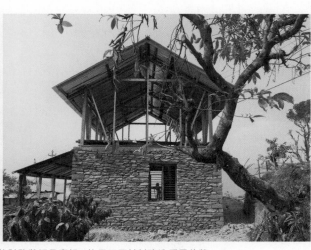

村民協力搭建鋼架結構後，可以根據各家的財務狀況及喜好，使用不同材料建造房屋外牆。

人力成本，兩個項目涉及的費用其實差不多，但我們仍尊重他們的決定。」然而，選擇政府資助計劃的村民要於一年半後才能收到首筆津貼，而且當時尼泊爾全國各處正進行重建工程，建築物料及工人短缺，單是人力成本已較之前上升了四成，興建一幢政府指定的防震房屋，費用高達七千美元（約五萬四千港元），導致不少村民負債纍纍，要繳付高昂利息。

與此同時，參與「築．動未來」項目的村民，他們的建屋過程也並非一帆風順。萬事起頭難，起初村民對於看圖紙、組裝鋼架缺乏信心，與專業人士溝通也不順利。工程師主導建造方向，要求任何尺寸都要分毫不差，村民卻有自己的一套，覺得這些做法不符合他們的傳統，感到十分不服氣，覺得：「為甚麼覺得我們做地基的方法不好？我們用了二十年都沒有問題！」卻不敢直接批評。面對文化差異，雙方缺乏互信，產生了不少不愉快。

Christie 說：「村民也需要提升能力（Capacity Building），建立自信，我們需要額外做一些工夫，去鼓勵他們勇於發表意見。」當項目牽涉到專業知識，自然會產生很多矛盾，這時當地機構或組織的協調角色就變得相當重要。在整個過程中，Dambar 一直認真理解村民和義工的文化差異，為他們準確地翻譯和傳達訊息，是令項目順利進行的關鍵。

後來團隊建議義工不要立刻點出村民的做法不妥，先放手讓他們嘗試，再提出改善建議。

Christie 觀察發現，雖然村民未必可以清晰地表達個人見解，但只要給予他們空間，在動手建屋的過程中，他們也會發揮很多創意，而這些創意都符合了他們的需要。例如：村民會在屋前建造小台階，可以防止水浸，平日也可用作與朋友喝茶小敍；他們又會將廁浴分開、將爐灶移至屋外等，以預留較大空間作儲蓄糧食之用；香港人都認為樓底高最好，但原來對當地人來說這並不需要，反而會增加建築成本。

Christie 指出：「在建造時運用參與式設計，要花雙倍時間，但最後的成品對用家來說有很大意義。因此，選擇怎樣的設計和建造方式，視乎你的目的是甚麼：只是為村民興建居所，抑或希望透過房屋令當地人提升信心、增進知識，如是後者，你就需要改變態度。另外，也不用經常問村民意見，反而可以思考有甚麼方法能讓他們有更多發揮空間。」通過人與人的互助，防震房屋成為了充滿生命力的家園。

● 工作坊埋下以創意改變世界種子

IDEA 團隊除了協助村民重建家園，也為當地約五十名兒童舉辦參與式設計工作坊，一同粉飾 Future Village 的兒童學習中心。團隊深信工作坊有助兒童嘗試探索設計、學會表達自己，在他們心裏埋下用創意改變世界的種子。

工作坊分為三個部份：一、為中心增添設施，例如黑板、粉筆、書櫃等；二、義工透過遊戲教導兒童不同事物，例如以卡片遊戲傳遞有關時間、度量衡和計算的概念，以桌面遊戲與孩子對答，以及製作生字學習卡等；第三、義工與孩子一同做小手工，用成品來裝飾中心內外牆壁、課室、天花板等。第三個部份佔了最多時間，兒童既能發揮創意，也可經歷體驗式學習的過程。

譬如「天氣天花板」是將絲帶、膠片、橫額、螢光貼紙等製成星星、月亮、太陽、彩虹等圖案，再吊掛起來，讓孩子能學習關於天氣的英文生字；室內牆上貼了不少手作風車，義工在教導孩子製作風車時，也能講述有關風能的知識；而中心外牆繪有多邊形動物圖案，亦能讓孩子從中學習與動物和形狀有關的英文生字。Edgar 指

在前往尼泊爾前，義工們每周都要聚在一起，討論教學方案和如何裝飾中心內外牆壁。

出，考慮到實際情況，義工選擇繪畫的都是當地常見的動物物種，希望貼近當地文化。

義工們出發到當地前每星期也要開會討論，如何在工作坊中結合設計和學習元素，其設計草圖亦會給當地人過目，希望能與當地文化連繫起來。團隊也着重社區關係，像是室內的壁報板上貼有由兒童拿着照相機拍攝義工團隊探訪村民的相片，孩子也可以在壁報板上寫下對未來的願望。由於他們沒有電話，中心設有由孩子以塑膠樽裝飾並組合而成的 Pigeonhole 式格狀信箱，孩子能以紙條互相傳遞訊息，加深彼此感情。

● 在生命中留下火花

Jenny 指，參與工作坊的兒童都樂在其中。工作坊在每天早上六時半

至八時半進行，這是當地學童上學前的小段時間，他們每天攀山涉水時前來參加工作坊，下午放學後又自發前來幫忙，可見他們十分珍惜參與的機會。孩子與義工臨別之際也依依不捨，眼泛淚光。Gigi 憶述，有孩子哭着把信交給她，說會很想念她，令她深受感動。

工作坊結束後，當地兒童有了自己親手打造的嶄新學習中心，他們更會自豪地指着牆上色彩鮮艷的圖畫說：「這是我畫的！」藉由參與式設計，他們學習到不少關於日常生活的英文詞彙，也對中心更有歸屬感、更願意來上課。

而經過粉飾的學習中心更產生了令人意想不到的影響。Future Village 每年都會邀請世界各地的義工前來義教，惟大部份義工都與當地兒童語言不通，即使義工早已準備好

團隊希望在他們的生命中留下火花，
令他們感受到自己也能自主掌握人生，
這就是項目的意義。

鋼結構抗震屋

包括	二十五間抗震住屋 （供給有居住需要家庭） 兩間抗震課室 （未來之村，為尼泊爾孩子 提供教育。）
時期	二〇一五至二〇一八年
地點	尼泊爾加德滿都以北約 一百公里 Dhading 區的 Katunge 村第九區
合作機構	尼泊爾社福機構：未來之村 IDEA 基金會義工隊
設計團隊	建築師謝英俊 常民建築 IDEA 尼泊爾項目設計團 隊：錢可欣（Jenny）、 潘詠姿（Gigi）、俞俊安 （Edgar）、王建明（Robert） 及各義工
其他參與者	尼泊爾村民、孩子 IDEA 義工 未來之村代表

教材，到達當地後仍會因文化差異
而不知從何入手，只能從兒童的日
常生活中就地取材。繪於中心室內
外牆壁、天花板上的圖案，正好幫
助義工與當地兒童打破隔閡：原來
每有義工到訪，孩子們便會興奮地
帶他們參觀課室，向他們介紹牆上
的圖案和詞彙，義工得以找到切入
點，從而能根據孩子的生活和興趣
作義教，雙方產生了積極的互動。

Jenny 指，IDEA 團隊期望工
作坊不只為兒童增加對空間的歸屬
感。「團隊希望在他們的生命中留下
火花，令他們感受到自己也能自主
掌握人生，這就是項目的意義。」

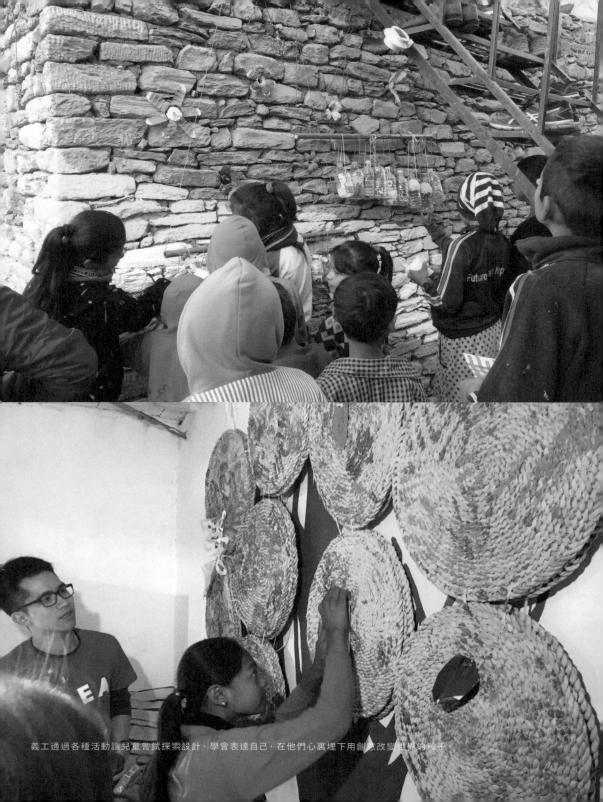

義工通過各種活動讓兒童嘗試探索設計、學會表達自己，在他們心裏埋下用創意改變世界的種子

要賦權
首要學懂
聆聽和耐性

Future Village 兒童學習中心為住在山村的學童提供
學習和接觸外界的機會

Future Village 多年來一直希望透過更好的保育、教育、醫療保健及農業機會，來改善尼泊爾偏遠農戶的生計。其中包括贊助一百多名農村孩子上學、贊助優秀農村學童到城市學習、贊助聘請六位全職村校教師、提供免費的定期補習班、支持村校的重建和升級項目、為七百多名住在偏遠地方的村民接駁清潔的飲用水、為村民提供免費健康檢查及牙科服務等。

Future Village 強調不收取行政費用，成員均為義工。

團隊強調村民在社區事務中的參與和貢獻，不希望他們過份依賴非政府機構和外界捐款，故十分支持參與式設計理念。惟 Christie 亦坦言，村民在參與時是否可以達到真正充權，甚至可以更積極地參與公共事務，有多方面考慮因素：

「首先要視乎這是甚麼類型的參與項目，以建屋為例，你可以容許村民做決定，有權參與由設計到選材的整個過程，或者只是付出廉價勞動力，這是兩碼子的事。要達到真正充權，即他們可以有信心去表達意見和做決定、建立自主能力，就要在過程中的每一步都將他們的參與程度最大化。但這很需要時間和耐性，而這在做任何發展項目時都是最棘手的。」

儘管她希望讓村民慢慢來，但無奈的是，很多捐款人都急於見到成效，會質疑：「為甚麼我捐了錢，但房子還未建成？」又或者：「我捐了錢，但房子為何建得這樣醜陋？」並提出要求，期望村民應該這樣做才覺滿意。Christie 慨嘆：「我們不是用家，只有用家才知道需要多少時間才會做得更理想，但無論如何他們一定會慢慢改善，因為這是他

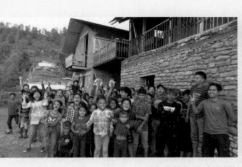

Christie（右）和 Future Village 一直希望為尼泊爾偏遠農戶創造更好的保育、教育、醫療保健及農業機會。

「某程度上他們的建屋知識有所提升。他們以前興建房屋時沒那麼多考慮，喜歡在哪裏蓋房子就在哪裏蓋，現在他們會思考地基深度、所瀉的位置等，謹慎了很多，這真的是一個學習過程。」

Christie 曾向參與程度較高的村民詢問，若將來遇上更大的困難，是否有信心可以解決？結果有一部份村民回答：很有信心。「他們一開始建屋時也很痛苦，很多事情處理不了，但當最後成功解決便重建了信心。這也是我們的初衷，我們想向當地人證明，有危就有機，只要親力親為就有可能克服困難。當然這個項目有很多可以改善的地方，但整體來說，也為村民帶來了正面的經歷。」

們的家，他們也想住得舒舒服服。當你要求他們要這樣做那樣做，某程度上會削弱了他們的自主，相信村民是很重要的。」

另一方面，非政府組織、專業人士和村民之間往往存在着不平等的權力關係，容易產生磨擦，專業人士更要放下身段。「面對專業人士，村民一開始會害羞，或者覺得自己說的話不管用，所以專業人士需要改變態度，多聆聽當地人分享其想法和做事方式，只有這樣才可以鼓勵當地人真正參與其中。」村民參與度愈高，所建立的信心會愈強。Christie 舉例，一位擔任建屋小隊領袖的村民便對自己建造房子的防震功能十分有信心，原來他從打地基、立鋼架，到裝修設計都參與其中，期間不斷與工程師溝通，學習防震設計的原理，因此對自己建造的房子和自己的判斷有信心。

讓建築回歸生產

這次尼泊爾項目所採用的「輕鋼架協力造屋」模式，由一直致力於協助災後重建和鄉村建屋、被譽為「人道建築師」的台灣建築師謝英俊及其團隊常民建築所研發。協力造屋的特點是成本低、抗震力高和易於組裝，鋼架不須焊接，只需要「螺絲擰一擰」就能夠接起來，被形容為像砌積木般簡單，沒有專業知識的普羅大眾都可以做得到。在今天房屋高度商品化的社會中，謝英俊認為，建築是基本人權，希望藉由讓建築回歸生產，「自己的房子自己蓋」，從而保育不同族群的文化。

根據聯合國指引，一般難民建屋預算為四千美元（約三萬一千港元），而在 Katunge 村內每間房屋的預算卻只有二千美元（約一萬五千港元），條

「人道建築師」謝英俊多年來他一直奔走於偏遠地區或災區，致力為人們提供專業建築支援。

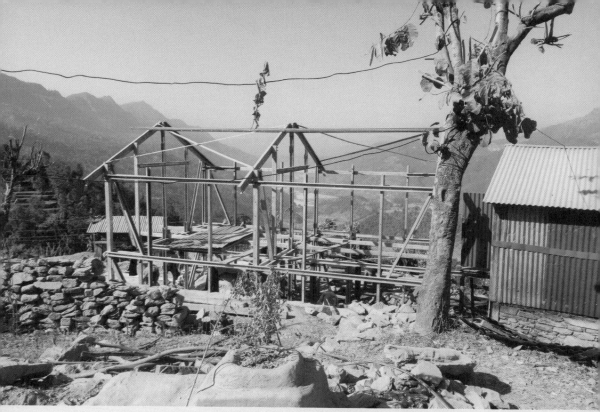

「輕鋼架協力造屋」模式成本低、抗震力高、易於組裝，令人人都可以搭建自己的家。

件非常嚴苛。但在這樣緊張的預算下，反而更能體現輕鋼架協力造屋模式的原則：人人參與和價格可負擔——在村民互助互利之下，省去了高昂的勞動力成本，最終製造出二十多間面積達七百平方呎的兩層高抗震房屋。

輕鋼架協力造屋採開放式設計，建築師只提供最基本的抗震房屋結構，其他部份例如牆體、屋頂、地台、內部規劃等，都需要由住戶構思，以及付出勞力建造。換句話說，從組裝至裝修的整個過程，住戶都參與其中。這除了可讓住戶打造更符合自己需求的家園，也提供了一個發揮創意的空間，讓他們增加對房子的歸屬感。觀乎尼泊爾災民設計的房子，也體現出當地的民間智慧，舉例說，屋簷上有延伸的帳篷，在雨季可遮風擋雨，屋門前有小台階，暴雨時可降低水浸的影響，平日又可作為與好友暢談的空間，既實用又有社交意義。

101

● 重拾社區互助傳統

謝英俊於一九五四年在台中出生，淡江大學本科畢業後與一般建築師無異，直接投身商業建築世界。然而，一九九九年九月二十一日台灣中部山區發生的七點三級大地震，成為了他人生的轉捩點。

大地震震央位於南投縣集集鎮，鄰近的日月潭邵族部落所在地一下子就被無情地滅村。謝英俊臨危受邀前往協助邵族族人重建居所，就在那個時候他和團隊開發出輕鋼架協力造屋，族人齊心協力，憑自己的力量重建家園。後來謝英俊更在邵族部族裏搭建工作室，作為行動總部，戶外空地一個帳篷一頂蚊帳，簡樸無華，他一待至今逾二十年。他笑笑說：「雖然你看這個社區的房子破破爛爛的，但當初我們的想法是保存文化。邵族是台灣人數最少的少數民族，只有三百人，但它的內涵很豐富。若果他們的文化能夠保存在一個小小的地區裏，影響會非常大。」

自「九二一大地震」後，謝英俊開始把工作重心轉移至弱勢和貧窮社群或地區，協助當地人建屋。除了受到如汶川大地震、莫拉克風災、尼泊爾大地震等影響的災區，更延伸至世界各地的鄉村、少數民族部落。他笑言：「主要是我參與這個工作（「九二一大地震」災後重建）以後，就踩到一個黑洞裏頭了。不只是災區，只要不是在都市生活的人類，所面對的建築問題都是一樣的，只是在災區這個問題比較尖銳。」他頓一頓，解釋道：「現在的建築技術以專業主導，城市人一般沒辦法自己建屋。但在過去傳統，尤其是在農村、少數民族和第三世界地區，蓋房子是一種集體生產行為，是社區一起合作蓋房子，全球七成人口基本上就是這樣子的。

但這種傳統做法和知識，沒辦法進入到新時代。」

在現代資本主義社會高度分工和謀利主導方向下，建築漸漸由原始的生產行為轉換成消費商品，甚至只是交易的貨幣，人們不再懂得親手建造屬於自己的居所。而他的目標，就是將傳統生產與現代技術和物料結合起來，讓人們可以重拾社區互助建屋的傳統。「所以我們不再只是協助災區重建，也要為一般的平常百姓家，尤其是在農村地區的人做這件事。」

「九二一大地震」後，謝英俊協助台灣人數最少的少數民族邵族族人重建居所。

● 建築是人的基本權利

身處在房屋高度商品化的城市，香港人始終無法想像自己建屋這回事，但如果回到最根本去思考，擁有安穩的棲身之所，其實是人類最基本的需求，由個體發展延伸至集體生活如社區倫理、文化歷史，都始於一個「有瓦遮頭」的地方。謝英俊認為，建築是人的基本權利，而人們能夠確保自己蓋房子的話，就更加能夠自己蓋房子的人，例如我失業了，還不起貸款就流落街頭，但如果我失業卻能自己蓋房子，將建築變成他的生產行為，自己就自己的業，就可以解決問題。但像你們香港人大部份時間都是幫地產商打工，

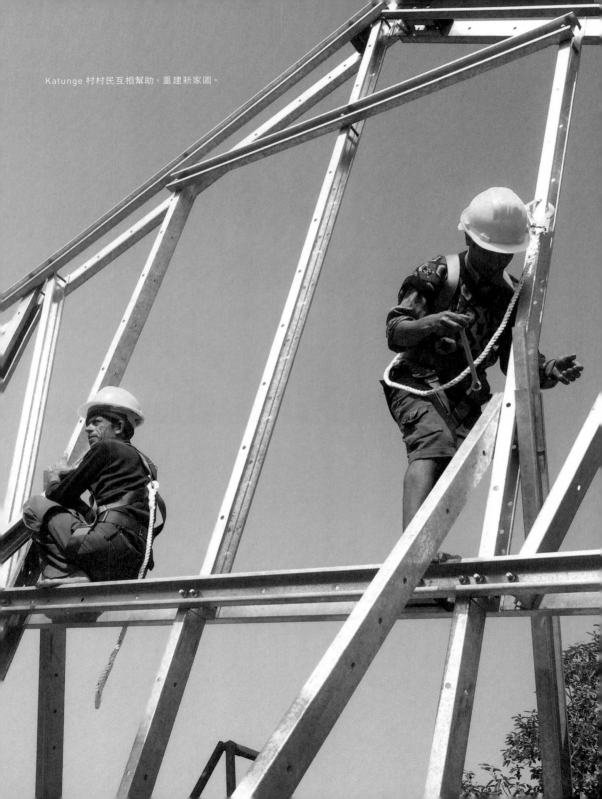

Katunge 村村民互相幫助，重建新家園。

很努力去還貸款，都被控制住了，所以到底誰是弱勢呢？還說不定。」

但他慨嘆，現在房屋變成交易貨幣，同時也將建築內涵裏的文化、社會特質壓縮掉了。他說：「要和家人、鄰舍一起去蓋房子，這是一個集體社會生產行為，這樣個體就會跟文化和社會各種元素結合在一起。但現在你一天到晚都在計算自己住的房子有沒有漲價，搞不好住了甚麼人都不認識，失去了互相幫忙、交流、溝通的社區生活內涵。」

● 人道關懷就像空氣

在現代建築中，普遍缺乏使用者的參與，謝英俊認為，參與式設計是一個趨勢，但當中怎樣操作卻很困難，因為建築師要懂得放下身段，同時降低技術門檻，盡量讓使用者有發揮的空間，才能提升其參與度。「我們花了幾十年，就是在研究怎樣讓房子的使用者可以參與。這很難講，但關鍵很簡單，首先是開放性：我們提供了一個沒有個性的平台，輕鋼架可以跟泥土、石頭、柱子、鐵皮等各種材質結合，而且可以調整、擴建，房子拆掉後又可以重新組合起來，不會浪費。建築師要懂得放下各種控制，只留下最核心的架構，個人的文化詮釋就可以在裏面實現。」

另一點同樣重要的，是建築師在把守結構安全的同時，也要盡量將技術簡化，讓一般人可以參與，至於各方面如何準確拿捏，就需要依靠建築師豐富的實踐經驗。

謝英俊多年來為弱勢社群服務，被大眾稱為「人道建築師」，但他卻從不把人道關懷放在嘴邊，笑言自己從來都是專業技術人員，理念是為了解決實際問題而行動。「人道關懷就像空氣一樣，是很自然的存在，不需要特別去強調。我們是專業技術者，不是慈善家，沒有辦法提供很多金錢給災區的人，但我們可以在這領域中作出很大的貢獻，提供我們專長的服務。」他笑說，不論在中國、非洲、美洲等多偏遠地區，若有需要，儘管開聲，「我們絕對可以幫上忙！」

在年輕人心中留下好種子

從教育實踐中探索人生價值

在天主教慈幼會伍少梅中學的有蓋操場，有一間文青風裝潢的精緻 Cafe。「築。動未來」的其中一位義工參與者校長李建文（Man Sir），正在裏頭熟練地操作意式咖啡機，親手為人們沖調香濃的咖啡。這間 Cafe 有板有眼，是否由學生經營的生意？他卻笑笑說：「這間 Cafe 的咖啡只送不賣，所有成本支出由學校負責，重點不是要教學生營商，而是要令他們從中發掘自己的能力和興趣。」

Man Sir 的名字常出現於各大媒體，這位愛心校長以善於創造空間讓學生發揮才能而聞名，是教育工作領域中的模範生。在踏入教育界之前，他原是一位社工，希望透過自己的力量為社會作出貢獻，而這個念頭萌生於他中學時期做義工的經歷。

愛心校長李建文積極參與義務工作，以身作則向學生展示對弱勢社群的關懷。

至今，他仍不辭勞苦遊走世界各地參與義務工作，以身作則向學生展示對弱勢社群的關懷。

從社工「執仔」到老師「教仔」

他抱着這個使命，在大學時期選修社工專業。上世紀八十年代正值香港經濟騰飛的黃金時期，產生了許多雙職家庭，在缺乏雙親的關懷下，青少年朋黨問題日益嚴重，故大學畢業後他決定投身青少年外展工作。Man Sir 回想昔日到球場、波樓、機舖「執仔」，在對輟學年輕人有更多了解

Man Sir 年少時就讀天主教學校，在老師的鼓勵下到明愛賽馬會樂仁學校擔任義工，服務肢體和智力嚴重殘障的學生。首次接觸弱勢社群，他才驚覺社會上有很多需要幫助的人。「原來有很多年輕人沒機會去做我們理所當然的事，像是行街睇戲食飯，我開始反思，生命到底是甚麼？生存又有何價值？這世界上有很多人比你困難。後來我才明白到，生存的價值，並不單在於有甚麼成就，更重要是你能貢獻多少，令別人、世界變得更好。」

後，赫然發現他們骨子裏其實很想繼續上學讀書，但無奈或因老師的偏見，或因一時衝動，就賭氣不再回到學校，着實可惜。發現問題癥結後，他沒有像其他社工一般繼續跟進青少年個案，反而索性轉行，搖身一變，成為 Band 5 中學教師，這樣所有學生都是他的潛在個案，比起當社工走得更前。

「年輕人的成長過程有很多挑戰和挫敗，有機會一走歪路就影響一生，如果在這個階段能做好預防和發展工作，他就能夠正面成長，對他自己、對社會都有幫助。我相信，年輕人不應太早脫離教育系統，特別是中學生涯，對於他們社教化、學科學習、性格成長是很重要的。」

他於教學上實踐社工專業經驗，為學校和師生帶來了改變。舉個例，任教音樂科的他牽頭在校內成立了全港公營學校第一間 Band 房，故意挑選被老師標籤為「最搗蛋、最沒自信、最沒出息」的一班學生來夾 Band 玩樂隊，大家從零開始學習樂器、編曲、填詞，最後錄製成 CD，再到會展表演。「這班反叛的年輕人行為、成績不是太好，但我透過音樂教他們做人。除了有型，我要告訴他們

還有其他價值：為甚麼拿起結他就可以表演？這就需要練習，做好一件事情需要訂立目標和堅持，當中要面對不少痛苦和困難。」他笑說：「所以喜歡音樂的人，心地不會壞。」當中一些學生因為這段經歷而找到自己的目標，有人畢業後到日本深造音樂，也有人到演藝學院進修，繼續在音樂路途上拚搏。

● 鼓勵學生堅持追夢

「其實 Band 房只是一個平台，我希望讓老師明白如何去栽培一個學生，不要用有色眼鏡去看外在行為似乎做得不好的年輕人，他讀書不行是否等於不好？全校成績最劣的學生都未試過站在會展的舞台上。我想講的是，不應該拿橙和蘋果相比，你成績第一，我應該拍手叫好，但同時你也要懂得去欣賞別人的優點。面對成績不好、反叛的學生，要更用心去教，當他做到不一樣的事情，就會改變他的思想和人生。」

投身教育界多年，輾轉間他當上了中學校長，至今不忘因材施教的初衷。天主教慈幼會伍少

梅中學不是傳統名校，甚至有許多別人不願意教的學生，例如來自少數族裔、新移民、基層家庭、有特殊學習需要等等，但卻成為了媒體的寵兒，學生的故事一遍又一遍地被報導：有人有讀寫障礙，卻擅長繪畫；有人成績不好，沖咖啡拉花卻屢獲獎

學校內既有 Cafe，也有健身室、人工智能教育中心等空間，讓學生發展潛能。

尼泊爾村民親建防震未來之村

精緻的咖啡杯都是學生的作品

項。這所學校會為學生設立 Cafe、健身室、錄影室、人工智能教育中心等空間，將樓梯設計成學習走廊；老師會因應學生的能力和興趣而作出個別指導，走廊佈滿學生的雕塑和繪畫作品，Man Sir 希望學生可以在自己喜歡的學校上課，也鼓勵他們不要放棄尋找自己的理想。

「要看得見學生。」他指着咖啡吧枱上大小、外形不一的咖啡杯，全都是學生在陶藝室親手做的。「我相信每個學生都是獨特的，但我們是否有眼界看到石頭裏面的玉？每個咖啡杯都不一樣，但每個都有用。如果只有單一標準，只有帶杯柄的才叫咖啡杯，它就會被篩走，你也會令它想到自己不是好的咖啡杯。但不同並不等於不足。即使有不足之處，你是否相信它也有好的地方？你給學生機會讀書，但你又有否給他機會去發展多元才能？在他的成長過程中留下好的種子，然後由他們去發揮，這便是我最想做的事情了。」Man Sir 的卡片正是由中一學生設計和繪畫，他珍而重之。

Man Sir 時刻注意聆聽當地人的想法和感受，與他們一起面對災後的困難和挑戰。

● 做義工　得着比付出多

在校長的身份以外，Man Sir 多年來走訪世界各地擔任義工，足跡遍及加爾各答、尼泊爾、汶川、青海、湖南等地，在加爾各答德蘭修女創立的仁愛之家，他學習照顧瀕死病人；在汶川大地震後，他到當地做災後支援工作。

而在尼泊爾發生大地震後，他成為了「築。動未來」項目的其中一位義工，與當地村校學生共同設計兒童學習中心課室，打造更具學習元素的讀書環境。啟程前，他每個星期都要和其他來自不同行業的義工開會作準備，過程中擦出不少火花。義工們大多來自設計、廣告、建築等行業，而作為資深教育工作者的 Man Sir 時刻提醒團隊，在設計中可以滲入怎樣的教育元素。「有些組別提出了教育方案，我覺得這樣教大人可以，但在一個甚麼都沒有的山頭，而你的對象是兒童，其實這樣是行不通的。教學需要透過溝通，溝通要靠語言和文字，但如果語言和文字都不行的話，要怎樣做呢？大家的教學目的是甚麼？怎樣可以令對方真正學得到？而

110

不是你教了便算。」組員間有着共同目標，互補不足，也正是參與式設計的意義所在。

「我很欣賞參與式設計信念的實踐，一座建築物，要賦予其生命價值和意義，要思考的不是建築師想呈現甚麼，而是用家在其中可以善用些甚麼，這才是最重要的。建築師也好，義工也好，都要經常記住用家的想法和感受，千萬不要抱着『你有不足，所以我來幫你』的想法，這是不對等的，你要真切地了解對方的需要，雙方一起處理困難。等於我們做教育一樣，也要以學生為本。」

他憶述，尼泊爾學生很投入、享受學習過程，綻放出燦爛的笑容更令他確認：每一個人都喜歡學習。不過，叫他最難忘的是在工作坊期間，他留意有一個小女孩背着一大紮草，頭上頂着一根繩，在遠處偷偷看着。他好奇地走近女孩，問對方可否讓他嘗試把草背起來，結果當他準備站起來時

卻動彈不得。「我不忿氣，結果試了三遍才勉強站得起來，慢慢走了一段路，已經覺得好辛苦，很難想像她每天都要這樣背着上山，而她亦毫無怨言，樂觀面對。」當城市人總說教育是一種權利的時候，世上有很多孩子卻連基本的教育權利也沒有。

他人所遭遇的困境，讓他時刻謹記要懂得善用自己的能力，在自己的崗位為有需要的人服務。

「小時候經常聽到『施比受更有福』，多年之後，才發現我的得着比我的付出多很多。種種經歷提醒了我，要保持謙卑感恩的心，明白自己已是好幸福。社會上雖然有很多不足夠、甚至不公平的情況，但人可以影響他人，人與人之間的互動會帶來希望，只要保持同一信念，總能帶來正面的改變。對我來說，可以善用資源給學生提供優質教育，就是意義所在。」

是次尼泊爾重建項目的其中一位義工，是在香港服務基層和弱勢家庭多年的社工兼安徒生會總幹事黃美坤（May）。原來早在一九八八年，她讀大學時已到過尼泊爾首都加德滿都作文化交流，深受當地熱情和純樸的民風所打動。她憶述二〇一五年得知該國發生大地震，仍不禁淚珠盈眶：「好傷心，看到自己去過的地方全都崩塌了⋯⋯」

她很是着急，到底自己可以為這個地方做些甚麼？在偶然的機會下，她從擔任 IDEA 義工的朋友口中得知，IDEA 將會舉辦「築・動未來」義工服務計劃。在仔細考慮自己可以如何貢獻後，她馬上聯絡運動品牌廠商捐贈禦寒物資，自己亦在周末朝九晚五持續參加 IDEA 工作坊，商討粉飾學習中心

黃美坤曾在大學期間前往尼泊爾作文化交流，對當地有深厚感情。

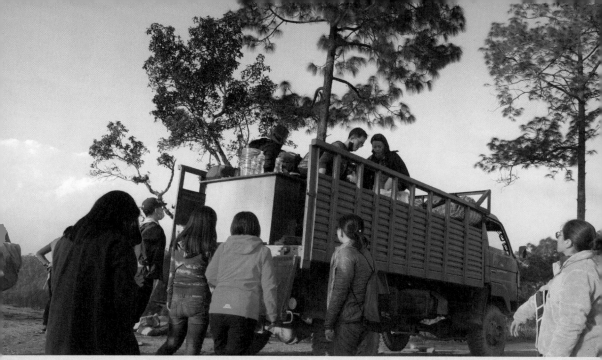

和救災物資一起擠在小卡車上的義工們

課室大計和製作教材套。

萬事俱備，只欠起行。從加德滿都前往Katunge 村的路途十分崎嶇，沿途沙塵滾滾，一行人在小卡車上顛簸達六小時，眾人擠擁在石油氣、食物、家具和各種工具旁，猶如逃難。村內的環境也甚惡劣，地震後餘下房屋寥寥，十七位義工擠在一間房內肩貼肩入睡，廁所只得早廁，村內無街燈，晚上要摸黑而行。當地晚上氣溫低至零度，由於沒有熱水，義工只能把握中午較暖的時間以冷水抹身。在舟車勞頓下，不少同行團友都病了，May也不例外。

● **不是消費式旅遊**

經歷了種種刻苦的體驗，卻讓 May 有了新的體會：「在香港怎會習慣沒有熱水沖涼、沒有快速的無線網絡、每餐都吃咖喱即食麵？但竟也安然度過了，對自己有了新認識，覺得沒有甚麼是克服不了的。」

每天清晨六時半，團隊就要和兒童進行粉飾

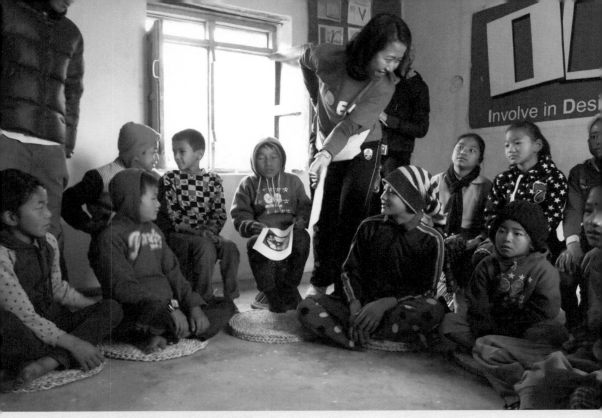

每天清早，義工都和當地兒童一起進行各種活動。

學習中心的工作坊。過程中 May 謹記：義工和孩子共同付出、參與和同行，是最重要的。「我不覺得我們做了很多事情，但我想讓他們知道，有困難時我們願意和你們一起度過。我覺得不可以一個高姿態來幫助他們，（做義工）也不是消費式旅遊，而是大家一起去做，一起去體驗，哪怕做到的事情很少，都會很珍惜一起參與的時刻。」

工作坊完結後，團隊就要到工地幫忙，以及入村探訪村民。家家戶戶都居於臨時搭建的鐵皮屋，鋪上幾塊紅白藍膠布便叫作遮風擋雨，十分簡陋。義工向村民派發物資，閒話家常間問及對方生命中最重要的東西。May 記得，一個女孩拿出和家人的合照，又記得一位媽媽指着身旁的女兒。原來對當地人來說，房子沒有了就重新搭建，農

114

田毀壞了就重新耕種，只要家人齊齊整整，就已是最重要。

● 回港後開展香港學童社區項目

當地人雖慘遭地震、生離死別，災後生活環境又惡劣，但仍難得保持樂天知命的態度，其天真爛漫的笑容，早已不經意地深深印在 May 的腦海中。這些年來，不論生活還是工作上，她都經歷了大大小小的難題，有時可憑個人能力解決，有時受制於社會大環境，每當失意時她回看當日在尼泊爾拍攝的相片，就會生出勇敢面對的力量：「記得負責接待我們的人第一天就和我們說，村民都是隨遇而安的人，今日有飯吃就吃飯，沒有飯吃就餓着肚子明天再說。這種態度令我反思：一個人不要過於着眼當下的困難而局限了自己，要相信自己的能力，明天再繼續奮鬥。」有時人們以為做義工是要去拯救弱勢社群，殊不知自己其實也是得到充權的人。

每當 May 低落時，只要回看在尼泊爾拍攝的相片，就能生出勇敢面對的力量。

小村落無形中給了她心靈上的支持，她亦以感恩的心將這份信念的種子散播出去。二〇一七從尼泊爾回港後，她開展了一些主要由兒童參與的社區項目，幫助區內有需要的獨居長者。「其實香港的孩子有能力和條件，可以多嘗試思考社會問題，了解身邊人的需要和困難，不要只着眼於個人利益。在助人的過程中，亦可藉此教導他們積極面對困難，勇於思考解決方法，不要局限了自己，在解難時亦可發掘自己的能力。」

CASE STUDY 04

十年磨一劍

始於柬埔寨建校項目的IDEA實踐

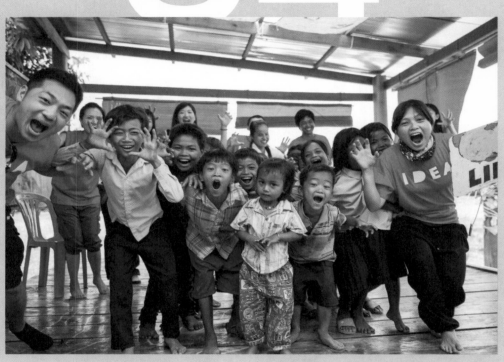

IDEA 創辦人王建明（Robert）早在二〇〇七年首次到訪柬埔寨，參與大學所舉辦的義工服務團，發現當地農村教學設施簡陋，幼童沒有機會上學，於是決定與當地非政府組織（NGO）合作興建幼兒學校，後在二〇〇九年正式成立 IDEA 建校項目。從二〇〇九年開始，IDEA 堅持每年帶領義工團到柬埔寨，協助當地興建教育設施和舉辦參與式設計工作坊，至今完成了近二十個建校項目，有逾五百位來自世界各地的義工參與其中，每年令超過五千名兒童受惠。

隨着一系列建校項目持續推行，參與者（包括香港義工和柬埔寨人）的種類和人數日漸增加，並不斷投入新的用家參與元素和意念，造成更強的衝擊和改變，令項目持續進化與深化，從而使整體參與度愈來愈高——這也是項目得以順暢運作的關鍵——匯集了所有持份者的智慧。柬埔寨建校項目可分為四大發展階段：探查階段（Inspection Stage）、探索與實驗階段（Exploratory and Experiment Stage）、發展與建立階段（Development and Establishment Stage）

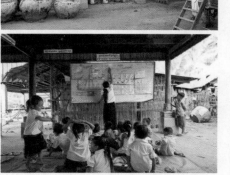

在柬埔寨，鄉村的幼兒學校通常選址於老師家裏的高腳屋樓下或樹蔭下，鋪一張地蓆，大夥兒就地上課。

和加強青少年義工參與階段（Scaling Up Stage）。

在柬埔寨，學前教育並非強制性的，而且沒有政府資助，鄉村的幼兒學校通常選址於老師家裏的高腳屋樓下或樹蔭下，鋪一張地蓆，大夥兒就地上課。然而，這樣的「課室」無論是通風還是採光都很差，絕對不是理想的學習環境，令家長卻步，孩子失去了上幼兒學校的機會。這個局面必須扭轉。

IDEA 的學校建築設施興建項目主要分為三種：興建學校課室、教學亭，以及周邊配套，如操場、圖書館等。課室參照幼兒和初小學生課室設計標準：面積達五十至八十平方米，最多可容納四十個學生。團隊又將建築預算控制在當地標準課室費用的範圍內，即約一萬至一萬二千美元（相當於約八至十萬港元）；而沒有牆壁的教學亭則在三千美元（約兩萬多港元）內，每個可容納約十五個學生。

以下將介紹 IDEA 在柬埔寨的建校項目的發展歷程，以及曾經參與項目的機構和義工分享自己的經歷和種種感受。

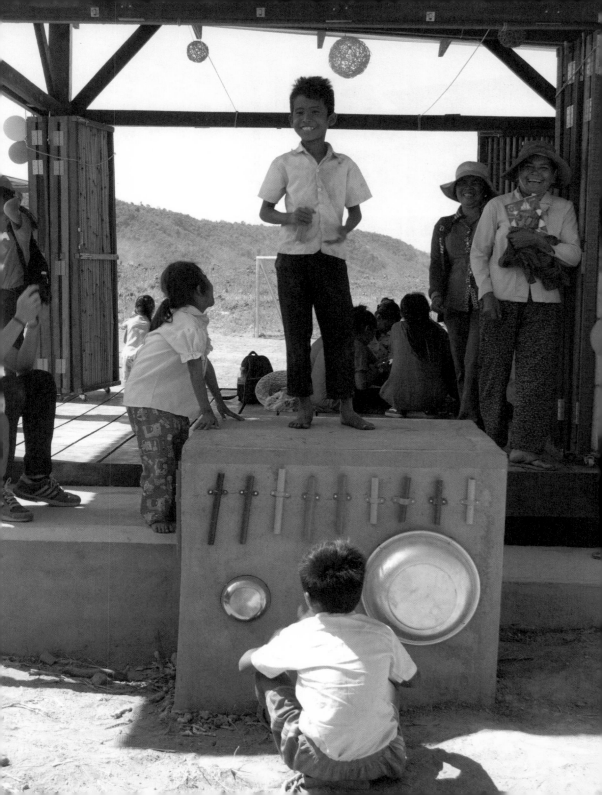

IDEA 在柬埔寨的軌跡

● **探查階段**
二〇〇七至二〇〇九年

在一個落後的國家或地區開拓發展服務團隊的關鍵，是要在當地找到值得信賴的 NGO 合作。IDEA 團隊找到致力於促進以鄉村為本的幼兒教育和青少年英語教育的機構 The Cambodian Children's Advocacy Foundation Organization（CCAFO）作為協調者，雙方一直合作至今。

與此同時，團隊冀望親身向對方示範何謂參與式設計。為「小試牛刀」，團隊探訪當地家庭，並與居民一起興建雞棚和水泥水井，又以參與式設計的方式和兒童一起做學校名牌，這種活動模式獲 CCAFO 和當地人認同。

● 探索與實驗階段
二〇〇九至二〇一三年

開始建校計劃後，就要確定校舍的具體位置。團隊「空降」到當地，雖說是為村民建校，也要得到村民的認同和信任，所以團隊和 CCAFO 先與當地小學校長洽商。由於當地小學校長多數為政府部門公務員，如果得到對方許可，在其小學校園內加建學前學校，村民就更願意讓孩子到新校舍上課；團隊也可藉此確保校舍得到照料、能被妥善使用。

除了為學校興建硬件設施，IDEA 也希望在軟件上出一分力，促進香港和柬埔寨的團隊互相分享知識。由二〇〇九年開始，團隊分為三路人馬開展工作：一、設計組負責為義工隊舉辦工作坊，並策劃讓當地學童參加的參與式設計工作坊，改善學校結構和配套設施；二、教育組研究在當地學校引入已發展國家的教學方法，如互動式小班教學，並為當地教師製作包含遊戲和學習法的教學手冊；三、世界公民

> **參與者**
> （四個建校項目合計）IDEA 團隊約一百二十位義工（來自香港、英國、美國、澳洲、法國、柬埔寨等）、CCAFO、NTTI 學生、柬埔寨居民和學生約二百人、柬埔寨小學校長、柬埔寨承建商

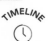

TIMELINE

2013
在貢布省的村落興建三個教學亭、一間圖書館及操場設施

2012
在貢布省的首府貢布市興建一間兩層樓高的學前學校及操場設施，學校的上層是課室，下層是遊樂場和單車停泊處。該校是全鎮全省第一間兩層學校，成了地標建築。校舍深受學生歡迎，入學人數超過四十人，需要分成上下午班授課。

2011
在貢布省的首府貢布市興建一間學前學校、一間圖書館及操場設施

2010
在當地貢布省（Kampot）的村落興建一間學前學校及操場設施，開幕當日有柬埔寨高級官員和軍人出席，為團隊在當地打響知名度。

組則着眼於將公民意識和平等世界觀帶給當地兒童，同時帶義工到當地實地考察，了解更多發展中國家所遇到的困境。IDEA 於二〇一一年成為香港建築師學會青年建築師項目基金得獎者，獲全額資助，讓項目順利起步。

為了增加當地人的參與程度，從二〇一一年起，團隊和當地的工程院校 National Technical Training Institute（NTTI, Cambodia）接洽，獲他們支持，讓工程職訓學生加入做項目義工。這些學生主要來自首都金邊，對於自己國家的農村情況並不了解。他們參與項目後，一方面能實踐工程知識技能，學以致用；另一方面，這也是一種公民參與的模式，讓學生與鄉村產生連繫，藉此機會思考如何改善自己國家的教育。有該校學生在參與項目後選擇到學校擔任教師。

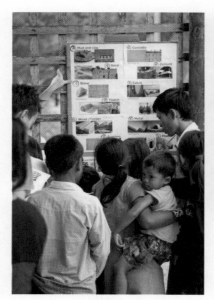

IDEA 義工在建校前會向當地孩子和家長作各種介紹，並了解他們的想法和意見。

與當地小學聯繫合作的模式實踐了數年，頗為成功，已確定能吸引更多孩子上學。

由於此前團隊已在當地建立了知名度，到了這個階段，校舍建築規模得到擴展，團隊甚至還興建了小學校舍，變相令部份教師的薪金能獲政府資助。長遠而言，團隊希望校舍的興建工程由政府接手，不再依賴外界和 NGO 資助。

● 發展與建立階段

二〇一四至二〇一七年

這個階段最大的突破，是校舍由以往採用無主題設計轉換成主題式設計（Theme-based Design）。這有兩個好處：第一，主題式設計以故事作為設計基礎，無設計背景的義工參與程度更大；第二，對當地兒童來說更有吸引力，他們的參與程度更高，校舍包含的教育元素也更多。

團隊希望設計更貼合幼兒的喜好，故邀請了明愛啟幼幼兒學校和香港童軍總會合作。香港童軍總會更將其列入童軍的服務學習體驗，年幼童軍與 IDEA 團隊共同創作主題式設計的故事，在參與建築設計之餘，亦可了解柬埔寨兒童的處境；成年童軍則跟隨團隊飛抵當地擔任義工。與此同時，IDEA 為義工進行水泥、木工的正規訓練，令他們到達當地後能身體力行參與建築過程，既增進知識和技能，也變相增加參與度。

TIMELINE

2015－1017

在 Chum Kiri 區興建一個大型教育校園，包括四間學前教育和小學校舍、一個教學亭、一個洗手間及操場設施。校園特別之處是採用了圓形廣場的設計，四座校舍圍繞着中間的操場，也是全省唯一一間圓形學校。

2014

在 Chunk 區及 Takeo 區興建兩間學前學校、兩個教學亭及操場設施

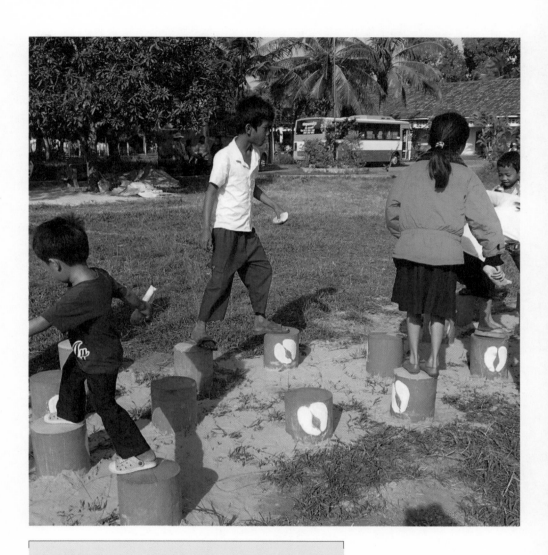

參與者
（四個建校項目合計）IDEA 團隊約一百五十位義工（來自香港、英國、法國、柬埔寨等）、CCAFO、柬埔寨居民和學生約二百人、柬埔寨小學校長、柬埔寨工程師、NTTI 學生、柬埔寨承建商、香港建築師學會（負責持續宣傳和推廣）、明愛啟幼幼兒學校、香港童軍總會

● 加強青少年義工參與階段

二〇一八年至今

由於主題式設計成效理想，故獲 IDEA 團隊繼續採用，同時先前項目中已有數間校舍由政府接管和資助，成效顯著。當項目漸漸成熟，團隊希望將理念推廣至香港的中學生和大專生，香港義工團不再圍於成年在職人士。因此這階段項目的參與義工還包括英華書院師生，以及香港大學專業進修學院（HKU SPACE）建築學系學生，而 HKU SPACE 建築學系課程主任更將項目列入建築設計課程中。

讓香港學生參與有幾個好處：第一，學生以專題研究形式參與項目，可以深入掌握建築設計知識，了解當地環境；第二，這些服務學習體驗讓學生能更明白以人為本的參與式設計；第三，在物資貧乏的環境下學習如何解決困難，對學生的個人成長也有幫助。

到了二〇二一年，受二〇一九冠狀病毒病（COVID-19）疫情影響，項目義工團未能成行。如今，IDEA 團隊正思考未來開辦線上建築設計課程予柬埔寨學生的方案。

參與者

（三個建校項目合計）IDEA 團隊約一百四十位義工（來自香港、英國、柬埔寨）、CCAFO、柬埔寨居民和學生約二百五十人、柬埔寨小學校長、柬埔寨工程師、NTTI 學生、柬埔寨承建商、英華書院師生三十五人、香港大學專業進修學院建築學系師生十八人

TIMELINE 🕐

2020
在磅士卑興建兩個教學亭、一間課室

2019
在 Krong Svay Rieng 興建一間青少年英語學校及操場設施

2018
在磅士卑（Kampong Speu）省烏棟縣（Odongk）興建一個擁有一間課室、一個洗手間及操場設施的校舍

在香港及國際上屢獲嘉許

IDEA 曾在香港獲得不同專業嘉許，包括：香港建築師學會二○一○年青年建築師基金得獎項目；二○一一年香港義務工作發展局的傑出義工獎；二○一七年，香港建築師學會亦推薦以 IDEA 項目代表香港，參與國際建築師學會聯盟（Union of International Architects）獎項競逐。

而在二○一五年，IDEA 在柬埔寨的建校項目獲聯合國義工項目（United Nations Volunteers）嘉許，被選為全球五百個項目之一，表揚其以義務工作推動千禧發展目標，以消除貧窮。另外，IDEA 也分別於二○一○、二○一一、二○一二、二○一六及二○一九年獲柬埔寨多個省份及城市嘉許，表揚其以參與式設計在當地興建了多達十五間大大小小的鄉村學校，不單建設校舍，令每年有多達上千孩子能夠上學，更讓孩子有參與設計的機會，表達他們對理想學校的想像。

INFO·BOX

柬埔寨村落
校舍建校項目
（十五間幼稚園）

時期	二○○九至二○二○年
地點	柬埔寨 Kampong Speu 省及 Kampot 省的十條村落
合作機構	柬埔寨社福機構 Cambodian Children's Advocacy Foundation Organisation（CCAFO）、香港英華書院、香港大學專業進修學院建築學系
支持機構	香港建築師學會、香港明愛啟幼幼兒學校、香港童軍總會
設計團隊	IDEA 柬埔寨項目設計團隊：尹家詠（Pam）、王建明（Robert）、陳漢霖（Eddie）、陳樂齡（Gloria）、楊子宜（Anna）、潘盛修（Eddie）、余啟昌（Andrew）、蘇梓維（Abbie）、張子端（Cherry）、李嘉琪（Angela）及各義工
其他參與者	柬埔寨的孩子、村校校長及老師、IDEA 項目義工、CCAFO 代表、香港英華書院的校長、老師及學生、香港大學專業進修學院建築學系的老師及學生

主題式設計
校園變身大
型探險樂園

Information

以故事為設計主題的校園及教室

二〇一四年，IDEA 團隊首次以原創故事為基礎，將整個校舍空間轉化為故事的實體場景，並加入相關的教育和設計元素，增加對兒童的吸引力，鼓勵他們參與。通過參與式設計工作坊，團隊可以與兒童共同完成各個場景的設計及製作，譬如粉刷牆面、製作道具、佈置場景等。

主題式設計（Theme-based Design）的方式構思校舍。當年參與構思的義工張可楣（May）和楊子宜（Anna）均指，採用了這個新模式後，當地兒童和義工的參與度都大大提升了。

主題式設計以 IDEA 團隊構思的

由於很多義工沒有幼兒教育經驗，團隊邀請了明愛啟幼幼兒學校和香港童軍總會合作，讓義工嘗試摸索和感受幼兒的需要。義工們分為不同組別，每組義工負責一個有關的道具，與兒童一起製作與場景有關的道具，與兒童一起製作與場景一起，成為完整的故事。最後，他們一起探索整個歷險故事。孩子樂在其中之餘，也能體驗自己的設計成果。後來他們更畫了心意卡贈送給義工。

126

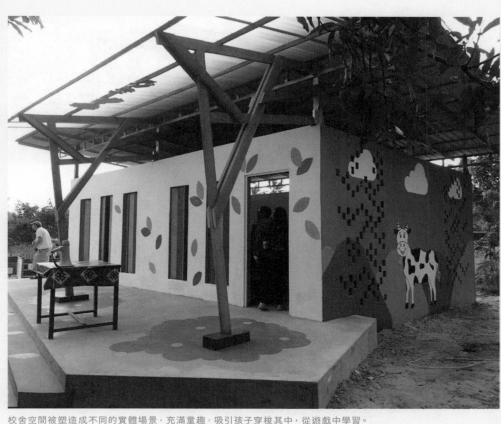

校舍空間被塑造成不同的實體場景，充滿童趣，吸引孩子穿梭其中，從遊戲中學習。

實踐主題式設計的首年，其中一個故事是關於尋找迷路乳牛 Ko Ko Mui。校舍設計以 Ko Ko Mui 作為中心，設施如操場、草地、教學亭等被塑造成不同的場景，如森林、迷宮、農圃、牛棚等，孩子需要穿梭其中，破解各種難題，如數學題、配對英文生字、辨認顏色和聲音等，以獲得 Ko Ko Mui 蹤跡的線索，就像是探險一般，充滿趣味。

團隊一直強調設計需要考慮幼童成長階段必須的教育元素，譬如二至六歲的學齡前兒童相當依靠身體去探索和認識世界，因此增添訓練其大小肌肉、認知能力、語言能力（包括理解和表達能力）和五感的元素尤其重要。May 舉出例子：「例如以汽水罐模仿鈴鐺聲音、讓孩子跳顏色石頭等各方面的刺激，對於訓練他們的五感和肌肉都很有幫助。」

新校舍不只是建築物，更能讓孩子從中學習，更加喜歡上學。

● 讓孩子愛上校園

主題式設計加強了校舍元素的連貫性，也更有趣味。Anna 最難忘的一幕，是校舍開幕當日，一群孩子興奮地衝進校園玩耍。「那給我帶來極大震撼，校舍不只是建築物或藝術品，而是真的可以讓孩子從中學習，更加喜歡上學。」另外，團隊也製作了故事繪本，讓 Ko Ko Mui 的故事繼續傳播。後來她聽說，兒童會不時請求老師跟他們講故事。

這個模式也大大提升了義工的參與度和投入感。Anna 憶述，在採取主題式設計之前，對於沒有設計或建築相關背景的人來說，面對參與式設計都會感到躊躇。「一講到抽象的設計概念，大家就會呆望着建築師，因為沒有相關知識，所以無法開口。但採用主題式設計後，大家可以實在地

想像、講述自己心目中的故事，就像大家有了共同的語言，也能更確切感受到自己參與了設計。」May 也認同，所有人在討論過程中都可以有貢獻：「沒有設計背景的人也可以構思故事或教育元素，每個人都可找到發揮自己長處的角色。」

FINDING KO KO MUI

團隊還為 Ko Ko Mui 製作了故事繪本，讓牠的故事繼續傳播。

128

IDEA 義工感言

參與活動──
IDEA 學校名牌工作坊

二○一○年

設計師：蘇梓維（Abbie So）

我參加的是創作 IDEA 學校名牌的工作坊。在學校落成的同時，我們希望讓孩子透過創作增加對學校的歸屬感。活動邀請了當地學童，以及來自不同年齡、性別、背景的參加者共同創造。先把英文字母 IDEA 遮蓋着，再請參加者在畫布上用塑膠彩印上掌印，最後拿走遮蓋英文字的膠紙，讓 IDEA 呈現出來。手掌象徵着攜手共建，人人都能運用他們的雙手來參與設計，不需要任何創作技巧或經驗。

孩子對活動感到好奇，反應很踴躍，來接他們放學的家長，以及學校的老師、義工、住在附近的村民皆共同參與，以簡單直接的步驟打破語言界限。有孩子在學校開幕日時，指向學校名牌上某一個掌印，並展現滿足的笑容，似乎學校名牌上的掌印也延續了他和學校的聯繫。

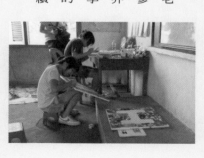

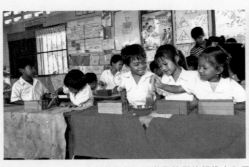

團隊希望建造孩子夢想的學校，以激發他們的想像力和反思。

● 參與項目——
粉飾校園牆身的設計工作坊

二〇一一年

設計師：李嘉琪（Angela Lee）

IDEA 團隊的使命是設計和建造學校，以改善當地的學習環境並賦權予當地社區。由建築師、工程師、設計師和心理學家組成的團隊在初步參觀當地期間，與當地人交流後，提出了不同的學校設計方案供當地人投票選擇。他們表示需要一個有兩座獨立建築的校園，團隊以此制定了項目的總體佈局，以供他們批准。

團隊又為即將使用校舍的學生組織了不同的設計工作坊，製作各種裝飾，以粉飾建築物的外牆和內部空間。這是一次緊湊但極富意義的經歷，由於設計涉及大量參與式繪畫和手工藝品製作，並要在一周內完成，

是很大的挑戰。然而，時間的限制並沒有令團隊卻步，相反，每個人都在盡最大努力確保參與式工作坊的想法能最終呈現在學校的設計中。

我們希望建立讓學生有歸屬感的學校。「你夢想的學校是怎樣的？」是這些設計工作坊的核心理念之一。設計工作坊引入了夢想和記憶等關鍵概念，以激發學生的想像力和反思。我們又製作了紀念牆，將一些材料如畫板等作為裝飾元素，展示在牆身立面上，提醒學生他們曾經參與這個項目。學校開幕當天，當孩子看到自己的畫板時，都感到特別興奮；他們也跑到由回收材料所建造的操場，嘗試不同的遊樂設施。團隊對設計結果非常滿意。

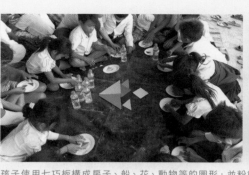

孩子使用七巧板構成房子、船、花、動物等的圖形，並粉飾課室內牆。

● 參與活動──
七巧板工作坊
二〇一五年

升級改造工作坊
二〇一六年

設計師：余啟昌（Andrew Yu）

在二〇一五年，我們通過展示不同物體的圖像，鼓勵孩子使用七巧板構成各種幾何形狀，組成房子、船、花、動物等的圖形。七巧板設在與數學主題相關的課室裏，貼在具有磁性的牆壁上，將牆壁變成了遊戲板，鼓勵孩子以幾何形狀組合各種物體。而到了二〇一六年，我們觀察到，當地社區居民經常直接在空地上焚燒垃圾。為了培養孩子的回收習慣，引入垃圾分類、升級回收的理念和減少垃圾的方法，我們為孩子提供回收材料進行練習。他們用廁紙筒和反光紙製作萬花筒，再以回收材料填充，創造出理想的視覺效果，還可以將其帶回家與家人分享升級改造的想法。此外，我們又帶着他們一起用回收材料創造數字、字母和他們最喜歡的動物，裝飾六角形軟木板。

IDEA 項目給不同背景的義工提供機會，讓他們得以在發展中國家協作及參與，為當地人締造更好的生活及學習環境。從落實至執行設計意念，參與者都能作出貢獻，建構以學生為本的協作設計校園。義工團在籌備互動工作坊時需要準備材料，並邀請老師和兒童圍繞與他們的學習和生活環境有關的教育主題來創作藝術品。這些藝術品融入了學習環境，不會被靜止地安放在教室裏，而能成為動態的、不斷演化的教材，變成兒童學習過程的一部份。

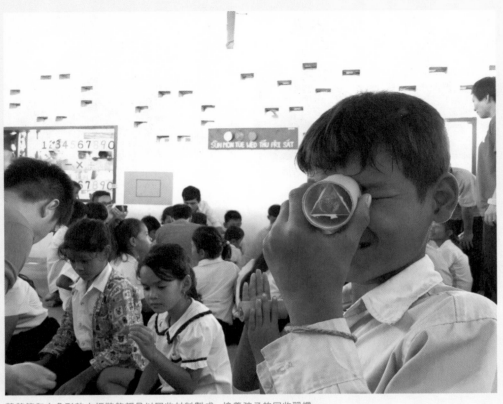

萬花筒和六角形軟木板裝飾都是以回收材料製成，培養孩子的回收習慣。

我們把軟木板放在六角形窗戶的牆上，可以不時更換。

參加兩個工作坊的孩子都很興奮——他們用雙手製作圖畫，苦苦思索七巧板的大小、方向、顏色和創作順序，通過反覆試驗，才創作出自己滿意的構圖並向義工團隊展示；他們利用萬花筒來觀察新校園、同學和義工團。從與學生和老師的互動中，可以看到他們對不同於傳統學校的新課室有着很高期望。我們為孩子設計，又與孩子一起設計，不能也不應該規定教師和孩子如何使用空間，而是為空間提供必要的設計框架，並允許靈活和互動的教學配置。我們相信，將參與者的想法融入學習空間，可以增加他們對學校的歸屬感，創造可持續的學習環境。

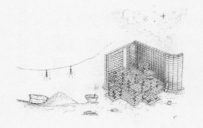
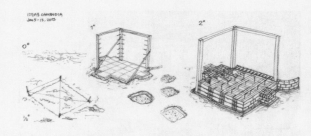

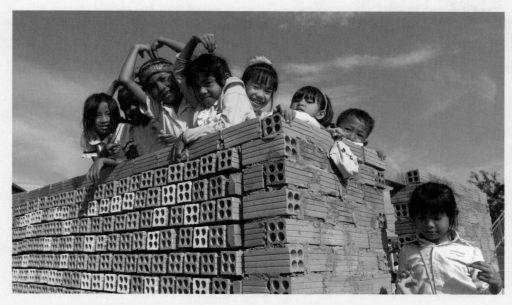

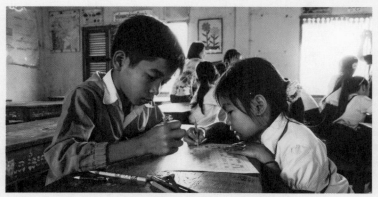

與孩子一起，通過填色比賽創作出操場紅磚玩樂設施的設計藍圖。

參與活動——
填色比賽工作坊
二〇一二年
設計師：張子端（Cherry Cheung）

Information

打破傳統
校舍想像
圓形廣場設計
增凝聚力

在二〇一五至二〇一七年間，IDEA 完成了歷年來最大型的建校項目。

學校，可以不只是學校，更是人與人之間連繫互動的地方。

由二〇一五至二〇一七年，IDEA 團隊進行了歷年來最大型的建校項目——一個大型校園，包括四座學前教育和小學校舍、一個教學亭、一個衛生設施，以及操場設施，包括小型足球場、小型籃球場、鞦韆、車輪繩網陣。而校園最特別之處，是採用了圓形廣場的設計。

校園位於柬埔寨南部地區 Chum Kiri，佔地約一萬一千平方米，跟其他 IDEA 柬埔寨項目相比，足足大了三四倍，可容納二百多名學生。經當地非政府組織 The Cambodian Children's Advocacy Foundation Organization（CCAFO）與地區政府協商後，後者答允批出土地使用權，並且批

准團隊可以不用跟隨傳統校舍的標準來建造校園，因而促成了全省唯一一個圓形校園的誕生。

一般而言，由柬埔寨政府資助的學校需要依循嚴格的建築標準：小學至初中學校的課室，大小規定在七米乘八米，可容納三十五至四十五名學生，樣式千篇一律——沒有粉飾的長方形校舍了無生氣，也沒有電力供應；按照標準興建的課室，其窗口設在左右兩個對邊，另外兩個對邊都是牆壁，假若校舍不是東西座向，自然採光奇差；窗口是固定百葉窗的設計，不利通風，有時老師還會因應上課情況關上部份窗戶，當地有着炎熱的亞熱帶氣候，沒有充足通風與採光的學習環境並不理想。

而 IDEA 所興建的校舍，在

134

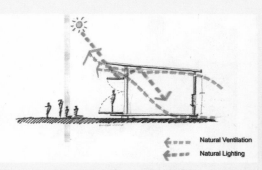

Natural Ventilation
Natural Lighting

團隊完成設計後，要向當地 NGO 和村民講解，讓更多當地人參與項目。圖為 IDEA 義工建築師劉偉基所繪的草圖。

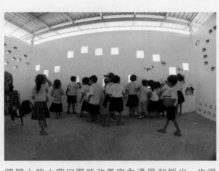

牆壁上的小窗口既能改善室內通風和採光，也很有設計感。

設計上考慮了當地環境等各方面因素，如陽光照射的方向、風向等，又在屋頂與牆壁之間留有縫隙、牆壁以扇形窗口代替等方法，改善通風和採光；為應對雨季水浸的風險，團隊也為建築物加上地台等。至於使用圓形廣場設計是基於怎樣的考慮呢？IDEA建築師義工陳樂齡（Gloria）指，四座校舍、一個教學亭和一個衛生設施圍繞着中間的廣場（也是集會時升旗的位置），可營造空間向心的凝聚力，在設施分散和人群流動的情況下，空間使用者可對整個環境瞭如指掌，令課室內外有更流暢的連繫。

建造工程分為兩個階段：首階段於二〇一五年實行，興建兩座校舍、一個教學亭和一個衛生設施；次階段於二〇一六年實行，建造餘下建築和跟進校舍的維修、改造。義工團隊在正式出發前往柬埔寨前，需要先在香港參與連續九個星期的工作坊，內容包括：商議校舍建築設計、構思主題式設計的故事內容和為當地兒童準備的參與式設計工作坊，以及參加水泥、木工、鬆油等的訓練班。然後團隊核心成員先前往柬埔寨作前期準備（Pre-Trip），像是進行實地視察，並向當地 NGO 和村民講解其建築模型，希望藉此機會讓更多當地人參與。其後成員帶着收集的意見回香港作最後修改。整個過程，團隊義工參與和花費心力的程度均絕非一般義工服務團可比擬，正因為有這樣的付出，他們所收穫的種種經歷才更刻骨銘心。

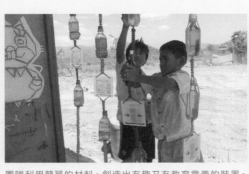
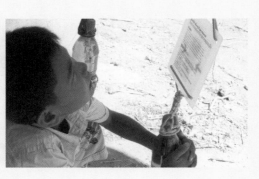

團隊利用簡單的材料，創造出有趣又有教育意義的裝置。

● 提早一小時上學享用設施

項目沿用二〇一四年首次提出的主題式設計（Theme-based Design）塑造故事場景。故事講述白雪公主和王子快快樂樂地生活下去之後，七個小矮人退役了，化身成動物的形態，巫婆因妒忌公主與王子的美好結局，以龍捲風把七隻動物吹到黑森林的蘑菇村裏。這個村落因受到詛咒而腐爛，生出惡臭，七隻動物要集齊四大元素：水、泥土、陽光和空氣，拯救蘑菇村。

義工根據四大元素設計四座建築物，又在設計中加入教育元素，包括水和科學、陽光和運動、泥土和數學，以及空氣和音樂，同時帶出品德教育。例如在設計衛生設施時，場景描述獅子和松鼠互相合作，鼓起勇氣潛入水底獲取寶物，拯救腐爛的蘋果

樹；有關科學的元素，則有以水樽造成的浮沉粒子，分析密度、氣壓和浮沉的關係。對孩子來說，這些設計既有趣又有教育意義。

而在校舍投入使用後，Gloria表示，持續跟進也能配合用家的不同需要。舉個例子，原先課室供小學生使用，教學亭讓幼童使用，但是可愛活潑的校園吸引了很多孩子上學，隨着報讀人數愈來愈多，原先不設牆壁的教學亭也需要改成有牆壁的課室，以及加入儲物空間等。從事銀行業的義工潘盛修（Eddie）說：「後來 CCAFO 表示，有些孩子會提早一小時回到學校使用那些設施並玩耍，令我留下深刻印象，因為香港的孩子不到最後一秒都不會上學去。」

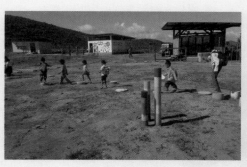
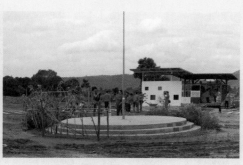

新校園落成後，吸引了愈來愈多孩子前去上學。　　校園內各個建築物各有特色，但都圍繞着中間的廣場。

● 破格共享設計讓居民受惠

每間課室或教學亭都是由孩子、義工及老師共同創作的，他們各有一個獨特的故事，老師在教學時，會向孩子講述建築及蘑菇村的故事，孩子覺得有趣，就有上學的意欲。

項目的整體規劃還有第三、第四期，以圓形廣場為設計概念繼續推展，直到當地有足夠的適齡兒童時，IDEA 會繼續籌組建校義工開展下一期項目。將來第三期會興建兩至三間課室，第四期更有可能設計並建造義工宿舍，供外國義工在校內居住、進行義教，提升學校的教學質素。團隊期望這間以學生為本、有創意故事及圓形廣場的校園能吸引更多孩子上學，也吸引外國義工前來，以知識改變孩子的命運。

雖說學校是學生上課的地方，但項目的受惠者卻絕對不只是學生，還有當地居民。像是洗手間內有一個儲水缸儲存雨水，讓學生如廁後洗手和沖廁，但是原來住在附近的居民也會來取水使用。IDEA 的柬埔寨項目有固定合作的承辦商和工程師，平常只會建造標準校舍的他們一度無法接受這類破格設計。從事品牌設計的義工尹家詠（Pam）說：「初時他們不明白為何我們要這樣設計，普普通通地砌磚就好了，為何要開那麼多孔洞？後來他們就理解了。這就像是在耕種，將我們的知識和資源持續與他們分享，然後在他們心中生根發芽。我覺得這樣的發展才是可以持續下去的。」

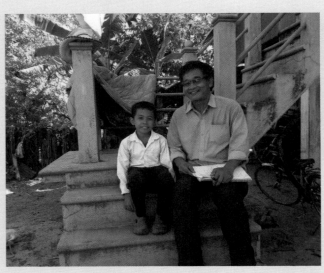

Rith 希望可以在柬埔寨的每條村落都建一間學前學校，讓幼童不必長途跋涉到其他地方接受教育。

以鄉村為本的幼兒教育

柬埔寨兒童機構創辦人的深耕細作

要在一個地方持續不斷地深耕細作，關鍵之一，是要在當地找到值得信賴的非政府組織。

作為 IDEA 過去十四年柬埔寨項目的合作夥伴，The Cambodian Children's Advocacy Foundation Organization（CCAFO）的協調者角色相當重要。

自二〇〇六年成立以來，CCAFO 一直致力於促進以鄉村為本的幼兒教育和青少年英語教育，希望藉此從根本減緩農村貧窮問題。

CCAFO 的首要任務，是確保農村裏三至五歲幼童盡可能接受學前教育。在柬埔寨，學前教育並非強制性的，而且沒有政府資助，很多鄉村家庭或因不重視，或因負擔不起費用而不讓孩子接受學前教育。另一方面，CCAFO 又為七至十五歲

138

青少年提供免費英語教育。團隊會在村落物色適合興建學前教育和英語學校的地方，然後對外籌集資金興建校舍。

創辦人 Hing Channarith (Rith) 對於兒童教育十分執着，全因他的自身經歷，讓他深切體會到失學是一件多麼令人痛心的事。Rith 生於一九六二年，八歲時遇上柬埔寨內戰而失去上學機會。至內戰結束，原以為有機會重返校園，卻遇上柬埔寨共產黨書記波布（Pol Pot）掌權，在任內推行血腥的赤柬大屠殺，導致大規模饑荒和人口死亡。在這樣嚴峻的環境下，生存已成問題，更別要說學習。

在波布政權被推翻後，Rith 熱切地渴望繼續學習，可惜苦無機會，只能一邊自學，一邊在地區政府工作。後來他任職記者、私人公司，又加入了聯合國維持和平行動（UN Peacekeeping）和美國地雷受害者組織。二○○五年，他終於得償所願，完成法律學位，後來成立 CCAFO。

學前教育提升學習能力

對 Rith 來說，學前教育是兒童教育中最重要的一環，甚至會影響孩子日後的學習能力。「在學前教育中，孩子不需要學習太多，可能只學基本的字母、數字、方向，以及日常自理能力便足夠了，我們希望他們可以開心健康享受群體生活。儘管如此，我們發現曾接受學前教育的學生在升讀小學後會更主動學習，進度更良好，而未曾接受學前教育的學生，學習進度緩慢，亦更容易留級，換句話說，學前教育可以確保孩子有能力接受政府規定的教育課程，同時減低他們留級甚至輟學的機會。」

他所推行的學前教育以鄉村為本，希望可以在柬埔寨每條村落裏都建一間學前學校，讓幼童不必長途跋涉到城市接受教育。然而無奈的是，在村落裏很難找到合適的校舍位置，亦因為資源問題，這些「學校」相當簡陋，缺乏正規而可持續的場所。二○○七年，Rith 透過朋友認識了王建明（Robert），得知對方有意在當地為幼童教育出一分力，雙方一拍即合，繼而展開合作。

Rith 在項目中擔任重要的協調者角色，直接促進了 IDEA 團隊和村民交流意見，因為他是當地唯一能說流利英語的人。當團隊完成校舍的設計草圖，Rith 會拿着草圖向村民解釋，並諮詢他們的意見，只有得到村民同意，項目才可以繼續。但這一環節難度甚高，原因是村民早已經習慣了政府校舍千篇一律的設計，一時間無法接受 IDEA 的新設計。舉個例子，若在屋頂與牆壁之間留有罅隙，作為採光和通風之用，村民便會疑惑，在雨季會否滲雨漏水？Rith 需要向村民逐一解釋。

「我需要明白雙方的想法，也需要理解設計，那麼我才可以向村民解釋，為甚麼我們要做與政府學校不同的設計，為何這樣做通風、採光會比較好，為何互動式、色彩繽紛的設計會產生更好的學習氛圍，讓幼童更愉快地上學等。這是最困難的部份，因為村民不太在乎通風採光，也不在乎校舍環境。不過幸好當我們詳細說明後，他們都認為是十分有趣，適合幼童學習及使用。」Rith 說。當校舍建好後，村民讚不絕口，認為學校涼快舒適、光線充沛，也更願意送孩子來上學了。

● 不用上課也來學校

在校園興建的過程中，村裏的孩子也參與了校舍設計上，這也令他們們更愛上學了。Rith 說：「我們過往進行了很多項目，但從來沒試過像和 IDEA 合作的項目一樣，邀請孩子參與其中。你知道嗎，很多孩子不覺得有必要上學前學校，學習的話等到六歲再上小學就好了。可是當義工和他們一起完成設計校舍後，他們變得非常開心，很享受舒適的學習環境，會說：『這是我們的學校，我們的設計。』甚至在周末日和假期等沒有課堂的日子，也會回學校玩耍。」

校園興建項目令 Rith 獲益不少，之後推行其他項目時，也採用了參與式設計的模式。

140

當學生與校舍建立了連繫，便能產生無可替代的歸屬感。「捐款人往往只是捐錢聘用本地承建商興建學校，再於開幕時現身一下便走了。IDEA團隊當然也會找本地承建商，但同時義工會與本地社區攜手合作完成項目，建立一種共同學習的文化──孩子、村民和義工互相分享、交流意念，

校舍建好後，村民都很喜歡，也更願意送孩子來上學了。

那麼村民和孩子就會覺得自己擁有這個空間，並因此而珍惜自己所做的一切。」有一天他走在街上，一位以前的學生與他打招呼。「他說很高興看到我，他現在已經是高中學生了，他還記得我們以前的互動時光。」Rith笑着說，想來那是多麼溫馨的場面。

即使這些校舍是非強制性上學的學前學校，亦得到了政府認可。校舍落成後數年，一些處於官地的校舍獲當地教育部門認可為「符合政府校舍標準」的建築，從而被政府接管，現有師資的薪酬和培訓也轉為由政府負責。Rith樂見這些成果，更希望所有校舍能全面交由政府接管。

參與式設計的模式，對Rith自身也帶來了不少影響，以致他在日後推行其他項目時，都採用了類似的方式。「我理解了何謂設計，例如課室設計一定與環境、採光、通風有關。有了這些概念，我就可以向捐款者解釋，他們的款項會用來做甚麼。後來當我們與柬埔寨慈善機構合作，也參考了參與式設計模式，讓義工與學生一起動手做設計。」

傳承服務社會信念

校長率學生建校體會協商精神

二〇一八年適逢英華書院建校二百周年，校方以「承傳使命 皕載自強」為主題，舉辦一系列慶祝活動，重點回顧校祖馬禮遜牧師（Robert Morrison）的建校初衷。時任校長鄭鈞傑希望藉此機會，將服務社會的信念傳承至下一代。「我想，校慶不應該只是放煙花、切蛋糕，更應該重溫我們的教育使命。」鄭鈞傑說道。於是他聯絡了英華書院校友、IDEA 創辦人王建明（Robert），為英華書院的學生籌辦柬埔寨服務學習團（Service Learning Trip），到偏遠村落為貧窮學生興建學校。

早於十九世紀開端，首位來華傳教的英國基督教教士馬禮遜牧師，便在馬六甲成立了英華書院。傳統名校一向予人只着重學術成績、課外活動的精神。傳統名校一向予人只着重學術成績、課外活動書院歡迎任何出身的孩子就讀，因此不乏草根階層

的學生。馬禮遜牧師認為，人生而平等，希望可以無條件地將基督精神和西方知識傳授給下一代，尤其要為弱勢社群服務。當時華人世界相當排斥外國人傳教，加上語言不通，令馬禮遜牧師遭遇極大困難，但他本着對基督的委身和承擔，為教育、翻譯和出版《聖經》作出極大貢獻，廣為後世傳頌。

理所當然地，英華書院亦繼承了校祖馬禮遜牧師的精神。

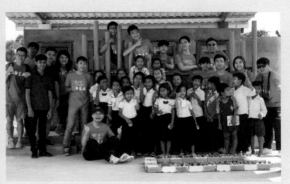

束埔寨服務學習團讓英華師生得以深刻體會弱勢社群的需要，傳承服務社會的信念。

獎項的感覺，但鄭鈞傑認為，為學生的生命帶來了甚麼影響，才是一間學校要考慮的事情，英華書院希望培育學生成為有使命感的人，以自己的專業去服務社會不同階層。「Try not to become a man of success but rather try to become a man of value.（與其追名逐利，不如追尋價值）。」

他引用了科學家愛恩斯坦的名言。「有時我會在家長會中問家長，大家都望子成龍、追求卓越，是為了甚麼呢？正正是要為社會帶來更大的影響和貢獻，這比起普通地追求成功更重要，而我認為在中學階段已經要向學生灌輸這個概念。」

現時教育界積極推動 STEM 教育，其實都是透過創新和科技來解決問題，而在此之前，學生首要培養查覺別人需要的觸覺，這就需要依靠不同的

體驗來獲得。「STEM 的精髓不是運用科技去做產品，而是解決人們背後的問題，當你能夠看見別人的問題，這樣做出來的東西就有更大意義了。」

● 與學生一齊粉刷廁所

在柬埔寨項目中，英華團隊的任務是為當地學生興建英語學校課室、操場和廁所，以及籌辦參與式設計工作坊，師生要一同構思校舍設計，並由學生一手包辦畫設計圖和砌建築模型的工作。構思時既要考慮當地天氣、文化、受眾特徵，又要考慮建築學上的可持續性，如通風、採光問題，並要兼顧預算控制，尤其處身陌生國度，更要面臨自身的生活和文化衝擊，對於這群中三至中五學生來說無疑是全新挑戰。「過往學校也有不同的本地服務學習體驗，但始終是自己『地頭』，容易忽略很多事情。一旦到了海外，學生便要重新適應當地生活和文化，更能體會當地人的困難和需要。」

抵達工地現場，老師與學生無分彼此，互相合作，即使是校長也不能空手發號司令，要與學生一起粉刷廁所。鄭鈞傑笑說：「平時在家裏也有幫忙油漆，但做義

義工體驗讓一群大男孩迅速成長，學會主動動手，學會凡事多考慮，也學會謙卑。

工具的是第一次！我覺得與學生共同參與、經歷一件有意義的事情很重要，老師的同行可以為學生提供人生經驗和意見，亦可作出合適的指引和教導，這一輩的年輕人值得我們花更多心思來陪他們一起經歷。」他又笑着說，「那一刻我也不覺得自己是校長，反而是他們的一份子。戴着工作帽的我看上去也很年輕呀，不是嗎？」

這些在香港並不會踏入工地的小男生，來到柬埔寨施工現場，自然是烏龍百出，先是買錯材料要臨時修改設計，後又因不懂得運用工具而遲遲不敢動手，一群男生面對電鋸不知所措，總是嬉笑着你推我讓，在旁的女老師看到了，她二話不說捲起衣袖，一把接過電鋸豪邁地幹活，讓這群男生瞪目結舌。第二天，學生不敢猶豫，紛紛主動拿起電鋸動手，彷彿一夜間長大了不少。

鄭鈞傑覺得，這就是體驗式學習（Experiential Learning）的力量。「年輕人有傲氣，但面對平常接觸不到的陌生環境，會令他們學懂謙卑。學生由當初覺得頗有趣，到後來發現設計校舍原來有那麼多考慮，自己自信滿滿覺得一定可行的事，到最後卻行不通、撞了板，便會知道很多事情不是理所當然，也不是自己想像中那般簡單。這些人生體驗和經歷對於他們建立品格很有幫助。」

● 服務社會是一場接力賽

另一方面，鄭鈞傑認為，相比起一般單向式的義工服務，以參與式設計的方式與當地人一同從無到有去建立學校，是更難能可貴的高層次服務學習體驗。「參與式設計既有設計理念，背後意義更在於嘗試去聆聽受眾的需要，讓對方也有機會去表達和參與，大家共同協商，對於使用者來說更有歸屬感（Ownership），也會對成果更喜歡和珍惜。」

「臨走前，不少學生都捨不得地哭了，他們着急地問我會不會再來。我就知道，得啦。」鄭鈞傑回想起最後一天在柬埔寨的場景。

想再次回來，不只是因為依依不捨，更是一種委身的承諾。鄭鈞傑認為，服務學習團不應只做一次便算。「我們對當地的孩子有承擔，所以會思考怎樣把項目延續下去，幫助他們，不然我們只是在滿足自己。」

其後兩年，鄭鈞傑每年都會帶同一眾英華老師前往當地，提供教學和物資上的支援，包括修補校舍、與當地教師分享教學和行政管理方面的經驗，又帶同在港募集的十多部二手電腦、投影機等器材，為該校設立網上學習系統。鄭鈞傑認為，除了學生，老師也有這樣的經驗和感受，那麼他們將來就可以帶學生去體驗。英華與當地學校是協作關係，不是我們單方面去幫助他們，某程度上他們也幫助了我們，讓我們對可持續的服務學習有更深刻的體驗。」

一次柬埔寨服務團，串連了幾代「英華仔」對於傳承的信念。鄭鈞傑畢業於英華書院，大學畢業後即加入母校執教鞭，長達二十七年，至二○二一年離職。IDEA創辦人王建明同樣畢業於英華書院，甚有淵源的是，他正是鄭鈞傑的學生，在學時期曾籌劃內地農村服務團，造就他第一次踏上貧困地區的義工體驗。而在這次柬埔寨服務團中，有三位「英華仔」更立志要成為建築師。

鄭鈞傑說：「不論你做了多好的事情，若果無人接力做下去，只不過是片刻間有人得到幫助，但如果可以傳承，意義就大了。昔日的義工服務在他心中埋下了種子，後來他又藉着其專業去幫助其他人，想不到現在他又以校友身份帶師弟去柬埔寨做服務團。這份傳承的心很重要，學生未必很清楚自己的路，但帶着這份精神，無論將來做甚麼，他都會有心去服務社會。」

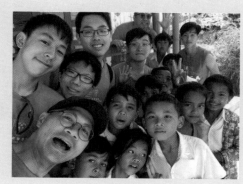

銘記於心的服務學習體驗

讓青年定下探索建築志向

在參與英華書院柬埔寨服務學習團的學生裏面，其中一位決定踏上建築之路的「英華仔」便是吳卓君（Tyler）。中四那年，他在好奇心驅使下，和幾個朋友報名參加了這個義工項目，原本只是想着「玩玩下」，沒料到最後卻成為了他人生重要的轉捩點。Tyler 現時正在英國著名建築學院 Manchester School of Architecture 修讀建築系課程。

學習團一開始已經不容易。Tyler 所屬組別負責設計衛生設施（Hygiene Booth），同時籌劃給當地兒童的設計工作坊，目標是教導孩子健康衛生概念以及英文生字。未出發前，團隊已經要像專業建築師般思考校舍的設計和畫圖，完成設計後便要

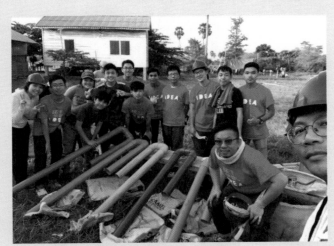

參與柬埔寨服務學習團令部份「英華仔」選擇以建築為未來發展路向，吳卓君便是其中一位。

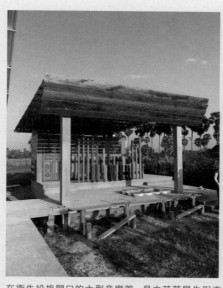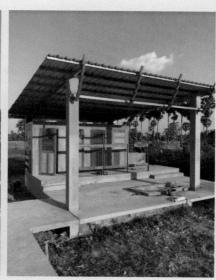

在衛生設施門口的大型音樂管，是由英華學生與柬埔寨孩子一起製作而成。

製作模型向當地校長和老師匯報，並要多次作出修改。

若是一般的設計項目，他們或可以隨心所欲地設計，但面對參與式設計項目，在設計上除了要實用美觀，他們更需要放下自我，仔細思考受眾的需要，以及如何吸引兒童參與與製作。由於與當地兒童有語言隔閡，他們便想到以音樂這種普世語言作為工作坊主題，於是在衛生設施門口出現了大型音樂管，這是團隊與孩子共同髹上顏色的成果。

「最初很擔心他們會不喜歡，之後看到他們反應熱烈，會很開心地敲出音樂，便安心了。其實真的要付出心思建立關係，你不可以期望教了他們學習，他們就會聽話跟從，反而要想辦法引起他們的注意，才能發展成互相聆聽的關係。」Tyler一臉認真地說。

147

● 從參與中獲得認可

當然也有過力所不及的時候。Tyler 曾想到購置塑膠樽和西米，用以製造計算洗手時間的漏斗，沒想到竟被同組的 IDEA 義工反對。原來當地村落貧窮，這些東西已經頗為「高級」，要是用作製造道具，當地人心裏肯定不好受，於是他們改為在入住旅館撿拾廢棄塑膠樽和塑膠珠子代替。至於製作小型排笛的塑膠管則是大班同學每天放學後去麥當勞的收穫，達到循環再用的效果。

Tyler 認為，當地兒童的參與相當重要，這樣就可以確保建築物和使用者的連繫更強。「參與式設計講求的是雙方互相尊重。使用者藉由參與過程，除了得到歸屬感，也會獲得被認可的感覺，這就像是建築物以設計者的名字來命名一樣，將來他們對整個經歷都會有美好的回憶。」

最後一天，大夥兒在校舍開幕禮上，以音樂管敲出《仙樂飄飄處處聞》（*The Sound Of Music*）的音樂，意味着這十天的建校項目正式迎來尾聲。臨別之際，一群熱血男生不禁落淚。原先不過抱着玩

要的心態前往，然後接連經歷嘔心瀝血地完成校舍設計、努力思考怎樣與當地孩子互動，再與他們建立關係和連結、親手打造大家心目中的校舍，這一點一滴的付出和收穫，所帶來的情感與體驗是無可比擬的。「我一輩子都會記得這項目。一方面，我第一次經歷從構思設計概念到看見實物出現在眼前，那種感覺很震撼。另一方面，人與人的連繫也是很珍貴的體驗，我亦真正體會到建築是關於人與建築物的連繫的道理。因為這個項目，我找到自己喜歡做的事，亦希望繼續探索建築這個領域，可以說，這個項目是我人生中很重要的里程碑。」

循環再造的計時小道具

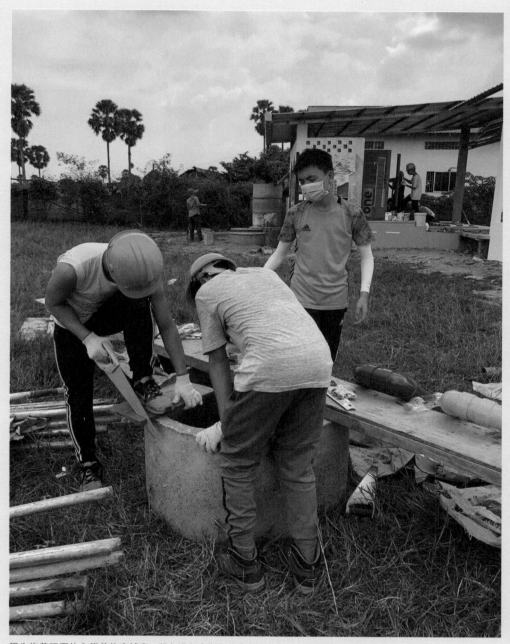

學生抱着玩耍的心態前往柬埔寨，卻在過程中漸漸學會付出，獲得珍貴而難忘的體驗。

Eddie 參與了 IDEA 柬埔寨項目後，重新思考作為建築師的價值，從而轉向教育道路。

將服務團納入課程

建築系主任冀學生領悟建築真諦

IDEA 自從成立以來，其項目已經改變了很多參與者的生命軌跡。曾任職香港大學專業進修學院（HKU SPACE）建築學系課程主任的陳漢霖（Eddie Chan），於二〇一三年首次參與 IDEA 柬埔寨項目後重拾建築初心，因而決定從則樓建築師轉投教育行業。二〇一九年，他將 IDEA 柬埔寨項目納入課程，帶同十四位建築系學生到當地興建青少年英語學校。他深信，透過參與式設計的體驗，可以讓學生更了解建築與人的關係。

Eddie 於建築學碩士畢業後，滿懷理想進入則樓。儘管工作順利，也備受器重，接手大型建屋項目，然而日復一日營營役役、身不由己的生活，讓他開始思考：建築所為何事？人與建築的關係為何？他甚至開始質疑自己作為建築師的價值。

二〇一三年，在偶然的機會下，Eddie 參與了 IDEA 柬埔寨項目，和組員一起負責興建教學亭。

他們從構思、分析各種元素，再結合成建築設計，並以模型向當地人展示和解釋，其後再飛抵當地為學童策劃參與式設計工作坊，雙方共同完成硬件和軟件部份。擁有不同背景的義工和學童互相補位，發揮自己的長處之餘，在思想上亦為對方帶來衝擊，這讓他深受感動：「項目最精彩的地方是，不只是建築師，所有人都可以是設計者。我覺得這個想法很重要，尤其是在城市中更應是這樣，因為人才是城市的用家，就算是公園裏的一張椅子，使用者也應該可以有自己的想法和參與設計。」

Eddie 還記得，團隊和學童一起做了生字牆，又在操場設置車輪繩網陣。其中有一面特別的透光牆，是團隊搭車時沿路撿拾廢棄玻璃樽造成的。因為當地沒有電力供應，玻璃樽可以增強儲物空間的光線。「有孩子通過玻璃樽窺看牆外，這個畫面對我的衝擊很大，就像他在探索這個世界。」他漸漸覺得，讓孩子看到自己的可能性和潛能，是十分重要的一件事。

孩子通過玻璃樽窺看牆外，就像在探索世界一樣，這一幕給 Eddie 帶來很大衝擊。

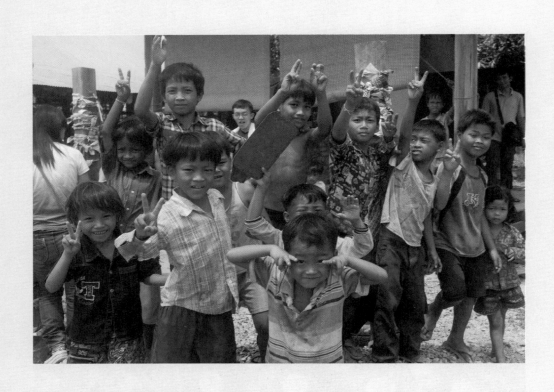

● 建築師要學懂聆聽

旅程結束，Eddie 回到則樓繼續工作，卻感到悵然若失：「建屋項目做出來的成品很好，但對我來說沒有成功感，我甚至覺得在這麼擠逼的環境下，不應該再建造房屋了，而應將空間還給附近的居民。」可以想像，當一個人懷疑自己的工作成果和價值時，是多麼令人痛苦。Eddie 曾經對建築有很大憧憬，但他慨嘆，在香港做建築設計的局限實在太大，在金錢掛帥下，所謂令人與城市變得更好頓成空話。「讀書時講設計概念，講建築為人服務、建立人與人的關係，但出來工作才發現是兩回事。我覺得建築物應該要有附加價值，設計也應該是平等的，可以讓大家一起去討論。我便開始思考，繼續在則樓工作是否就是我要追求的道路。」

二〇一六年，他決定轉換一個全新

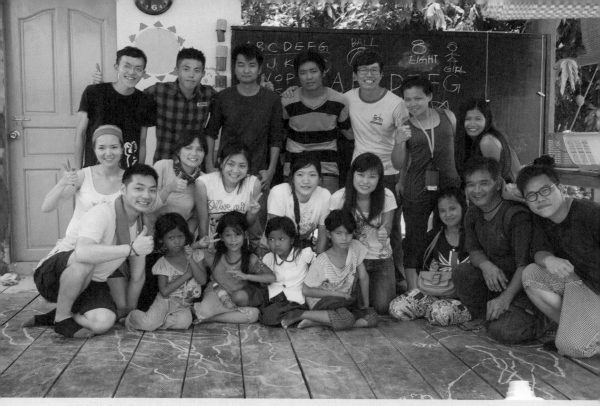

建築師的成功感來自甚麼？對 Eddie 來說，能透過建築為人服務，社會也會變得更好。

實踐一直以來學習的建築技巧和知識。

服務團列入課程，希望學生有機會深度根深蒂固，Eddie 將 IDEA 柬埔寨建校

後只會『離地』。」為了讓這種想法更

而不只是一味堅持自己的想法，不然最用者的核心需求，再將需求變成設計，

識，就有責任透過聆聽和觀察去掌握使

再為當地人做設計。「建築師掌握了知

生態多樣性、歷史文化、特質，然後

實地考察，充分研究和分析當地社區的

　　Eddie 構思的課程，強調學生要先

個社會的將來就可以很不一樣。」

建築不是為了賺錢，而是為人服務，這

們未畢業前已經產生了這樣的想法：做

法，每年都有大批學生畢業，如果在他

「我需要更多人和我一起實現建築的想

過建築為人帶來影響，於是轉行教書。

的環境，再次實現自己的初心——透

● 跟學生講現實世界

要在時間有限、缺乏準確信息的情況下完成完善的設計，讓不少學生手忙腳亂。

校方挑選了十四位一年級和二年級學生，項目一開始便要他們參與兩日一夜的宿營，從零開始體驗建築師的工作，令不少沒經驗的學生手忙腳亂。

柬埔寨方面提供的資料只有一張不合比例的平面圖，有太多不確定的資訊，學生既要做數據假設、估算偏差，又要學懂控制預算。而設計時最重要的一點，是學生需要有全面的規劃，思考在當地沒有電力的情況下通風和日照問題，考慮設計如何更貼合當地學童的需要。第一天晚上趕工做好設計後，第二天就要透過視像向柬埔寨CCAFO創辦人Rith報告。這群學生大概已提前感受到建築師的「亡命生涯」。

Eddie認為這對學生來說是非常好的經驗：「香港學生太手到擒來了，在香港做設計怎會沒有足夠資訊？怎會沒有電力？怎會需要思考如何設計才能令學生上課時不會太熱？這是很好的機會，用一個真實的項目，讓他們感受建築設計的實用性。尤其當預算有限，建築師更要清楚每做一個決定的原因，不可以為設計而設計。」

Eddie指出，學生對上課的態度也有轉變：「以前他們上課只為了考試，但現在他們知道，擁有這些知識可以如何令別人生活得更好，令當地學生得到接受教育的機會。」

團隊在設計時也會思考空間的延伸和多樣化，將來是否可以因應不同的教育用途而靈活改變。「建築物的不同立面有不同的概念，例如其中一個立面可讓孩子爬上車輪，另一個則掛滿了他們的畫作。我們認為學校本身處於多變的情況，設計應該隨着不同學生和課堂需要而有所轉變。做建築，不是建一間學校就夠了，而是透過設計令校園可以配合不同情況和不同的教學用途。」要達到這個目的，只有讓建築師和使用者建立關係，以及讓使用者參與部份設計，才能令空間產生更多可能。

154

「參與式設計的好處在於，用家會因為自己的貢獻而覺得自己參與了設計，從而產生歸屬感。他們不再需要逆來順受，不是你給我，我就只能要或不要，這等同沒有選擇。」這些項目固之然令柬埔寨用家受惠，同時對香港學生的成長也有幫助。

「香港學生在成長過程中，聽了太多旁人指手畫腳，甚麼應該做，甚麼不應該做，很難有空間去發掘自己的想法。但當他們得到一定程度的指導、信任和空間，就會慢慢發現自己的理念也可以對社區有很好的貢獻，幫助他們建立自信心。」

推而廣之，每一個人不論有否建築背景，其想法都是真實的，都應該受到尊重、有發揮空間，這是充權的重要。Eddie 也談到香港的建築生態：「在香港的建築系統中，使用者無法參與設計，設計就是由發展商、客戶去做一式一樣的建築，建築師不過是為服務於這目的而存在。但我認為建築設計一開始便應該讓用家參與，在日本和新加坡正在實踐一種叫做 Open Layout 的方向——建築師只是設計一套系統，用家可視乎自己需要而改變建築物。作為教師，我最希望做

到的就是讓學生通過考證和分析去認識不同的文化，透過觀察了解用家的需要，這樣他們才可以做出適合用家的設計，而不是自己完成一個設計後，放在一個地方，讓用家去用。」

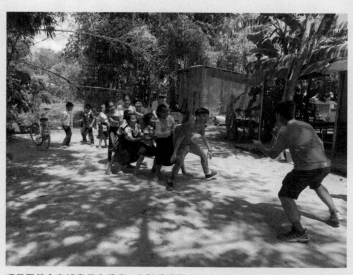

項目固然令柬埔寨用家受惠，也對香港學生的成長有所幫助，學會考慮使用者的需要。

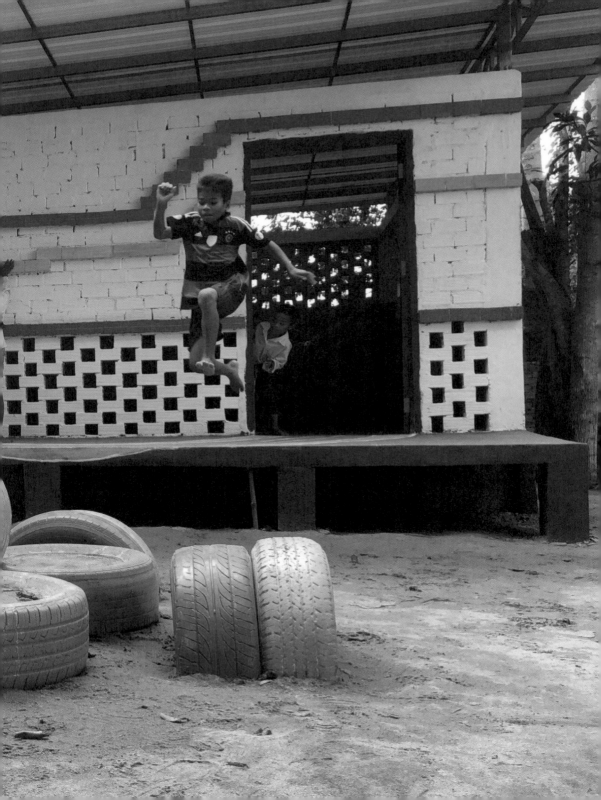

學校建築物的不同立面有不同的概念，能隨着學生和課堂需要而轉變。

Sopheap Chhuon 從小熱愛建築設計，卻礙於柬埔寨的刻板性別文化，使她的追夢之路走得相當辛苦。

擺脫性別枷鎖追逐建築夢

柬埔寨空姐與孩子一起重拾自信

穿上整齊的白色工作服，毫不猶豫地拿起電鑽，有板有眼地打孔鑽牆，大概任何人也想像不到，這位空姐居然是水電木工高手。來自柬埔寨的 Sopheap Chhuon 是 IDEA 柬埔寨項目的常客，她從小熱愛建築設計，尤其擅長裝修項目，水電木工基本上都難不到她，現時她更開創了自己的裝修事業，進軍美國市場。想當日，礙於當地刻板的性別文化，她這條追夢之路走得相當辛苦。

Sopheap 對於建築設計的熱愛始於小時候。她的父母誕下了五個女兒，父親雖然一直想要個男孩，可惜天意弄人，他便將 Sopheap 當成兒子般看待，每次做木工、水電、水泥等「男人的工作」時，便着她在旁幫忙遞上工具材料，久而久之，她

成為了父親的得力助手，也讓她萌生了將來成為建築師的夢想。

然而，自從父親不幸離世，母親便強烈反對她去做這些「男人的工作」，也不希望她繼續上學。

「我的母親是非常傳統的一代，她認為女孩子不應該讀太多書，將來嫁了人，就要留在家中做家庭主婦，不能再做甚麼『大事』。所以她從來不支持我讀書。」

Sopheap 的姐姐完成初中便輟學，然後結婚生子，走了一條「正常的路」。但 Sopheap 無法壓抑內心對於建築設計的執着。「那些設計的概念不斷在我內心滾動着。我想去了解更多，根本無法停止，只能不斷向前走。」她終究走出了一條不一樣的路。

她的家境貧窮，家裏負擔不起她上大學的費用，她在中學畢業後找了全職工作，同時為了實現進修的夢想，報讀私立大學夜間課程。「我曾經在街上撿垃圾，又幫人洗車。我的家人不斷罵我，覺得我瘋了，因為這不是正常女人會做的事──誰會這樣工作一整天？誰會這樣晚去上學？」在當時

木工、水電、水泥等一向被視為屬於「男人的工作」，Sopheap 卻堅信自己也能以這些技能闖出一片天。

的社會──說的不過是二十年前的柬埔寨，她甚至受到保守的性別文化桎梏──「你在晚上外出，不會有男人願意娶你，因為你不是端正的好女人。」

「當你走一條與別不同的路就會相當困難。但我必須捍衛我的夢想，而這也讓我的內心變得更加堅強。」Sopheap 堅決地說。

● 自學裝修建立事業

Sopheap 打造的家具

她抵受種種壓力，終於半工讀完成了課程。畢業後，Sopheap 一邊任職空姐，一邊嘗試創立自己的事業，透過上網自學裝修，孜孜不倦地增強自己的技能。後來，她開始租賃空置單位，自己親手裝修、製造家具，再以更高的價錢租出，賺取第一桶金。遇到不懂的東西，她會聘請專業人士處理，自己從中偷師學習，當完全掌握後就會親自上陣。

Sopheap 投入在裝修設計的世界裏，在逐步實踐夢想的過程中，得到前所未有的滿足感和成就感。「在你建造某些東西之前，腦海裏會浮現出一個意念，當你將這個意念轉化成現實，即使很微小也是成就。我在過程中建立了信心，令我相信只要肯花時間，自己一定做得到。」

因此，當她從朋友口中知道，IDEA 柬埔寨項目有從香港遠道而來的義工幫助當地孩子興建學校後，深受感動。「因為我年輕的時候，沒有人向我伸出援手、支持我上學，如今我很高興有人為孩子興建學校，給予他們學習的機會，這意味着有人願意給予孩子更好的將來。」

Sopheap 在項目中任翻譯，作為義工與當地

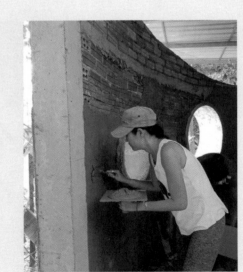

與此同時，她也能以建築技能為其他人作出極佳示範。

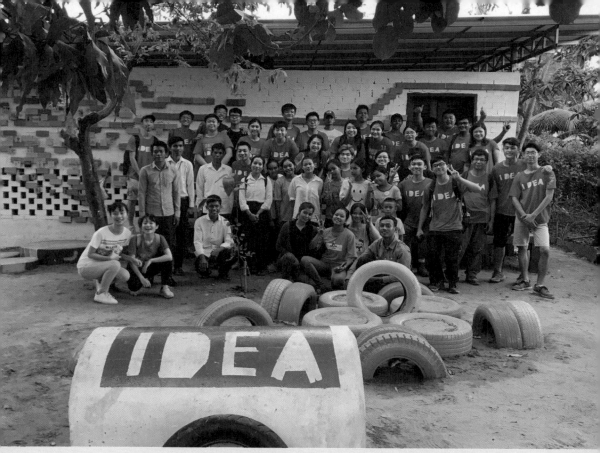

在 IDEA 柬埔寨項目中，Sopheap 是翻譯，是義工與當地工人的溝通橋樑。

工人的溝通橋樑，協調工程進行。另一方面，她的建築設計技能也發揮了極大作用，譬如她能穿着合適的安全設備，熟練地使用電鑽在牆上開洞，又或是用電鋸切割木頭，為其他人作出了極佳的示範。

項目過程並不順利，當時正值雨季，施工困難重重。Sopheap 解釋，由於水泥牆上的濕氣未散，水氣穿過油漆從裏面跑出來，第二天油漆便剝落了。因此她提議在油漆前先上一層底漆，由於底漆會吸收牆上的濕氣，於是便沒有再出現油漆剝落的情況。

Sopheap 的畫作

● 讓孩子學會相信自己

同行義工和學生從 Sopheap 身上學習了不少新技能，而對 Sopheap 來說，參加這個項目亦有所得著。「最大的得著是體會到分享的重要。以往我只是將知識和經驗應用於生意上，但這次我可以將它們活用於社區，便可以將知識一直傳授下去。而且，香港義工分享了他們的設計，也豐富了我的想像力。例如繪畫，一直以來我只是畫自然、動物、家庭之類的主題，然而他們會畫出『夢想』，讓我更加了解設計的力量。團隊打破國界藩籬和文化隔閡，為孩子的教育努力，是一件令人振奮的事情，因為與此同時，我們也在一起賦予自己力量。」她認為，參與式設計有一種力量，可以建立人與人之間的關係。

相比起個人在項目中的得著，她更念茲在茲的，是當地孩子的成長。她的成長經歷讓她深切體會到，「機會」是多麼難得。「你知道嗎？能夠參與這個項目，對柬埔寨的小孩

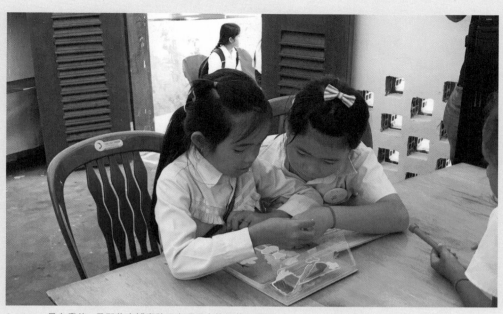

Sopheap 最在意的，是那些柬埔寨孩子在項目中的得着和體驗。

是很難得的，他們能夠親身體驗，並透過設計展現想法 ── 即使那是多麼微小的想法，一旦有機會實現，他們就能學會相信自己，繼續去追求更多夢想，建立他們的未來。」

現時 Sopheap 的生意如滾雪球般愈做愈大，除了在柬埔寨設立公司，更進軍美國，建立海外分公司，同樣以室內裝修為主。她計劃買下一整棟建築物重新設計，再分租或售賣出去，一步一步貼近她的建築師夢想。

那麼，母親看到她如今事業有成，是否改變了當初的想法呢？「哈哈，不完全是！她仍然希望我當全職家庭主婦，很不滿意我總是做『男人的工作』，但我不認為這些工作分了男女，只要我應付得來，我就可以勝任。正如有男性做髮型師一樣，女性也可以選擇自己的事業。」

「我總得要捍衛自己的夢想嘛！」她再一次笑說。

163

CASE STUDY 05

社區百繪集

以公眾的想像建構城市

人們每天營營役役的生活，匆忙走過不同街道，與他人擦身而過，錯失了很多好風光。抬頭一看，才發現社區早已面目全非。感到可惜之時，不妨停下腳步見證變遷。二〇一八年，香港建築中心與「油街實現」合辦「玩轉——互·社區百繪集」（PLAY to Inter-act－100 Drawings on Community）展覽，帶領公眾遊走於北角別具歷史價值的街道、建築，並拿起畫筆記錄城市百態，透過想像重現社區的魅力。

香港建築中心與「油街實現」於二〇一七年至二〇一九年間，以「玩轉『油』樂場」（PLAY to CHANGE）為主題，開展一系列展覽和活動，「社區百繪集」正是其中之一。展覽設計師為同是建築師的高浚明（Anthony）、曾偉俊（Aron）和梁皓晴（Rosalia），團隊希望將展覽塑造成開放式平台，以城市寫生作為公眾參與的方式，讓北角獨特的城市風貌與公眾互動，交織出實景和夢想的圖集。展覽的最終展品是公眾的畫作結集，可以說，公眾參與構成了展覽主體，而展覽空間則收集了人們對城市的記憶。

展覽共分為兩個部份，第一個部份是將油街展覽室改造成建築師和公眾一同參與的漸進式繪圖檔案室。展覽室的場地最初被空白的畫紙鋪滿，就如白盒子畫廊空間，當中放置了可作枱凳用的木頭手推車，讓觀眾拿起紙筆隨意描繪心目中的北角。畫紙經精心設計，上方留有空白位置，有些則帶有方格、點格或透視格輔助繪圖，下方印有一個詞語為畫作標題。團隊以「生活與社群」和「足跡與發展」為主題，準備了約一百個詞語，如人情味、海、轉

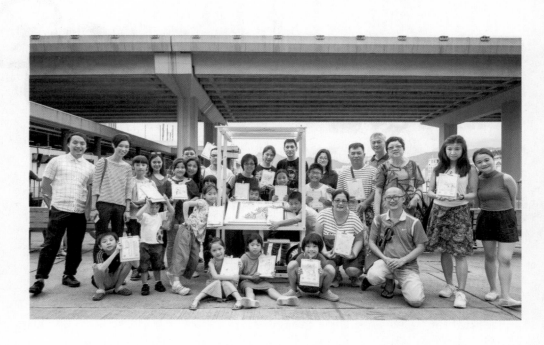

展覽的室內部份將油街展覽室改造成建築
師和公眾一同參與的漸進式繪圖檔案室

● 繪畫有助表達情感

第二個部份是寫生工作坊，團隊公開招募約三十多名公眾人士參加，有一家大小，也有年輕人、老年人，有北角街坊，也有即使並非住在北角，卻在成長過程中與北角結緣的人。在工作坊開始前，團隊會教導參與者基本的建築繪畫技

變、嘈吵、愛、家、行人、食物、現代、浪漫等，讓公眾有目標地發揮天馬行空的想像力，同時藉此反思自己對於空間的詮釋。Anthony說：「北角最有趣的地方，在於它正處於新舊交替最頻繁的時刻，許多豪宅相繼落成，同時不乏舊區老店，兩者共同存在，這種衝突是很有趣的，因此引發我們構思這兩大主題。」

巧，包括簡單的透視法、比例法，並解釋繪畫對建築師的重要性。

然後團隊帶領公眾遊走北角具象徵意義的地方，路線從油街實現開始，經過艇街、城市花園、春秧街街市、糖水道，再以北角碼頭為終點。為了加深參與者對這些地點的感受，團隊邀請了非政府組織綠腳丫作歷史文化導賞。過程中，團隊會推着木頭手推車作為繪圖板，一方面營造流動的寫生空間，另一方面也為活動增加了具標誌性的儀式感。

綠腳丫善於以引人入勝的方式講述歷史故事，大大增加了參與者的投入熱情，連孩子也十分專注，可以說，它在某程度上擔當了促進者的角色。參與者聽完故事後，會透過寫生表達對這些地點的想法。到達終點後，團隊邀請參與者分享畫作，當中記錄了北角人與人之間的互動、都市自然生態、舊商店老街坊等，即便同一主題亦生出了不同的想

作為繪圖師的小型手推車也跟着眾人於北角遊走，為活動增加更具標誌性的儀式感。

像。有人在「現代」和「未來」描繪一棟正在興建的豪宅外牆棚架；有人在「海」畫下北角碼頭的天橋和馬路，海只佔小部份；有人的「天空」佈滿了高樓大廈；有人印象中的「老友記」，總是孤身坐在花槽旁；有人的「街坊」，是日常街市的場景；有人的「人情味」，就存在於一豬肉檔內。

一般工作坊相當依賴參與者言語表達，Rosalia 認為，以繪畫作為媒介適合各年齡層人士，比起單靠對話更能達到深度討論的效果：「情感並非三言兩語就能說出口，相反繪畫普及程度較高，門檻更低，可以從中更深層次地看到一個人的內心世界，像『人情味』那樣抽象的東西便更容易畫出來。而畫作是否像真、漂亮並不重要，重要是他看到了甚麼。」Aron 認為，與其去改變實體物件，不如嘗試去改變他們對於既定空間的觀感，帶出另一個層次的理解。展覽一方面改變了參與者對北角的觀感，另一方面亦改變了展覽觀眾對北角的觀感。

以繪畫作為媒介，參與者發揮創意，表達他們對北角區內不同地點的觀感。

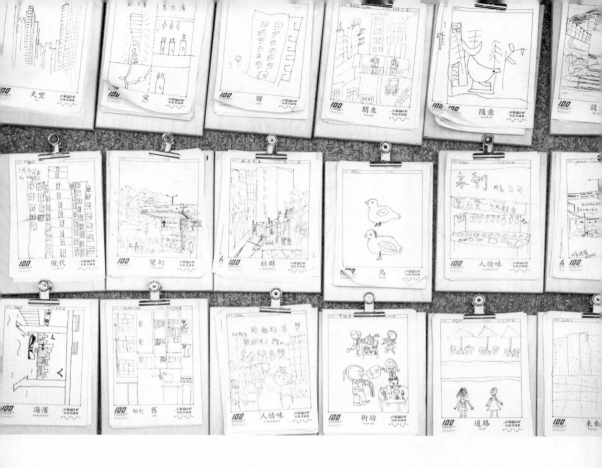

設計出參與的框架

與一般設計或建築項目不一樣，「社區百繪集」並沒有要解決的疑難，是次展覽中，設計師或建築師的身份，甚至設計或建築本身，都不再是為了解決問題而存在，相反其目的是提出問題，邀請公眾討論城市發展。Rosalia 指出：

「有別於有確實設計任務的項目，是次展覽的內容需要透過公眾參與而逐漸成立。設計師的任務就是要設計一個框架，讓觀眾去填充內容。參與式設計本身的價值，不一定是為了解決疑難，也不是純粹作為手段和工具，最重要是因持份者的參與而得出設計成果，而是次項目的成果就是展覽本身。」

Aron 亦認為，相比起參與式設計，是次展覽更像是「設計了一個參與」。他指出：「參與式設計未必需要有實際的成果，改變居民對空間的理解亦很重要：

171

三位設計師在展覽中不再是解決問題的角色,而是提出問題,讓公眾參與、理解,再給出他們的答案。

將習以為常的景觀陌生化,從而抽絲剝繭地深入探討,帶出反思和新的可能。對設計師來說,當中最難和最有趣的地方,就是如何設計一些工具給參與者使用,諸如畫畫、寫字、模型,甚至是心理測驗,去收集不同的想法。」Anthony對此亦有深刻的體會:「只要有空間讓參與者發揮,他們的理解和設計能力遠比設計師想像的高,當然指導或框架要到哪個程度最適合,就是設計師需要思考的課題。」

不同持份者的想法往往大相徑庭,若要於建築項目中使用參與式設計,除了設計合適的框架,增加持份者的參與度並蒐集有意義的意見,再萃取出最適合的意見從而得出最好的設計元素,則是下一步的難題。雖然在是次展覽中不需要的,但這在一般建築項目中篩選想法,

> 現時英國的建築項目已表明
> 需要將參與式設計列入合約條款，
> 設計師可能要開展一些工作坊，
> 以作公眾諮詢，蒐集於當地生活的持份者意見後，
> 再設計一個公平的過濾系統去蕪存菁。

是必須的。Anthony 觀察到，香港的參與式設計不多，普遍透過投票選出設計，其實不是好的做法。他說：「現時英國的建築項目已表明需要將參與式設計列入合約條款，設計師可能要展開一些工作坊，以作公眾諮詢，蒐集於當地生活的持份者意見後，再設計一個公平的過濾系統去蕪存菁。林林總總的意見不能得出一個設計，一個設計需要綜合用家意見和歷史文化等元素，當然亦要兼顧美感，不然成品全由參與者決定完成，卻效果參差，久而久之（參與式設計）就未能成為大家常見的方式。」Aron 亦認同：「不是因為選擇了參與式設計，就要將所有事情交由參與者決定，他們需要對設計有一定程度的理解和標準，才知道怎樣去回應。」

INFO·BOX

「玩轉——互：社區百繪集」展覽

時期	二〇一八年
地點	香港北角油街實現
合作機構	香港康樂及文化事務署藝術推廣辦事處 油街實現 香港建築中心 綠腳丫
設計團隊	梁皓晴（Rosalia）、高浚明（Anthony）、曾偉俊（Aron）
其他參與者	兩次工作坊共有 50 位市民參與；展覽則吸引了約 300 位參觀者

可持續的參與模式

社區藝術空間埋下改變的種子

「油街實現」前身為二級歷史建築香港皇家遊艇會會所，後於二〇一三年被活化成藝術空間，成立初衷以推廣社群藝術（Community Art），鼓動大眾共同參與及創作藝術為目標，希望讓藝術成為載體，連結人與社區。作為社群藝術平台，「油街實現」的項目相當注重公眾參與，前館長連美嬌（Ivy）認為，邀請公眾「參與」的目標不只是單純的行動，更重要是，參與者的參與經驗可以轉化成為更深層次的討論，在其生活層面實踐，從而作出令世界更好的改變。

「玩轉『油』樂場」緣起於二〇一六年香港建築師學會在太古坊 ArtisTree 舉辦成立六十周年展覽「築・自室貳之家－城＋」。展覽展出超過九十位建築師的創作，評審之一的 Ivy 對於建築師驚人

的創造力，以及其將建築知識活用於生活層面的創作手法，留下了深刻的印象，故在展覽完結後，她便邀請香港建築師學會攜手展開「玩轉『油』樂場」項目，讓建築師團隊繼續以一系列輕鬆有趣的活動，深入探討社會議題。

「玩轉『油』樂場」項目之一的「社區百繪集」帶領公眾遊走北角寫生，展開了一場社區想像的實驗。Ivy 認為當中木頭手推車是相當有趣的概念，宛如流動工作空間。「這輛手推車在社區不同角落隨時打開就能變成繪畫空間，而這個空間又能與社區空間互相結合，建構了人與環境的互動關係。」而更重要的是，項目改變了參與者對社區的觀感，由此亦改變了他們在社區中的行動，相比單是在博物館欣賞展品的「參與」，她認為項目帶出的參與

174

經驗是可持續發展的。「透過觀眾、策展人、創作者等人的參與，能夠令作品產生更大的意義和力量，因為當中集合了很多人的看法，參與對觀眾來說更是難忘的體驗。但問題是，這種參與是否可以轉化到更高的層次、更深度的討論，從而成為推動的力量？只有參與這件事能進入參與者的生活，以及在生活層面反映其參與的成果，才是重要的。」

「油街實現」在活化成主力推廣社群藝術的藝術空間之前，原址一直沒有對外開放，怎樣融入以民居和街坊老舖為主的北角舊區，吸引街坊參與，是一大難題。因此團隊在構思活動和展覽時刻意挑選公眾能夠能參與的形式，藝術家、設計師的作品大多需要透過觀眾的參與而完成，參與式的設計或藝術項目不勝枚舉。

其中深受街坊歡迎的「盛食當灶」計劃，便是一例。在每周指定時間，館內活動室將轉化成開放式廚房，邀請公眾帶同家中剩餘的新鮮蔬果食材、有效期內的罐頭及包裝食品前來，交由社區廚房設計師運用創意重新烹調，以換取一頓免費午餐。計劃希望透過創新的實驗方式吸引公眾參與，藉此引

發大眾討論並重新審視社會每日所面對的三千六百噸廚餘問題，而最重要的，當然是在大眾心內埋下改變世界的種子。

Ivy 憶述，不少家長和子女將家中剩餘的食材帶來，互相分享家中的剩食經驗，過程中對自己的生活形態亦有所反思。「活動不過是幾個鐘頭的事情，但只要能為參與者帶來啟發，就會影響以後的決定。當他們回到日常生活情境，例如購物時多加考慮自己的需要，這便是可持續的參與經驗。」

要產生這種可持續的參與經驗，項目負責人需要考慮的事情更多，例如設計師與參與者怎樣溝通、雙方如何建立關係與互動等等，能達到互相分享乃至互相充權，是最理想的狀態。「這需要幾方面元素，第一、需要有同理心，從對方角度思考；第二、雙方地位平等，建築師要放下專業，但也不等於要放棄專業，雙方就能更容易建立信任。在構思參與式藝術或社群藝術項目時，即便我們想吸引公眾參與，也不要為『參與』而『參與』，藝術的形式是流動的，最重要是思考想向公眾傳遞的訊息或價值。」

協青社蒲吧板場大改造

引領青少年走向新生活

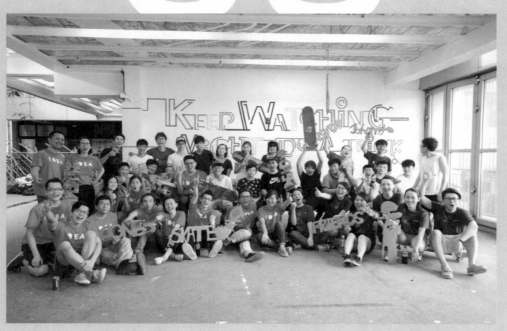

協青社旗下的蒲吧（二十四小時青少年偶到中心），一直致力於打造非一般的青年文化基地，透過滑板、電子競技、街舞等不同方面的培訓，令青少年重新建立自信心，更幫助不少徘徊在社會邊緣的高危青年免入歧途。二○一四年，蒲吧駐場滑板教練張恒達（達達）帶領一眾青少年學員成立滑板隊，可惜的是，蒲吧滑板場並不完善，欠缺吸引的形象和設施，有見及此，協青社、IDEA設計師義工隊和太古地產愛心大使團隊於二○一五年攜手進行「YO BRO! SKATE4GOOD 太想滑翔」板場改造項目，並由逾三十位年輕「板仔」和一眾義工親手實行大改造，「板仔」紛紛說過癮之餘又有成功感。

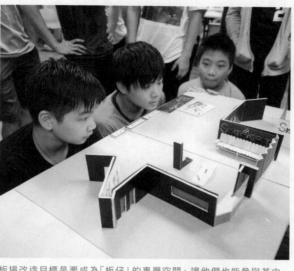

板場改造目標是要成為「板仔」的專屬空間，讓他們也能參與其中，增加其歸屬感。

據達達所言，原來蒲吧供「板仔」踩滑板的位置，只是一塊小小的普通空地，嚴格來說並非正規的滑板場（Skatepark），因此，這個「板場」空間有不少問題。首先，空間沒有型格裝飾，視覺上沒有板場應有的形象；硬件方面亦有欠缺，例如場地光線不足，「板仔」呂伊婷（阿婷）便指出，入夜後練習打 Trick（做花式）會無法看清前方，變相增加受傷的機會。

「板仔」最渴求的，固然是方便他們玩花式的設施，但他們只能靠玩犯規位，如欄杆、樓梯練習，若要進一步練習更高層次的技巧，就要去其他板場。達達說：「其實這裡作為一個板場來說很不適合──只有普通又易壞的木製設施，遇上風吹雨打便會受浸泡而損壞。」他坦言，在這個空間玩滑板的唯一好處是不會被人趕走，「起碼能玩下碟下」。當他得知板場將會進行大改造時，即喜上眉梢：「當然好，滑板是潮流的運動，如果只是在一個普通的地方玩，就會變得遜色。我們都覺得，如果板場能有一個新形象，型啲潮啲，會更容易傳達訊息，吸引其他『板仔』來玩。」

IDEA 設計團隊綜合空間使用者的意見，訂立板場改造四大任務：一、重新打造板場的視覺形象，要有一個「型啲潮啲」的「板仔」專屬空間；二、增加練習花式動作的道具；三、增設可供吸煙、休憩的椅子；四、改善場地光線不足的問題。

當然，最重要的任務，是鼓勵「板仔」參與。在參考「板仔」意見後，除了花式設施交由專業師傅建

177

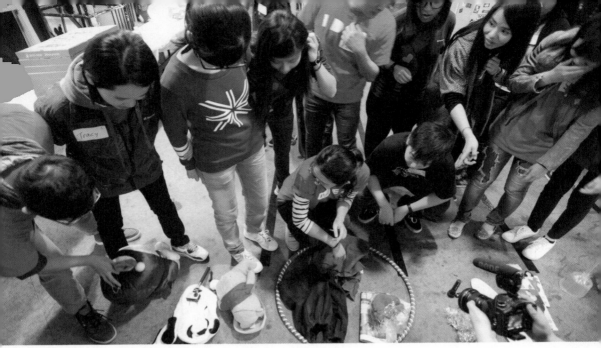

在溝通設計前，義工在「板仔」教導下嘗試踩滑板，過程中彼此也能交流，加深了解。

造，其餘三項任務均由 IDEA 團隊以設計工作坊的形式，讓「板仔」親身動手參與，增加他們對這個地方的歸屬感。

● 舊滑板成為板場一部份

改造歷時三個月，共五節工作坊，參與工作坊的板仔約有三十人，年齡介乎十二至二十歲，特徵是好動活潑，拒絕「娘爆」沉悶，要吸引他們參與，就不能要他們乖乖坐下來「聽書」。於是第一節破冰工作坊，團隊因應「板仔」平時喜歡看短片學技巧，從而構思了滑板微電影環節，讓「板仔」透過拍攝影片作自我介紹。多媒體設計師黃千宸（Jackie）說：「最初見面時也想了解他們為甚麼如此喜愛踩滑板，我們希望透過拍攝影片，慢慢將他們帶進思考層面，思考如何設計他們理想的滑板空間。」

團隊亦著重互動交流，在工作坊中加插了由「板仔」教義工踩滑板的環節。身高只有五呎的阿婷，主動扶着一位有六呎多高的太古義工踏上滑

板，她笑說場面有點險象環生：「高的人平衡力會較差，若果沒有人扶着她學習就好危險。看到她從完全不會，到能夠直行轉彎，也很有成功感！」

「板仔」固然能夠發揮自己最引以為傲的滑板技巧，對團隊而言，掌握滑板的技巧是接觸滑板文化的第一步，對於空間設計和雙方溝通亦有幫助。

熱身過後，第二節工作坊正式進入設計環

Summer（左）運用在工作坊學習的技巧，把剩餘木板材料製成漂亮的項鏈。

將承載了珍貴回憶的舊滑板製成掛飾，也為舊滑板賦予了新生命。

節。其中之一，是利用廢棄的舊滑板製作成牆上的掛飾。「板仔」先要畫出寫有自己名字的紙樣（Stencil），再運用曲線鋸剉出圖案，最後用砂紙打磨便大功告成。他們對於這個環節尤其興奮。一塊滑板使用到某個階段便因損壞而需要丟棄，但這些不能再使用的滑板，往往承載了「板仔」跌宕起伏的珍貴回憶，也不捨得丟掉。

將舊滑板循環再用製成掛飾，正是為舊滑板賦予新生命，他們練習時看到就會勾起昔日回憶。

一邊踩滑板一邊噴漆，這個天花的製作過程既有趣又有意義。

阿婷說：「我沒想過可以這樣做。雖然鋸的過程流了很多汗，但將自己好有回憶的滑板變成板場的一部份，將你喜歡的東西用在你喜歡的地方上，都會覺得是值得的事情。」滑板通常由七層或九層楓木製成，中間夾層為不同顏色的木板，另一位「板仔」Summer 運用學到的技巧，把餘下的木板材料打磨並製成漂亮的項鏈。在意想不到的地方，亦有發揮創意的機會。

● 滑板噴漆畫出天花板

第三節工作坊是滑板噴漆。團隊認為既然要為板場安裝光管，倒不如將光管設在假天花的木板上，既可以達到燈光效果，又能粉飾天花板，而裝飾的方法便是滑板噴漆。據「板仔」透露，外國「板仔」流行在滑板上安裝噴漆系統，一邊踩滑板一邊按遙控，就可隨着滑過的路線噴出圖案，十分有型。團隊立即想到「山寨版」，用牛皮膠紙將噴罐貼在滑板底下，就做出了一邊滑行一邊噴漆的效果，令「板仔」喜出望外。

不同顏色的噴漆是由 IDEA 設計團隊精心選擇，設計師歐鳳雯（Abby）指，他們選擇的都是原色及螢光色，有對比效果，無論如何邊滑邊噴，總能設計出帶有藝術效果的天花板圖案。達達則認為，這個設計「好有 Feel」：「我們踩滑板基本上常常跌倒，跌倒時一轉身就會看到天花板，看到自己滑過的軌跡，又會有另一種感受。」

第四節工作坊是將舊滑板再造成長椅及滑板掛架。板場休息位置不足，「板仔」往往要席地而

坐，設計師因而想到將舊滑板改造並合併成長椅。

「板仔」在滑板上噴上自己喜愛的圖案和字句，然後打磨、拋光、鋸木和入榫，便成了板場別具特色的長椅，也成為他們喜愛的「煲煙凳」。達達指，板場設施很容易損毀，但惟獨這張由「板仔」自己親手製作的滑板凳，大家都十分珍惜，有時「板仔」圍在一起「煲煙」時會說：「這是我畫的、我設計的！」達達說：「別的設施在其他板場都有，但這張滑板凳真的可以算是我們的標誌。平時『板仔』會圍圈丟煙頭，這張凳子卻是最乾淨的。他們在言語上未必能好好表達，但從行為中已經說明了他們對此的尊重。」

最後一節工作坊是板場的牆壁和設施大裝飾

行動。義工和「板仔」合力在牆上貼上紙膠帶，然後噴上鼓勵字句或塗鴉，如「Practice Makes Perfect」，每次練習時就會看到自己的鼓勵。「板仔」不但在不同地方噴上自己喜歡的字句和圖案，甚至會主動對怎樣才能呈現蒲吧的味道提出意見。

達達說：「設計師可能會覺得，像外國的板場一樣就是最好的了，但我們想突顯出蒲吧的特色和文化。我們未必會做很美觀或很厲害的東西，但會做一些屬於他們和這個地方的東西。」

至於新增的設施則有三款：滑坡台（Skate Platform）、四分之一管坡道（Quarter Pipe）和梯級看台（Curved Skate Bench）。其中四分之一管坡道的彎面以鐵打造，需要更精細的計算與技術，也比以往的道具更耐用，「板仔」愛用來做出 Drop In 的動作。這項工程得到工程顧問戴遠名的幫助。戴先生一直在社企工程公

Sketch of skateboard Bench Design

181

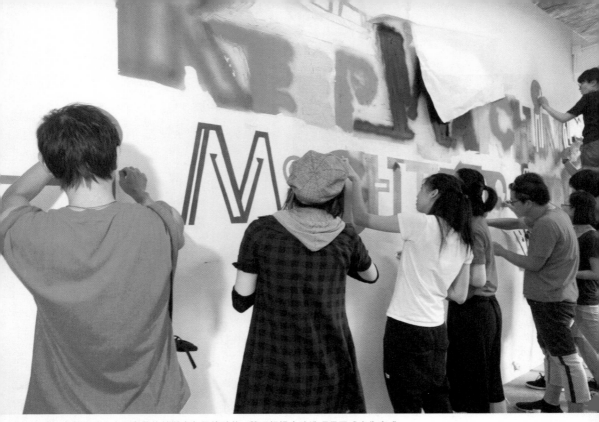

眾人在牆面噴上自己喜歡的鼓勵字句及塗鴉後，蒲吧板場大改造項目正式宣告完成。

司工作，這次板場改造工程是他建造工程生涯的新嘗試。他說：「專業的管坡道彎面及梯級看台需要做得很精準，有點像在建造國際級滑板場；而與充滿熱誠的 IDEA 青年設計師及滑板教練達達合作，自己亦提升了對建築工程的專業要求。」梯級看台的弧形板，可以幫助『板仔』做出 Grind 和 Slide 的動作，在香港實屬少見。與蒲吧設施最相近的場地要去到粉嶺，故新板場建成後對港島東區的一眾滑板愛好者來說實在是福音。

● **自由發揮吸引參加**

綜觀這五次工作坊，「板仔」的參與度頗高，更有「板仔」向義工提出要求，想在既定工作坊時間之外，回到板場繼續噴漆鋸木。Summer 認為，這些工作坊與一般工作坊不同，是吸引她參與的原因：「這幾個工作坊很好玩，沒有人會限制我做甚麼，要噴甚麼顏色、要貼甚麼貼紙、要畫甚麼都可以自由發

揮，可以自由發揮就會想繼續玩。由鋸滑板、剝木到砌上牆，每一個步驟我都參與了，看到成品就會更開心！」達達也同意，雖然「板仔」未必可以在大方向提出自己的想法，但他們在細微處也會有自己的想法和參與：「例如一張長凳要多長、多寬，選擇用哪些滑板，要噴甚麼圖案和字句，他們會覺得自己也參與其中。」

板場大改造後，「板仔」都非常開心，相比起以前的一塊空地，現在板場總算是似模似樣，也吸引了不少新「板仔」加入一起玩。達達解釋：「他們會覺得『Flow 咗』，即可以踩些更加流暢的線條。踩滑板講求線路，以往他們 Flow 到某個位置就要停，現在多了設施，就可以繼續加速，會覺得好正！訓練比賽和練習的線路更多樣化，可以吸引更多『板仔』。」他指出，雖然沒有正式統計數據，但也看到有更多「板仔」帶新朋友來踩滑板了。

自己也能參與親手打造新板場的長凳，讓「板仔」特別珍惜。

INFO·BOX

香港協青社蒲吧板場——
板場大改造　舊滑板變潮椅

時期	二〇一五至二〇一六年
地點	香港西灣河協青社賽馬會大樓
合作機構	香港協青社 太古地產愛心大使團隊
設計團隊	IDEA 香港設計團隊：張際然（Vince）、歐鳳雯（Abby）、麥靜文（Selina）、董萍萍（Ping）、黃千宸（Jackie）及各義工
其他參與者	協青社社工 青年板仔共二十五人 太古地產愛心大使團隊共二十人 IDEA 項目義工

Information

平衡資源與
真正需要
設計團隊
經驗總結

太古地產社區關係經理梁寶恩

太古地產愛心大使團隊為是次資助整個項目支出的組織，他們除了出錢，更出力召集公司員工和技工，在項目中擔任義工，協助帶領分組活動和提供技術支援，例如派出公司的維修特工隊協助製作滑板凳等。自二〇〇一年起，太古地產愛心大使團隊便一直透過各種類型的義工活動積極回應社區需要，同時與社區人士建立友誼，教導及學習新技能，達到社區營造的使命。

太古地產社區關係經理梁寶恩（Bobo）記得，當初達達曾向她表示，自己的夢想是滑板能夠列入奧運項目，希望透過不同方法令更多人願意投身滑板運動，Bobo 聽罷深受感動，決定支持板場改造項目。

「第一次開會時，他們提及在外面玩滑板有好多限制，蒲吧則可以提供一個安心踩滑板的場地，所以如果

這個空間得到改善，就可以容納和吸引更多年輕人來玩滑板了。」

即使改造的過程沒有「板仔」參與，將翻新工程全權交予設計師和承建商負責也一樣，不過 Bobo 認為，讓使用者參與其中有其必要。第一，理所當然是更能貼近使用者的需求，從而能夠更有效率地改造空間，以板場為例，滑板設施的弧度和重量都要按照一定的規定，才可以做到指定的線路，技術性的改造需要使用者的實踐經驗。

第二，使用者參與會增加對板場空間的歸屬感，每個人能在當中發揮自己所長、作出貢獻，就能營造社區守望相助的氛圍。「我們着重和受惠對象一起去參與、改變和貢獻，社區的根本理念就是大家互相幫助和學習，只有這樣才會對社區有正面影響。」

184

板場改造項目少不了太古地產愛心大使團隊參與，義工協助帶領分組活動和提供技術支援，從而為社區作出貢獻。

如果將蒲吧視為社區的縮影，那麼使用者參與空間改造，其實也是一種充權的形式——只有當每個人對自己生活的地方有話語權，才有可能擴展人和社區的價值，而價值，正是參與式設計項目的核心之一。Bobo 說：「我覺得參與式設計項目這種雙向式的社區參與模式應該一直存在，現在大家經常講社會資本，但如果一個社區中只有富有的人可以貢獻，貧窮的人不可以貢獻，社會資本就不可能不斷滾存。相反，如果可以將參與的元素放進社區項目，人人都可以貢獻自己的長處，那麼社會資本就可以持續擴大，在不同的範疇中增加價值。」

從參與中貢獻所長

讓社會資本增值

雖然項目只歷時短短三個月，但

果，天花板噴漆那一類活動便最適

要在整個過程中得到大部份「板仔」

合了。」

持續參與，加上要確完成板場大改

造，絕非一件易事。負責是次項目的

而這次項目的介入點，毫無疑

IDEA 設計師團隊，在構思活動時也

問就是通過滑板這個媒介，在設計

要仔細考慮和準備。

師、義工和「板仔」之間架起一道

溝通橋樑。Robert 曾經向「板仔」

① 找出介入點

借了一個滑板，獨自到公園苦練，

想藉此拉近與「板仔」的距離，沒

在構思活動內容前，必須先思考

想到比想像中困難：「原來連拿滑

目標的參與者。這次項目的主要目標

板都要學習，如果你蹲下再把滑板

參與者為三十多名「板仔」，年齡介

拿起來，那你肯定是不懂踩滑板的

乎十二至二十歲，他們朝氣勃勃，愛

人，因為把滑板一踩起來就用手接

新鮮好玩有型。滑板教練達達憶述，

住是最基本的技巧。」他認為，做

設計團隊最初也未能從這些年輕人的

參與式設計項目首先自己要夠「貼

角度出發：「他們（設計團隊）想開

地」：「設計師所擁有的經驗與使用

會討論，這當然不可能，他們（「板

者的經驗愈接近，就愈容易理解使

仔」）怎會坐定定聽你說話呢？你要

用者需要甚麼，也能更靈活地運用

令他們覺得好玩、有型、輕鬆、時間

推進（Facilitation）工具或手段，

又不可以太長，但又可以做出一些效

因為設計師會明白那些沒有設計知

識的使用者在設計上最關注的是甚

186

經過第一場工作坊的互動交流，設計師、義工和「板仔」也能建立互信，架起一道溝通橋樑。

麼。而且，當他與使用者更「同聲同氣」，也更容易引導使用者說出自己的想法。在參與式設計項目中，雙方是否有足夠的信任很重要。當然，最好的情況是兩者合而為一。」

❷ 資深用家聚焦需求

參與式設計項目的理念是愈多使用者參與其中愈好。不過，當參與人數愈來愈多，協調眾人意見的難度便會大增，容易出現非理性、無建設性的討論，難以聚焦問題所在，除了浪費時間，也會磨蝕與會者的心力，因此討論範圍要收窄。然而，若果範圍收得太窄，甚至涵蓋不了使用者的需求，又會衍生新的問題，所以在參與式設計項目中，設計師需要懂得一定的技巧，來定義討論範圍。

Robert 深明此道：「單是討論社區需求便有千變萬化的選項，每一個選項都不可以說是錯的，但在有限的資源下，就要找出當中的平衡。」這時，若能在項目中找到想法更全面的資深用家（Senior User）

在參與式設計項目中，設計師需要懂得找到平衡，才能讓設計既可達到專業要求，同時讓參與者投入其中。

作為引導者（Facilitator），協助定義問題和討論範圍，便變得極為重要。

這次項目中的資深用家為滑板教練達達，他是富經驗的滑板好手，一方面清楚了解場地的問題，另一方面亦熟知「板仔」的需求，尤其可以在設施上提出專業意見。加上當時二十三歲的他，在「板仔」心目中「德高望重」，又可以與他們打成一片，可以承擔起協調不同意見的重要角色。他清楚地概括出場地光線和設施的問題，使設計不會出現不太理想的選項。「板仔」曾經想要一個U形台，但在與設計師、師傅商討過後，發現因場地樓底不高，容易發生意外而作罷，期間達達一直居中平衡：「不可能全部由『板仔』或設計師單方面決定，如果由『板仔』作主，但最後無法實行，又或者設計師想這樣做，但『板仔』覺得不好玩，同樣都是沒有意思的。」

在探討設計的實際需求時，資深用家會比較主導討論的方向，但其他參與者也不是沒有參與的位置―――他們可透過參與由設計師精心安排的工作坊，肩負起美化場地形象的重任。

188

Chapter 3 ｜ 項目介紹 06 ── 協青社蒲吧板場大改造

③ 框架的重要

　　讓參與者發揮天馬行空的創意構思，固然是很美好的事情。但當大部份參與者缺乏設計思維和習慣，若討論範圍過於空泛，反而會令他們無從入手，因而產生一定的抗拒。因此，若然能有一個框架提供靈感，讓他們在既定範圍內自行發揮創意，會大大提升其參與度。

　　設計師在各個活動中花了不少心思作出預選（Pre-Selection）：在活動開始時展示樣版，給予參與者引導和提示創作的方向。舉個例，在思考如何利用舊滑板剝出牆上裝飾時，參與者很容易迷失在浩瀚的圖案和字句中，團隊就想到，提議參與者剛出自己的名字，可自由發揮的創作空間會更大。設計師張際然（Vince）說：「給他們一個簡單的開始，他們不用思考太多題材，反而可以從中探索，專注思考設計。有的人會在名字裡加入心形、星形圖案，漸漸創作出個人風格。但若果一開始是從零開始去完成任務，他們就會又害怕又害羞，有了壓力，反而有了距離感。」其實不只是「板仔」，同

樣不是設計師的太古地產義工隊亦會無所適從。

　　這樣的引導亦在不同的活動中出現──主要負責牆上塗鴉的設計師 Abby，暗地裏花了不少工夫，考慮「板仔」的喜好和各種顏色的搭配，所挑選出來的六至八種顏色，不論怎樣混合都入型入格。製作滑板凳要在凳面噴上字句和圖案，設計師事先也做了資料搜集，了解「板仔」喜歡的塗鴉大概會是怎樣的風格，然後先準備好紙樣，如「板仔」用語（Ollie、SKATE、Kick Flip 等）、與蒲吧相關的字句（聖十字徑2號、OPEN 24 HOURS等）、其他鼓勵字句和塗鴉圖案等，任君選擇。結果「板仔」的反應出奇地好，踴躍地挑選自己喜歡的字句和圖案，然後運用工具在滑板上噴出漸層顏色，製成自己獨一無二的塗鴉。在預先定好的基本大方向下，他們可挑選自己喜愛的滑板，以及決定一張長凳到底要多少塊滑板，這些都令他們感到自己參與其中。

　　設計師麥靜文（Selina）則認為，設計固然要講求美感，但最重要的是知道他們為甚麼會喜歡這樣的設計，了解他們想要、而且會使用的東西。

了解「板仔」喜歡的塗鴉風格，先準備好紙樣，這樣「板仔」
和義工皆有了方向，懂得如何在製作時加入自己的創意。

④ 認同理念的建築師傅

參與式設計項目一如其他建築項目，不論理念有多好，最後都需要落到實行層面。但參與式設計項目相比起一般建築項目，在細節執行上更繁複，要如何與承建商的師傅配合也有一定的難度，惟幸運地，是次 IDEA 團隊找到勇於接受嶄新想法的社企工程公司，建築師傅戴遠名認同項目中「參與式」部份有其重要性，才得以順利完成板場改造。

依前文所述，工作坊中有一個環節是要讓「板仔」以滑板噴漆方式參與粉飾天花板，但原來相比起傳統天花板裝潢，這樣令建築師傅多做了幾重工夫：師傅要先將一塊完整木板切開，再合起來，讓「板仔」畫畫粉飾，一星期後才將木板嵌在天花板上；而傳統做法只需直接將木板嵌入天花板即成。

Robert 回想過往其他項目，明白傳統師傅對於施工技藝有一定的驕傲，會很堅持自己的做法，設計師和師傅鬧得面紅耳赤更是屢見不鮮。Robert 說：「大家會覺得，給了錢就一定要師傅做事，但他們不明白行有行規，就算你給得起錢，只要不合行規，那些師傅也不會動手。」惟是次項目中有願意放下身段、肯嘗試新做法的師傅並肩同行，最是難得。

阿婷

從踩滑板到開網店

「沒有滑板就沒有今天的我」

這個小小的板場孕育了不少滑板好手，更改變了不少人的生命，「板仔」阿婷便是其中之一。二〇一四年，十五歲的她在機緣巧合下加入了蒲吧滑板隊，後來更獲協青社聘為職員。現時阿婷開設滑板網店，繼續發掘自己在滑板路上的更多可能。

阿婷小時候因為家庭問題而入住宿舍，經常因此而自卑，然而滑板這項運動為她帶來了成功感，令她重拾自信。在蒲吧工作的那段時間，她幾乎每天都練習超過九小時，有時更練習到凌晨一兩點，坦言：「雖然好劫，但好開心！」開心的，當然是不斷成功挑戰花式動作，但中間的挫折亦令她成長，甚至改變了她的性格。

最深刻的一次經歷，是她從六級樓梯上摔

練習滑板、挑戰花式動作，讓阿婷重拾自信心，得以成長。

下，骨折入院。「當時有個小學五年班的『嘅仔』好囂張地和我說，他跳到波浪，我想：我的能力和資歷都比他高，怎會跳不到呢？結果我在末段雙腿突然無力而向外拗，被送入了醫院。」這對於視滑板為生命的她確實造成很大打擊。休息半年後，再次踏上滑板時，她打從心底笑出來，更反省了自己的性格：「受傷之前，我是一個固執的人，即使有旁人提點，我還是左耳入右耳出，但受傷後，我開始懂得接納別人的意見，做不到也不會硬來，要先好好作準備，結果技術方面反而更進一步，比之前更好。」

「可以說，沒有滑板就沒有今天的我，所以要多謝滑板，更要多謝蒲吧和達達，以生命影響生命

阿婷用加了噴漆的滑板設計板場天花板燈槽的圖案

的力量很大。」阿婷心懷感激。

對於板場改造項目，她坦言，作為板場一分子，想不到原來自己也可以親手改造板場：「可以學習各種技巧，有不同的新體驗，有得玩又有得學，而且用（板場）的人又是自己，好正！」

開設滑板學院留住人才

教練冀推廣運動完善產業鏈

「其實我好愛好愛蒲吧這個地方，我在這裏度過了十五至二十五歲，人生中最寶貴的『黃金十年』，有許多難忘的快樂時光，這裏已經是我的第二個家。」滑板教練張恒達（達達）在訪問中多次強調。二○一八年，他離開了協青社，轉而開設香港滑板學院（Hong Kong Skateboarding Academy），除了繼續推廣滑板運動、培訓奧運選手，亦希望在香港發展滑板行業，為「板仔」謀求出路。

要說蒲吧是達達的人生轉捩點也不為過。他回想初中時，自己一時好奇加入黑社會，要聽「大佬」命令參與打鬥，終日游手好閒，十三歲時又被誘惑吸食毒品，險些染上毒癮。差點就要踏入歧途

之際，卻因一次受朋友邀請在協青社學踩滑板，從此改變了他的人生軌跡。

「最初到協青社踩滑板是因為有型，可以『識女仔』，而且感覺踩滑板遠比以前做黑社會刺激，於是便沒有再混黑社會了。」達達回想起十五歲時青澀的自己也不禁笑了。不過，後來他愈玩愈起勁，發現玩滑板除了有型，每當自己做到別人做不到的花式動作時，也帶來了持續的成功感和滿足感。

● 全國滑板比賽奪冠

在新手「板仔」心目中，蒲吧是個練習的好地方──場地二十四小時開放，玩多久也不會被

在接下來的日子，達達和隊友在滑板比賽上屢獲佳績，例如在全港公開賽項目 8five2 Game of SKATE 取得冠亞軍，二〇一六年他更和隊友加入香港隊，在全國平地花式滑板比賽中奪冠，實在振奮人心。但與此同時，相比起往昔的「有型、開心、有滿足感」，對於滑板，達達開始思考更多：滑板這個運動，在香港可以怎樣更有效地推廣？滑板這個行業，在香港又怎樣能夠繼續生存下去？

● 列奧運項目帶來熱潮

蒲吧多年來孕育了不少滑板好手。然而，當他們的技術發展至巔峰時，在職業方面卻無以為繼。

達達說，這些「板仔」後來做了侍應、跟車、炒散等，甚至有一位冠軍級人馬放棄滑板，到夜場打碟維生，他對此深感可惜：「我很開心可以培育一班『板仔』，但我問他們為何不來練習，他們卻說因為沒錢，所以要兼職，這是很現實的事情。你用了那麼多時間培訓，他卻沒法從事滑板相關工作。非牟利機構固然也有少量職位，可是一旦沒有資助就

趕走，玩得差也不會被取笑，二〇一五年板場改造後又新增了好玩的設施，職員也會全力給予支持和鼓勵，駐場教練亦免費提供培訓，基本配套十分齊備。蒲吧以培養興趣為主的方針，讓不少青少年安然度過了最容易學壞的年齡階段，達達直言自己也是其中之一：「可以說，我被這個地方拯救了，是生命改變生命。」他希望其他青少年也可以像他般藉着滑板重回正軌。

達達的踩板技術日漸精進，在二〇〇七年成為了協青社職員和蒲吧駐場教練，並在二〇一四年帶領五十名學員成立滑板隊「Youth Outreach Skate Team」（YOS）。除了指導板仔學員，YOS 更成功進入中學推廣滑板，並協助學校成立滑板隊。

在分享知識的過程中，達達進一步體會到，令別人快樂，自己也會滿足。「來協青社的青少年都有頗為複雜的經歷，平時他們沒有甚麼機會展露笑容，比較難獲得成功感，當他們完成一個簡單的花式動作，就已經覺得好開心好有成功感。對我來說，這也產生了難以言喻的滿足感。」

滑板教練張恒達在蒲吧度過了人生的「黃金十年」，並在接觸滑板後將其變成了自己的事業。

沒有了，這是一大問題。我覺得如果真的想把踩滑板發展成職業，應該要讓他們在市場上都可以維生。

但在香港，要靠自己的興趣維生很困難。」

再三思索過後，他於二〇一七年辭去了工作十年的協青社職位，決心開設香港滑板學院，另闖一片天。他聘請了約二十位視滑板為志業的年輕「板仔」擔任教練，冀望延續行業產業鏈。「這些『板仔』平均年齡只有二十四歲，這份工作可讓他們整日對着滑板，上班時間不會太長，收入與外面其他工作看齊，所以很多人都想來這裏工作。

不過要找到有教學理念的人才有些難度。」達達說道。

最重要的是，他看到滑板運動在香港有一定的市場。

回想過去，他當年最大的願望

達達曾加入香港隊，在全國平地花式滑板比賽中奪冠，現在則帶領學生參加各種賽事。

是滑板能被列入為奧運項目，令更多人對這個運動有正面的看法。這個願望終於在二○二○年東京奧運中實現。縱然比賽因二○一九冠狀病毒病（COVID-19）疫情被延後，他依然深信，在二○二四年巴黎奧運、二○二八年洛杉磯奧運上，滑板項目仍將會延續；在這十年間，滑板運動仍會有不俗的熱潮。

現時學院除了致力培育滑板人才，參與亞洲賽事、甚至奧運項目，亦不斷在中小學推廣，例如舉辦課外活動、校際聯賽等，降低滑板普及的年齡層。達達說：「每年都會有孩子出生，家長會嘗試為子女找些不同的活動接觸，例如踩單車、溜冰等，滑板當然也會是其中一個比較流行的活動。有孩子想學滑板，就有人教，教練就可以有收入，繼續在行業中生存，學生長大學成後，又可以參加比賽，有機會得到贊助繼續發展，這樣便產生了一條產業鏈，留住滑板人才。」

● **進行一場滑板革命**

不過，他認為要真正推廣滑板運動，還是得靠比賽。學院的目標之一，是舉辦更多比賽，為「板仔」增加比賽經驗。「以前每年會有四個純粹玩票性質的大型活動，官方比賽就只有一次，即所有年齡組別混在一起的全港公開賽。而一次比賽只會給『板仔』兩次機會晉級，狀態好時當然開心，但狀態不好就要拜拜，等下一年，所以好多人都未能夠

適應比賽節奏，這與外國每一兩個月就搞一次比賽很不一樣。」

惟他估算，計及人力物力，一個比賽至少需費四、五萬港元，但因香港人習慣參加者不需付報名費，他直言「肯定會蝕錢」。然而，他覺得若果學院賺了錢，就要將資源放回圈子內，圈子才會不斷成長。「在香港，沒多少人會推廣滑板，因為未必有成效，又擺明蝕錢，但若果你永遠只會在圈子中抽取資源，就不會有人繼續玩這個運動。」

儘管他充滿鬥志與理想，但事實上，開設滑板學院這件事一開始也引來圈中人一些齟齬，認為滑板不應該「商業化、體制化」，簡單來說，就是教滑板不應該收錢。達達對此也曾有所掙扎：「我也曾經想不明白這件事，因為當初別人也是免費教我踩滑板的。但開始做這間公司就發覺，我熱愛滑板，但我也要生存，如果不能維生，這個圈子就會少了一個熱愛、好想推廣滑板的人。我見過太多了，好多厲害的前輩，在他的年代也無法靠滑板維生。現在多了人理解，我們的理念不是純粹賺錢，而是真正在養活一班人，正在進行一場滑板革命。

坦白講，現在多了人願意投身滑板這個行業，因為大家都覺得有前景。我不知道最終是否可以改變甚麼，試一下吧！」在跌宕起伏裏仍不斷的嘗試和堅持，達達透過生命的種種實踐，親身示範了滑板的信念。

達達認為，要讓愛滑板的人能夠以滑板維生、看到前景，這項運動才能長遠發展下去。

人人＋參與＋玩樂＝藝術

小小積木擴闊孩子想像空間

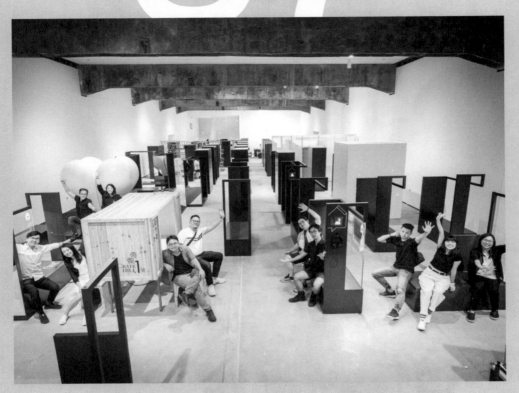

在二○一八年於北京舉辦的「城市觸覺──二○一八港澳視覺藝術雙年展」（雙年展）展場上，一件巨大的積木裝置作品《People + Participation + Play 小格子》（人人＋參與＋玩樂小格子）瞬間抓住了在場人士的目光，小孩子看到了更是雀躍不已，紛紛走上前拿起積木肆意把玩一番，樂而忘返。這是展場上少數需要觀眾參與才得以完成的作品。

雙年展香港展區的參展藝術家為八位香港青年建築設計師，他們以「城市觸覺：建談城市相遇」為主題，呈現空間設計如何塑造都市人的生活形態。展品之一《People + Participation + Play 小格子》，特別加入了讓觀眾參與的元素，由孩子、家長和設計師共同創作，盡情發揮創意，對孩子來說尤其吸引。設計師王建明（Robert）想透過作品帶出建築的意義：「所有人都可以平等地設計及享受自己理想的生活空間及環境。建築不僅是設計的結果，更是相互作用和相互理解的過程。」

Robert更進一步指出這個作品的四大美學元素。一、創出虛與實：《People + Participation + Play 小格子》由四件裝置組成，最吸引人們目光的是大型長方形通道，當孩子穿梭其中，猶如體驗「捐山窿」（穿山洞）的樂趣。通道上方和兩邊的牆面均設有網格，外牆全是網格，內牆的網格則呈波浪形，構築出虛實並置（Solid and Void）

的連繫。

二、創出三原色的美：網格的設置讓參與者得以隨意放入色彩繽紛、長短不一的積木，從而拼砌出不同的圖案。由於積木的顏色是三原色（紅、黃、藍）和白色，無論怎樣配搭組合，在視覺上亦充滿了美感。

三、彈簧燈創造光影變化：是通道旁有一個彈

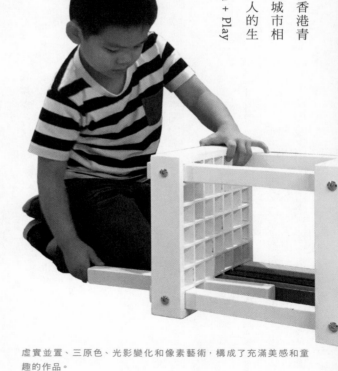

虛實並置、三原色、光影變化和像素藝術，構成了充滿美感和童趣的作品。

簧燈裝置，附以梯級，看似簡單，原來在美學上亦經過深思熟慮。當孩子站在梯級上，可以大人視角往下看向通道，成年人則可蹲在通道內，以孩子的視角向上望，生出無窮樂趣。當有人觸碰彈簧燈，彈簧便會晃動，在通道內製造出光影變化，令拼砌的圖案產生更為立體的效果。

四、構成像素藝術（Pixel Art）：另外兩個裝置為桌椅套裝，桌子兩旁同樣是可以放入積木的網格，而桌面上的磁石小格子，可供孩子拼砌不同的圖案，形成像素藝術。椅子則是空心的，若想坐在

上面，首先要動手將長條形的積木逐一插進椅子的框架內，充滿童趣。

這個作品並不複雜，亦正因為很有趣味，能夠吸引觀眾參與其中。Robert 指出，這件藝術作品既是創意玩具和牆壁裝飾，也可以作為訓練工具，供有特殊學習需要的兒童和有認知障礙的長者，透過顏色配對及圖案拼湊的模式，提高感知能力、專注力和耐性，更達到訓練肢體肌肉、手眼協調的治療效果。

● 參與式設計助培養社交技巧

不說不知道，作品的幕後功臣之一，是Robert 任職的香港聖公會福利協會的社工和職業治療師同事。他們在二〇一六年為協會的幼兒教育訓練中心及長者地區中心裝修時，便曾把渠蓋與不同顏色的積木結合，設計出名為 P.Cube 的積木，可用作鍛練特殊需要兒童及長者的感知和協調能力，並將其設置在聖公會福利協會多間中心的牆身上作訓練之用。而這次一比一大的積木，也有賴與

聖公會福利協會跨專業團隊的合作，才能為孩子創作出能擴闊他們想像空間的作品。

另一個重要人物則是 Robert 的太太林絲靖（Cici）和兩個兒子。Cici 是教育心理學家，專門研究兒童心理學。在製作這個藝術作品時，兩個兒子正處於幼稚園階段。她指出，兒童年紀愈小，尤其是學前兒童，愈需要透過感官刺激學習新事物，

惟綜觀現時玩具種類，太多數屬於現成品，早已訂立了框架，某程度上妨礙了孩子發揮創意和想像力。在 Robert 獲港澳視覺藝術雙年展邀請創作藝術品時，並沒有太多想法，更沒有想過把參與式設計融合到作品當中。在創作期間，Robert 把他與聖公會福利協會社工和職業治療師同事合作設計的 P.Cube 故事與太太分享，Cici 便建議，不如買不

Robert 表示，《People + Participation + Play 小格子》不但是藝術作品，也有助有特殊需要的兒童或長者鍛練感知能力、協調能力等。

同的材料，與兩個兒子一同創作；並提出利用自製積木條，讓孩子思考如何拼砌他們喜愛的圖案。她表示：「以前孩子拿着簡單的樹枝和石頭，就已經可以玩遊戲。我覺得積木是很好的玩具，幫助兒童發揮創意之餘，亦可鍛練他們的小肌肉。若果連積木也是自製的，他們的想像空間就會更大。」

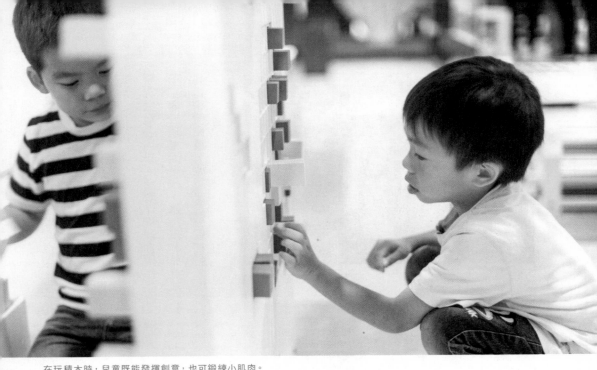

在玩積木時，兒童既能發揮創意，也可鍛練小肌肉。

把比兒子還高的木條，切割成積木條及組裝，再根據兒子們的想法，將積木條噴上油漆，並用鎚上釘子，一家人齊心協力，完成比兒子身高還要高大得多的積木作品。順帶一提，展覽開幕時，展品中戴眼鏡的人形圖案，正是兒子親手砌出爸爸的樣子！

早在雙年展之前，《People + Participation + Play 小格子》的雛形曾於香港中文大學建築學院在銅鑼灣時代廣場舉行的「破例：香港中文大學建築學院廿五周年校友展」展出，深受公眾歡迎，兒童踴躍參與。Cici 留意到，即使面對一樣的物件，不同的人也會拼砌出不同的圖案，還有個兩歲左右的幼兒拿着兩塊積木當作樂器般敲擊，反映出簡單原始的玩具有助擴闊幼兒的想像空間。「心理學有個名詞叫多元智能，每個人都會有自己的天份和獨特之處，幼兒在未接受幼稚園教育前，因沒受到老師的思想灌輸，他們對於物件的發揮可以超越我們想像得到的認知。」

即使在家中，Robert 和 Cici 也會採用參與式設計方式處理家庭事務，例如為牆壁髹油漆時會

Robert 的太太 Cici 和兩個兒子也參與其中，協助完成作品。

問及孩子的喜好、與孩子一起整理花園等。

在安裝家具時，他們一家會一同動手，拿起螺絲起子、電池鑽等工具，互相合作，裝砌的書櫃和書桌。在為牆壁髹油漆時，孩子先要學習水性和油性油漆的分別、如何稀釋油漆、如何穿戴手套及使用油掃，是實實在在的體驗式學習。這個過程更是家長和子女之間寶貴的互動時光，讓他們在一整天的勞作中，建立更親密的親子關係。

「讓孩子去設計自己的生活環境，對他們的成長是非常重要的。在過程中，孩子學會

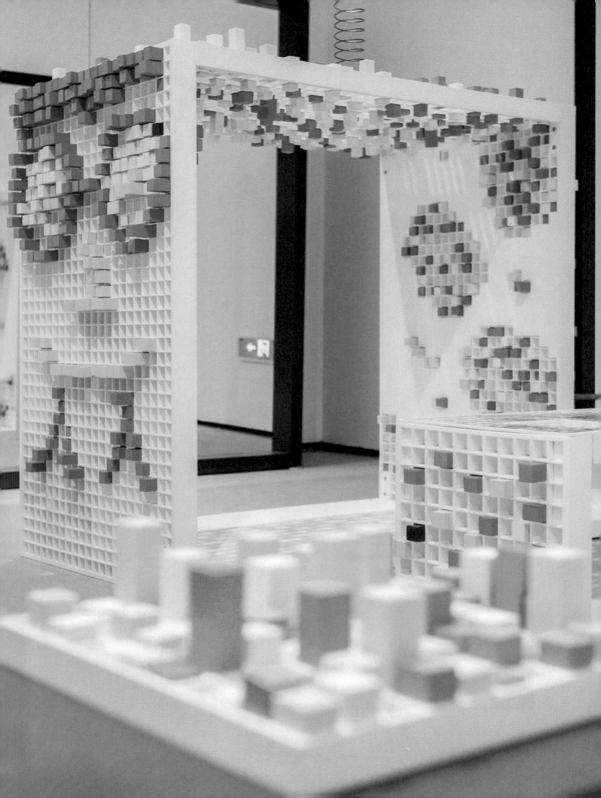

INFO·BOX

「人人＋參與＋玩樂＝藝術」──
二〇一八港澳視覺藝術雙年展展品

時期	二〇一八年
地點	中國北京民生現代美術館、浙江美術館、絲綢之路（敦煌）國際文化博覽會
主辦及協辦機構	香港康樂及文化事務署藝術推廣辦事處 澳門政府文化局 甘肅省文化廳 浙江省文化廳
設計團隊	王建明（Robert）、陳詠琳（Gwyneth）、林瑞新（Sam）、林絲靖（Cici）
其他參與者	特殊學習需要的孩子、展覽參觀者

表達自己的想法，明白自己的意見會被接納和尊重，而家長也能學習聆聽孩子的需求。人與人之間產生連繫，正是社交的基礎，故參與式設計有助孩子發展社交技巧。」Cici 亦深信，增加孩子對空間的歸屬感，可讓他們在充滿安全感的環境下長大。

chapter
04

結語

Conclusion

眾人心聲

眾

Yiu ● 香港，資訊科技

好的設計需要用心代入使用者的角度和感受，需要屏除自己的偏見與傲慢。設計者和使用者的身份是平等的，無分主次，缺少了任何一個人的意見都不能完成一個好設計。多年裏，在跟其他義工進行參與設計的過程中，我學懂無論做任何事，都要彼此尊重，常常要保持一顆謙卑的心。

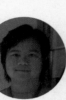

Calvin ● 丹麥，公共衛生專家

如果成品是根據用家的想法而出現，用家會更開心、更珍惜。丹麥有很多知名設計，但內在空間並不方便人們使用，所以我支持「人人設計」的概念，用家與專業人士互相取長補短，成品會更能持續發展。

Carol ● 香港，社工

我認為，要與用家一起參與、嘗試和修正，才可以做出真正切合其實際需要的設計。每個人都有份設計他的社區，除了會令他更有歸屬感和珍惜，也締造了人與人之間的連結。這種連結不只是他們和義工的關係，最重要的是他與社區鄰里的關係，對社區的歸屬感（Sense of Community）好重要。

Chiling ● 香港，飛機師

每個人都有能力去設計，只是缺乏工具或機會去表達他們的想法而已。由用社區的人去設計社區，歸屬感會更大。

May ● 香港，公共事務界

作為一個沒有設計和建築背景的人，我不會想像自己可以設計一間學校。有這樣的平台讓我去逐步實現自己的想像，是好神奇的事情。

Anna ● 香港，工程師

參與式設計一開始就已經是從用家的需要和文化出發，人們有份參與，投入程度自然會增加，然後便會將自己參與所得的經歷分享出去。

Gloria ● 香港，建築師

作為建築師，習慣了香港建築業會浪費很多錢在沒有用的設計上。但當面對預算很緊張的項目，你才可以回到建築的本質：需要聆聽多方面的意見，才能去蕪存菁，留下最符合用家需要的設計。

Eddie ● 香港，金融界

作為參與者，我們要滿足的不僅僅是自己的夢想，更要滿足當地人真實的需求。另外有一點有趣的是，社區本是屬於大家的，為何我們要到柬埔寨才可以做參與式設計？大家住所樓下的公園，可否也有份參與設計？

Pam ● 香港，設計界

設計師有能力去將想法實現，但不代表他們最清楚物件的用途。參與式設計可以鼓勵本身不認識設計的用家參與其中，這才是真正的充權（Empowerment）。

Gwyneth ● 香港，室內設計師

相比普通設計項目，參與式設計要做好多準備功夫，要想得很周詳；最花心思的是怎樣可以有效地獲得用家意見，這需要雙方建立互信關係，才可以獲得好的效果。

Vince ● 香港，平面設計師

設計界常會出現「文人相輕」的現象。參與式設計的好處是讓設計師學懂這樣的道理：不要永遠覺得別人的設計不夠好，這樣會剝奪了其他人表達他們想法的機會——對設計師來說，這也是一種修養。

項目中，大家一起學滑板，即使我們是已經工作的人，也會向擅長滑板的板仔學習滑板技巧。

Selina ● 香港，導視標識設計師

參與參與式設計項目，不可以太執着於設計師的自我意識（Ego），不能總是把自己想要的東西強加在對方身上；相比起商業設計的客戶會希望你給予他提案，是兩種思維模式。

Ping ● 香港，設計師

每個人都有自己的專長，不論你的經歷和工作技能有多好，始終不會懂得所有事情。在蒲吧板場

Lawrence ● 香港，社會企業家

每個人，不論是甚麼背景，有沒有設計經驗，也可以參與討論及在設計過程中作出貢獻，這個被賦權的經驗是最可貴的，不但使設計變得有溫度，更可幫助參與者建立成長思維，受用一生。

Edgar ● 香港，建築師

做我們建築師這行，工作通常都是由上而下單向地傳達的，而參與式設計則開闢了很多與社區對話的機會。當然它不是最有效率的，因為要和每個人解釋甚麼是設計，對方才有一定能力做選擇。但好處是用家會有歸屬感、自豪感，覺得自己是社會一分子。然而，可悲的是，當柬埔寨人和尼泊爾人都有權去表達想要一

個怎樣的空間，反而香港人就沒有這樣的資源和選擇。

Gigi ● 香港，工程師

作為政府工程師，希望可以盡量向市民解釋一項基建的重要性。讓用家參與其中，對方就可以產生歸屬感，大家一起去改進設施。

Jenny ● 香港，工程師

現時商界也開始想了解終端用戶的意見，並作為其中一個賣點。現在的商業模式不再是作為單一服務提供者般簡單，愈來愈多企業向着「加入更多人和意見」的模式去做。一個商場太單一，人們會覺得厭倦，除非你永遠都做得好，否則再用以前的模式，是不可能持續發展的，模式將會慢慢轉型。

Cedric ● 香港，教師

小時候，我看到任職老師的母親與她的學生互動，當時我已對育人事業深感興趣。後來我有幸加入教育界大家庭，專業為設計與科技科。這一門學科，教學法可謂五花八門，本科推崇「設計程序」，我一直致力鑽研這種教學方法。在教育界工作十多年，我深信「設計程序理念」加上「委身服務精神」應為未來社會主人翁必備的素質。我希望自己可以走出課室，將自己的專業知識應用在社區建設之上，培育更多未來的社會棟樑。到了今天，我看到自己的學生青出於藍，而且能夠薪火相傳，將這份精神傳承下去，實在感恩。

Vaughn Kelly ● 美國，建築師

A woman once told me that she stopped crying the day I walked into town. To be clear, I hadn't done anything for her. It wasn't me. It was

the idea that somebody cared; that she wasn't alone. The IDEA Project team shows whole communities that humanity is bound together by those who care. They show up. They listen. They inspire our sisters and brothers of this earth to keep pushing upward and onward on life's path, and that they are never alone.

Dr. Lara Jaillon ● 法國，建築師及大學教授

A good architecture is a human-centric design solution with everyone's participation.

Dinesh ● 印度，海洋科學家

As a marine scientist, being involved in design was such a memorable experience to me. I value the time bringing Indian children to work with oversea designers in decorating the shelter school. It was very meaningful to the Indian children in their lives.

Rith ● 柬埔寨，非牟利機構創辦人

It is such a great opportunity for children in villages in Cambodia to experience the design process. Children and parents can voice out their needs. They enjoy coming to the school that they designed.

Amala ● 印度，社工

Participatory design is a way to involve everyone to communicate, understand and help each other. This is a way to demonstrate the social justice in design in the society to let everyone speak out on their design wishes and needs.

Cici ● 香港，教育心理學家

讓我們重新想像學習，讓孩子參與設計而得以啟發，學會了設計思維，有同理心地看待我們的解難方案，用雙手去體驗式地學

212

習；我們會更感受到建築、設計、藝術及生活的美。

Robert ●　香港，建築師、社會企業家

人人參與設計，讓我們看到設計的深度，更體味到設計的「心」度。

Naga ●　印度及尼泊爾，工程師

Involving the Nepal post-earthquake reconstruction project allowed me to understand the villagers' needs. We appreciated very much listening to their voices through participation in design.

Dorris Leung ●　香港，銀行客戶服務管理

參與式設計讓持份者反思自己的生活需要，從而創作理想的生活空間。這不單是為了更好的用家體驗，還賦予用家一個思考過程。而在發展中國家，參與式設計更是別具意義。透過來自不同國家背景的義工與當地居民一同分享、參與、設計，大家團結起來建造更美好生活。當地人從中得到新意念啟發，建立勇氣，相信自己能創造更好的生活；另一邊廂，義工們也從中學懂珍惜簡單生活的快樂。We build, we care, we share.

謝英俊 ●　台灣，建築師

在現代建築中，使用者的參與普遍缺席，參與式設計是一個趨勢，但當中怎樣操作卻很困難，因為建築師要懂得放下身段，同時降低技術門檻，盡量讓使用者有發揮的空間，才能提升其參與度。

結語

參與式設計的未來

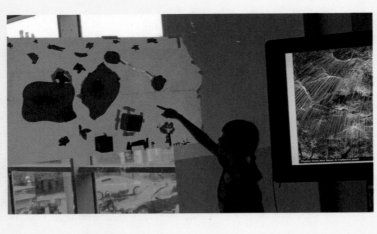

回到我們現實的生活環境，放眼四周細看，許多與生活相關的空間，如公園、社區設施、遊樂場、學校，或者社區環境的發展規劃，如果在空間建造過程中，設計師能從為了人們而設計（Co-design for the people）的出發點多走一步，成為「與人們一起設計」（Co-design with the people），或許將更了解人們的實際需求，令設計更能符合大家期望。我們樂見更多與人們共同設計的創新生活環境。

參與式設計就像是一個設計交流平台，更是大家的想像空間，使得用家有機會在建築及設計上得到發表及發揮的機會。

IDEA 正是設計交流平台的代表者，由共同設計（Co-design）的概念出發，自二〇〇九年起在亞洲不同地區（香港、柬埔寨、尼泊爾、印度）一直從事設計教育工作，以及推廣參與式設計。IDEA 取名自英文 "Involve in Design, Empower with Action"，有着「人人設計」之意，是參與想像（Involvement & Inspiration）、設計思維（Design Thinking）、體驗學習（Experimental Learning）及建築藝術（Architecture & Art）的共同體。人們在參與式設計中了解到不同設計方

214

案，除了解決社會問題，還可把意義延伸至更廣闊的領域。

由二〇二一年開始，IDEA 在英國倫敦的不同小學中，以實驗方式在校實踐參與式設計，與學生一同想像學校未來的室外學習空間；一起動動手，建造屬於他們的小椅子。在十多節「小小建築師」課程中，孩子們從遊戲中實踐，愛上建築設計，並在動手的過程中驗證所學的設計理論。一邊玩，一邊學，讓孩子興致盎然，他們甚至常常提出很多令人驚喜的創意想像。課程亦引領孩子發掘相關的興趣，甚至為他們培養生活技能。

讓孩子學習建築設計，目的並非只為培養建築師及設計師，我們認為，好的建築設計與愉悅的環境，是人類最基本的需求與權利，就是所有美學教育與設計的基礎。IDEA 相信讓孩子學習建築設計並不奢侈，而是每一個人的權利，所以我們一直致力透過建築設計讓每一個人都可以接觸、享受建築設計美學，不因參與者的環境、身體或經濟狀況而設限，而最重要的當然是實踐 IDEA 名稱所代表的四大理念。

● 參與想像：

展望將來的教育，我們需要的是創新的思維，面對社會上的問題，提出不同的、創新的解決方法。

● 設計思維：

傳統的應試教育制度往往只要求學生追求標準答案，局限了創意的發揮。設計思維大師 David Kelley 便清晰簡單地說明了設計思維的定義：「創意是一種心態、一種思考方式，也是一種解決問題的積極

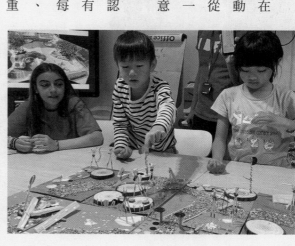

態度。」IDEA 希望能藉着「與人們一起設計」的過程，向他們灌輸設計思維的重點，從使用者的需求出發，去設計產品、服務或體驗，讓創新「有跡可循」；並用具體、完整的步驟，引導人們思考創新的解決方案。同時，IDEA 希望引發參加者的同理心，讓每一個設計者在一開始都能看到別人的難題，而不是只為自己做設計。透過觀察和訪談，設計者能設身處地考慮使用者的使用經驗，找出難題更深層的意義。

● **體驗式學習：** 又稱「實踐式學習」（Hands-on learning），正是 IDEA 十多年來一直沿用的服務社群方式。每一次服務團隊到各地建校前，都會先了解當地人面對的難題及其真實需要，當知道當地居民的處境後，我們才去提出框架和問題，讓參與者根據個人感興趣的領域作深入了解，投入同理心和情感，發掘當地人面對的問題核心，從中引發其學習動機。舉例說：參與者以觀察者的身份，重新體驗當地居民的居住環境、日常生活習俗、周邊社區的配套等的主題，從中悟出洞見（Insights），嘗試透過創意提出改變。

建築美學：

IDEA 相信重視美學、美感是人的天性。

建築設計是社會、歷史、美術、地理、藝術的結合，從小培養孩子對美的感受力，讓他們自由發揮想像力和創造力，從中學習觀察環境，感受自己和環境的關係，便擁有對世界的觀察力；讓孩子和建築環境、設計對話，孩子便能創造屬於他們的故事。

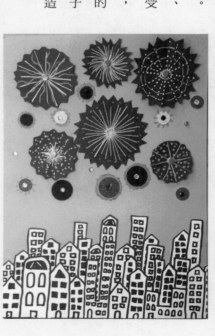

IDEA 不僅把參與式設計體現為一種設計方法，更是一種設計及教學態度。拉近設計師與用家的距離，設計的效能則可以更「以人為本」。在小學實踐參與式設計教育，讓孩子接觸建築設計，是他們認識「美」的第一步。推廣開來，社會上將會有更多人學習欣賞設計、體驗設計、成就設計。設計師能理解用家需要，用家懂得設計的美學及創意，大家共同設計，會激發創造力和協作的強大力量，帶來更成功的集體創造力，共同創造一個美好而以人為本的未來。

「與人們一起設計」是 IDEA 一直奮鬥的目標，期望有你們的參與，將來的城市可以變得更貼近人們的需要，讓每一個人都享受建築設計為生活帶來的美感及好處。建築不僅僅是設計的結果，更是相互作用和相互理解的過程。讓空間留白，通過互動，思考人與人的生活空間，並感受設計，體驗設計，繼而演變成美好的環境設計。

鳴謝機構

（按機構名稱筆劃排序）

太古地產愛心大使

尼泊爾未來之村

印度 Kalki Welfare Society

協青社

油街實現

柬埔寨 National Technical Training Institute

柬埔寨 Cambodian Children's Advocacy Foundation Organization

英華書院

英國倫敦 Greenside Primary School

英國 IDEA Design Hub CIC

香港大學專業進修學院建築學系

香港明愛啟幼幼兒學校

香港建築中心

香港建築師學會

香港康樂及文化事務署藝術推廣辦事處

香港童軍總會

香港聖公會福利協會

常民建築

綠腳丫

IDEA 基金會

01 摩士公園
MORSE PARK

你是一位有 2 個孫兒的婆婆，請你畫下一個長幼共融的公園設計概念。

You are an old woman with two grandchildren. Please share your design idea for making a child- and elderly-friendly park.

參與式設計項目清單
Participatory Design Checklist

地點 摩士公園
VENUE MORSE PARK

◎ 誰 長者
 WHO Elders

Ⓦ 如何 諮詢和決策
 HOW Consultation & Decision

Ⓝ 何時 設計階段、模型、完工後
 WHEN Design Stage, Mock-up & Completion

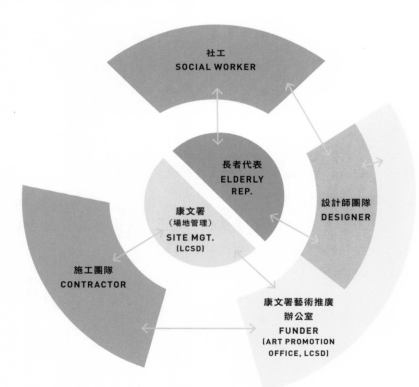

社工
SOCIAL WORKER

長者代表
ELDERLY REP.

設計師團隊
DESIGNER

康文署
（場地管理）
SITE MGT.
(LCSD)

施工團隊
CONTRACTOR

康文署藝術推廣
辦公室
FUNDER
(ART PROMOTION
OFFICE, LCSD)

參與式設計（用家為本）
PARTICIPATORY DEISGN MODEL
(USER-CENTRED MODEL)

02 印度本地治里市
PONDICHERRY, INDIA

你是一位在印度本地治里市成長的小孩,今天你獲邀參與設計你心目中最理想的街童學校,請你畫下一個充滿創意的設計概念。

You are a child growing up in Pondicherry, India. Today, you are invited to draw and share your design ideas for making your school more creative.

參與式設計項目清單
Participatory Design Checklist

地點 印度本地治里市街童學校
VENUE SHELTER SCHOOL, PONDICHERRY, INDIA

◎ **誰**
 WHO 街童學校小孩
 Children in Shelter School

Ⓦ **如何**
 HOW 諮詢和決策
 Consultation & Decision

Ⓝ **何時**
 WHEN 設計階段、模型、施工、完工後
 Design Stage, Mock-up, Construction & Completion

IDEA 設計團隊
IDEA Design Team

IDEA 項目籌委會
IDEA Organising Team

學生
Students
(Kalki Welfare Society)

老師
Teachers
(Kalki Welfare Society)

建校項目捐款者
School Project Donors

印度工程技術工人
Indian Skilled Workers

IDEA 義工
IDEA Volunteers

參與式設計（用家為本）
PARTICIPATORY DEISGN MODEL
(USER-CENTRED MODEL)

03 尼泊爾Dhading區Katunge村第九區
9th REGION, KATUNGE VILLAGE, DHADING, NEPAL

你是一位在尼泊爾 Dhading 區 Katunge 村第九區山區居住的長者，在 2015 年 4 月尼泊爾地震後，你獲邀參與 Future Village 和 IDEA 舉辦的村落重建工作坊，請你畫下心中對於村落重建的設計概念。

You are an old woman living in the 9th Region, Katunge Village, Dhading in Nepal. After the April 2015 Nepal earthquake (also known as the Gorkha earthquake), you are invited to join a brainstorming session organised by Future Village and IDEA. Please draw and share your idea on how you would like to rebuild your house in the village.

參與式設計項目清單
Participatory Design Checklist

地點 尼泊爾 Dhading 區 Katunge 村第九區
VENUE 9th REGION, KATUNGE VILLAGE, DHADING, NEPAL

誰 山區村民、小孩
WHO Children & Villagers

如何 諮詢和決策
HOW Consultation & Decision

何時 設計階段、模型、施工、完工後
WHEN Design Stage, Mock-up, Construction & Completion

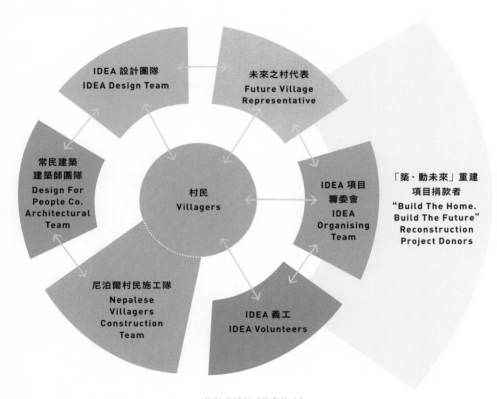

參與式設計（用家為本）
PARTICIPATORY DEISGN MODEL
(USER-CENTRED MODEL)

04 柬埔寨貢布省村落
VILLAGE IN KAMPOT, CAMBODIA

你們是一群在柬埔寨貢布省村落的孩子，獲邀參與 IDEA 建校項目的設計工作坊。請你以四格漫畫，創作一個創意的故事，表達你心中的學校設計概念。

You are a group of children living in a village in Kampot Province, Cambodia. When you join a design workshop organised by IDEA Project, please draw and create a story in four boxes and share your creative ideas for your school.

01	02
03	**04**

參與式設計項目清單
Participatory Design Checklist

地點
VENUE

柬埔寨貢布省村落
VILLAGE IN KAMPOT, CAMBODIA

誰
WHO
村民、小孩、老師
Villagers, Children, Teachers

如何
HOW
諮詢和決策
Consultation & Decision

何時
WHEN
設計階段、模型、施工、完工後
Design Stage, Mock-up, Construction & Completion

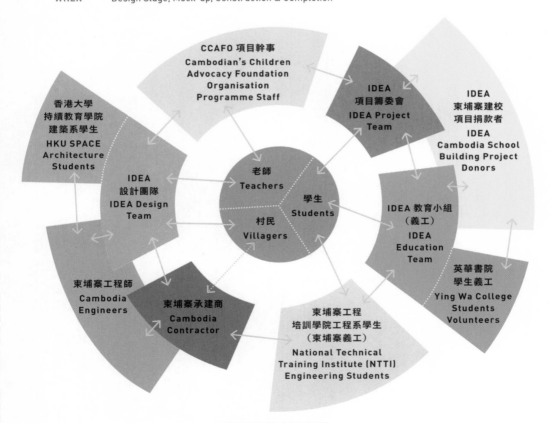

CCAFO 項目幹事
Cambodian's Children Advocacy Foundation Organisation Programme Staff

IDEA 項目籌委會
IDEA Project Team

IDEA 柬埔寨建校項目捐款者
IDEA Cambodia School Building Project Donors

香港大學持續教育學院建築系學生
HKU SPACE Architecture Students

IDEA 設計團隊
IDEA Design Team

老師
Teachers

學生
Students

村民
Villagers

IDEA 教育小組（義工）
IDEA Education Team

英華書院學生義工
Ying Wa College Students Volunteers

柬埔寨工程師
Cambodia Engineers

柬埔寨承建商
Cambodia Contractor

柬埔寨工程培訓學院工程系學生（柬埔寨義工）
National Technical Training Institute (NTTI) Engineering Students

參與式設計（用家為本）
PARTICIPATORY DEISGN MODEL
(USER-CENTRED MODEL)

228

05 《玩轉 ── 互．社區百繪集》展覽
"Play to Interact – 100 drawings on community" EXHIBITION

你會怎樣形容你的社區？請選擇一個詞語為主題，然後遊走大街小巷，選一個街景回應主題，並在工作紙上寫生記錄。

How would you describe your living environment? Please select a word as your theme, then walk around your district and draw an urban scene which can demonstrate the theme that you have chosen.

題目： topic:	人情味 communal	活力 energetic	轉變 transforming	平靜 peaceful	相聚 gather	回憶 remember

參與式設計項目清單
Participatory Design Checklist

地點 《玩轉 —— 互 · 社區百繪集》展覽
VENUE "Play to Interact – 100 drawings on community" EXHIBITION

誰 社區寫生工作坊參加者，展覽參觀者
WHO Urban sketching workshop participants, exhibition visitors

如何 決策和製作寫生作品
HOW Decision and making of urban sketching artwork

何時 展覽階段
WHEN Exhibition period

工作坊參加者及展覽參觀者
**Workshop Participants &
Exhibition Visitors**

設計師
Designer

參與式設計（用家為本）
PARTICIPATORY DEISGN MODEL
(USER-CENTRED MODEL)

06 香港西灣河協青社板場
SKATEPARK, YOUTH OUTREACH,
SAI WAN HO, HONG KONG

你是一位在協青社學滑板的年輕人，你參加了「太想滑翔」計劃，與義工一同翻新改造位於西灣河協青社的滑板場，打造全新的滑板場。請運用你的創意，把舊滑板設計成滑板場的牆上裝飾。

You are a young skateboarder who joined the YO BRO! Skate4Good programme. You are now invited to participate in refurbishing the skatepark at the Youth Outreach building. Please draw and share your idea on using the old skateboard in making a wall decoration.

參與式設計項目清單
Participatory Design Checklist

地點　香港西灣河協青社板場
VENUE　SKATEPARK, YOUTH OUTREACH, SAI WAN HO, HONG KONG

誰　滑板愛好者「板仔」
WHO　Skateboarders

如何　諮詢和決策
HOW　Consultation & Decision

何時　設計階段、施工、完工後
WHEN　Design Stage, Construction & Completion

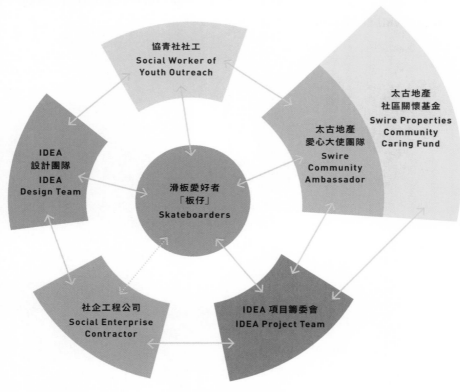

參與式設計（用家為本）
PARTICIPATORY DEISGN MODEL
(USER-CENTRED MODEL)

07 《人人 + 參與 + 玩樂 = 藝術》展覽
"PEOPLE + PARTICIPATION + PLAY = ART" EXHIBITION

你在參觀《人人 + 參與 + 玩樂 = 藝術》展覽時，拿起一張方格咭，用紅、黃、藍、白的方格，設計不同的藝術圖案，表達你心中的藝術品。

You are visiting "People + Participation + Play = Art" exhibition. Pick a grid card and colour a loverly Pixel Art Pattern by filling in RED, YELLOW, BLUE and WHITE colour blocks.

參與式設計項目清單
Participatory Design Checklist

地點 VENUE	《人人 + 參與 + 玩樂 = 藝術》展覽 "PEOPLE + PARTICIPATION + PLAY = ART" EXHIBITION

誰
WHO — 展覽參觀者
Exhibition Visitors

如何
HOW — 決策
Decision

何時
WHEN — 展覽藝術作品設計階段
Artwork Design in an Exhibition

參與式設計（用家為本）
PARTICIPATORY DEISGN MODEL
(USER-CENTRED MODEL)

展覽參觀者
Exhibition Visitors

設計師
Designer

CREATING SPACE FOR PARTICIPATION

Participatory Design in Architecture

讓空間留白

參與式建築設計

責任編輯 趙熙妍

書籍設計 曦成製本（陳曦成、焦泳琪、鄭建啓）

書名 讓空間留白——參與式建築設計

作者 王建明、梁皓晴、陸明敏

攝影 戴毅龍（社區百繪集）、陸明敏（部份受訪者相片）

出版 P. PLUS LIMITED
香港北角英皇道 499 號北角工業大廈 20 樓
20/F., North Point Industrial Building,
499 King's Road, North Point, Hong Kong

香港發行 香港聯合書刊物流有限公司
香港新界荃灣德士古道 220-248 號 16 樓

印刷 寶華數碼印刷有限公司
香港柴灣吉勝街 45 號 4 樓 A 室

版次 2023 年 5 月香港第一版第一次印刷

規格 十六開（170mm x 220mm）352 面

國際書號 ISBN 978-962-04-5103-4

© 2023 P+

Published & Printed in Hong Kong, China

Acknowledgement Organisations (in alphabetical order)

Architectural Studies Subject Group, HKU School of Professional and Continuing Education

Art Promotion Office, Hong Kong Leisure and Cultural Services Department

Cambodian Children's Advocacy Foundation Organization

Caritas Kai Yau Nursery School

Design For People Co. Ltd.

Future Village, Nepal

Greenside Primary School, London, United Kingdom

Hong Kong Architecture Centre

Hong Kong Sheng Kung Hui Welfare Council

IDEA Design Hub CIC, United Kingdom

IDEA Foundation

Kalki Welfare Society, India

Little Green Feet

National Technical Training Institute, Cambodia

Oil Street Art Space

Scout Association of Hong Kong

Swire Properties Community Ambassador

The Hong Kong Institute of Architects

Ying Wa College

Youth Outreach

Reference:

Bannon, L. J., & Ehn, P. (2013). Design: design matters in Participatory Design. In *Routledge international handbook of participatory design* (pp. 37-63). Routledge.

Binder, T., Brandt, E., Ehn, P., & Halse, J. (2015). Democratic design experiments: between parliament and laboratory. *CoDesign*, 11(3-4), 152-165.

J. Simonsen, T. Robertson. (2013). *Routledge international handbook of participatory design*, Routledge, New York (Eds.), pp. 1-17.

Jones, J. C. (1971). *Closing comments. Design participation*. London: Academy Editions.

Sanoff, H. (2010). *Democratic design: Participation case studies in urban and small town environments*. VDM Publishing.

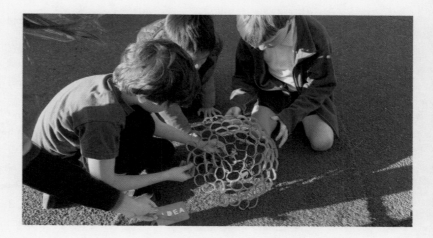

worldview. The Architectural Design Education Programme, developed for use in preschools to primary schools, holds the potential for developing children's imagination, creative and critical thinking skills, communication skills, and ability to express their feelings. Including architecture study in education programs can help develop the positive attributes necessary for global citizens of the 21st century.

Looking forward, in these uncertain times, there is a need to question how architecture is now practised, including architects and designers to develop alternative ways to engage people, communities and the public in the design process. There is still ongoing mutual learning between architects and users in architectural participatory design. This new understanding will certainly contribute to better spatial awareness and mutual communication among different parties in shaping better environments.

throughout these practices, the participants/users become empowered and grow through understanding their own capabilities.

IDEA as a Participatory Design Platform

IDEA is a representative of the participatory design communication platform. Starting from the concept of co-design, IDEA has been engaged in design education and the promotion of participatory design in different Asian countries and regions (Hong Kong, Cambodia, Nepal, and India) since 2009. IDEA stands for Involve in Design, Empower with Action. It is a community that participates in imagination, design thinking, experiential learning, architecture and art. In participating in the design, people understand that different design schemes can not only solve social problems, but also extend the meaning to a wider range.

The purpose of learning architectural design is not just to train architects and designers, but to believe that good architectural design and a pleasant environment are the most basic needs and rights of human beings and are the basis of all aesthetic education and design. IDEA believes that understanding and appreciating architecture and art shouldn't be a luxury, but a right of every human being. Therefore, IDEA has been committed to making architectural design accessible to everyone and enjoying the aesthetics of architectural design, regardless of the environment, physical or economic conditions of the participants.

From 2021 onwards, IDEA has expanded a new chapter in the U.K. to promote Architectural Design Education Programme for children. We believe that when young children have the chance to reach out for aesthetic education, it will be beneficial to their future development in understanding the space around them and being more aware of the environment they are in. So, it is of paramount importance to start aesthetic education at an early age. We believe that all children are natural designers. If children discover architecture early in life, they may be able to effect change in the environments in which they act, such as playgrounds and neighbourhoods. Architectural education can easily be integrated into school programmes alongside the content-area curriculum. This approach to architecture education may be the best way to educate children in this subject matter because it will promote a holistic

3 Experiential Learning

Participatory design involves doing something concrete and tangible. It has developed a variety of tools and techniques to support collective 'reflection-in-action' to enable participants to participate in design. The *"extensive use of material mock-ups and prototypes led to new ways of performing design in participatory design through 'design-by-doing' and 'design-by-playing"* (Bannon & Ehn, 2013). It is an ongoing process, with cycles of design experiment and evaluation (Binder, Brandt, Ehn, & Halse, 2015). Through hands-on experiential learning, participatory design helps different participants to express their needs and visions.

4 Architecture & Art

Although architectural participatory design seems new to the Asia-Pacific region, it has started in the Western countries since the 1960s. There have been re-alignments in understanding architects' relationships with users and with design research, as it is undertaken through practice. The architectural participatory design project acts as a site for mutual learning

between architects and users, and may include the participants' changed understanding and appreciation of the value of the community in which they live, as well as concrete changes to spatial arrangements in the environment. During such practices, there are changes in the mindset, knowledge, emotions and social relations of people who participate in such practices. It is believed that

We believe Jones' statements on the important part that participation plays in helping people to change. This perspective connects with social change and uses design as a medium to transform situations, to make better futures, using design processes in creative ways to engage more people in finding solutions to complex problems. Indeed, the social transformation of neighbourhoods is enabled through participatory design in the field of community architecture where, *"Participatory design is an attitude about a force for change in the creation and management of environments for people. Its strength lies in being a movement that cuts across traditional professional boundaries and cultures. Its roots lie in the ideals of a participatory democracy where collective decision-making is highly decentralised throughout all sectors of society, so that all individuals learn participatory skills and can effectively participate in various ways in the making of all decisions that affect them."* (Sanoff, 2010, p. 1)

2 Design Thinking

Participatory design is *"a process of investigating, understanding, reflecting upon, establishing, developing and supporting mutual learning between multiple participants in collective 'reflection-in-action'. The participants typically undertake the two principal roles of users and designers where the designers strive to learn the realities of the users' situation while the users strive to articulate their desired aims and learn appropriate technological means to obtain them."* (Robertson and Simonsen, 2013) Participatory design encourages and enhances the understanding of different participants, by finding common ground and ways of working.

Looking Forward to Participatory Design

Design belongs to everyone. It influences how we live, what we wear, how we communicate, what we buy, and how we behave.

In order to design for the real world, we need collaboration from the stakeholders involved. We need to learn how to understand and solve problems together and how to solve intricate and often unexpected problems. This book showcases how involving all stakeholders and cross-disciplinary discovery can deliver effective solutions to complex problems.

While the book provides a great overview for designers that are interested in learning about participatory design and how to use them, it is also useful to strategists and decision-makers as it can expand their problem-solving toolkit to incorporate users in the design process in the pursuit of new, original and better outcomes.

Design a co-creation process between designers and users. We believe that it is essential for us to learn, analyse, and develop co-design solutions which can contribute to improvements in quality of life. Four major elements of co-design include: 1) involvement and inspiration; 2) design thinking; 3) experiential learning; and 4) architecture and art.

1 Involvement & Inspiration

John Chris Jones once said:

"People in the design world should begin to look deeper not only into the political sense, but also into the possibility of helping people to change. Participation may be one educational approach to this." (John Chris Jones, 1971)

out their opinions, and understand how to respect each other's views and choices." On the other hand, parents can learn to listen to the needs of their children and respect children's choices. They believe design can be a medium to connect people and build up relationships for family. Cici hoped that through participatory design, her children will flourish to live in an environment in which they have the chance to participate, build up a strong sense of belonging to the community and contribute back in the future.

"People + Participation + Play = Art" – Art Exhibit at 2018 Hong Kong-Macao Visual Art Biennale

Duration
2018
Location
Beijing Minsheng Art Museum, Zhejiang Art Museum, Silk Road (Dunhuang), China
Host and Partners
Leisure and Cultural Services Department of the Government of Hong Kong
Cultural Affairs Bureau of the Macao Government
Gansu Provincial Department of Culture
Zhejiang Provincial Department of Culture
Design Team
Robert Wong, Gwyneth Chan, Sam Lam, Cici Lam
Stakeholders' Participation
Children
Visitors in exhibition

use their imagination. She stated, "In the past, the kids were able to create a game with only tree branches and stones. I think blocks are a great tool to help the kids develop their own creativity and train their muscles. And if they can even build blocks in their own ways, that will certainly help develop their imagination." She was pleased to see "People + Participation + Play = ART!" as one of the examples that could be treated as a game to foster the parent-child relationship when they had a platform to co-create artwork together and understand each other in conversations.

Before the Biennale exhibition, the prototype of "People + Participation + Play = ART!" had been exhibited within the School of Architecture at the Chinese University of Hong Kong during their 25th Anniversary Alumni Exhibition at Time Square in 2017. The artwork had been so popular among the public, and the artwork was always surrounded by groups of children who tried to fill in their imagination by interacting with the blocks. Surprisingly, Cici noticed that different audiences would create varying patterns, even using the same object. During the exhibition, she saw a 2-year-old child grab 2 pieces of blocks and used them as drumsticks to create sounds. Cici found that there is no limit to children's imagination when children have the chance to interact with simple objects, even a brick. "In psychology, there is a concept called multiple intelligence. Everyone has their own talents and unique dimension of intelligence. Sometimes, it is beyond adults' imagination of how the way these children express their creativity. This in turn reminds us as adults that we have to think outside the box for creative solutions."

The participatory design approach was also adopted in Robert and Cici's family when handling housework together. For instance, they would involve their sons in painting the wall and ask them to voice out their preferences for the colour of the paint they want. The shared work strengthened the family relationship, as well as built bonds within the family. "By involving children in design work, they learn how to express their own ideas, voice

Robert would also like to thank his wife, Cici, for the idea of inspiration for making a larger art installation of "People + Participation + Play = ART!" in the exhibition. Cici found that the most enjoyable activity was engaging her two sons and allowing children to express their thoughts and ideas freely by means of creation.

Robert and Cici believed that it would be important for the children to involve in hands-on activities and adopt a "design thinking" approach in the development process of this artwork. They took their sons to go through the whole process of designing and making the art installation, such as purchasing the materials, sawing the woodwork and assembling multiple parts together. Both of their sons voiced out their favourite colour and sprayed the paint on the prototype. Robert was glad to see the family's involvement in making such participatory artwork happen.

As an educational psychologist, Cici is always keen to understand how she could apply child psychology in parenting. She pointed out that since children may not have enough vocabulary to express themselves, art and co-creation can be a medium to benefit children in expressing themselves to others. She pointed out that for children, it is important for them to have hands-on experience and use a multi-sensory approach to help the children understand the objects around them. Sensory stimulation, such as the touch, the smell, the sound – all these senses will stimulate the brain of children and assist them to learn better. However, she pointed out that nowadays, most of the toys available in the market are all ready-made products, which has predetermined the way how the kids interact with the toys. In this regard, not much space has been left for children to explore and

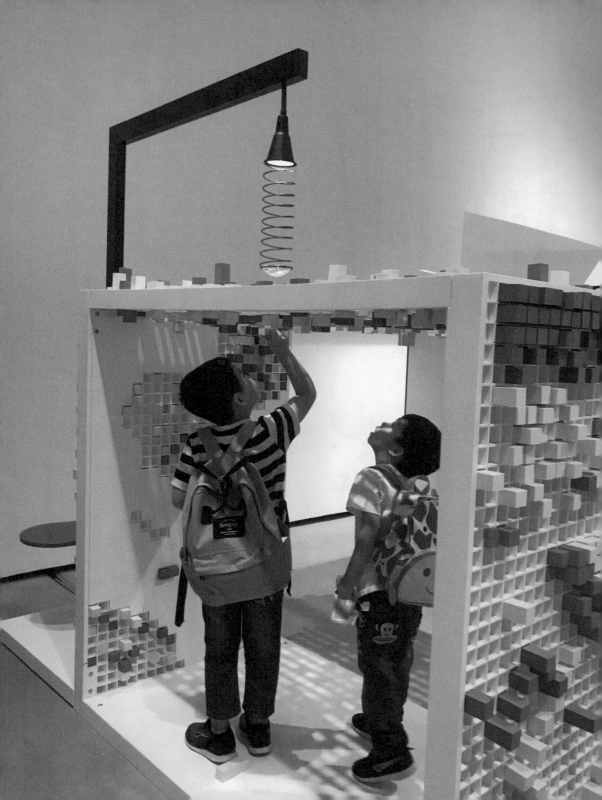

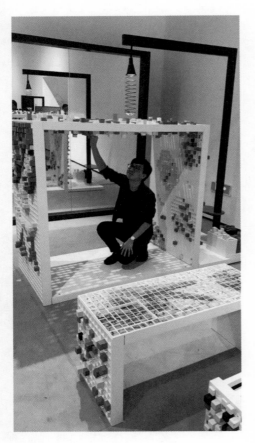

"People + Participation + Play = ART" was structured in a simple way so that every audience could easily understand the installation work and interact with its elements. Robert explained that the artwork is more than just a decoration. The work could further extend its meaning as a training tool for kids with special needs and the elderly struggling with dementia. These vulnerable groups could benefit by participating in manipulating the blocks, matching the colours and creating different patterns to stimulate their sensibility, enhance their concentration and even eye-hand coordination.

Participatory design enriches kids' social skills

Although the art installation of "People + Participation + Play = ART!" was developed by Robert, he was so grateful to have a strong team back up his idea in creating the artwork. The team included social workers and occupational therapists from Hong Kong Sheng Kung Hui Welfare Council. In 2016, when the team refurbished elderly centres and early education training centres under the welfare council, they tried to combine the idea of playing blocks in the projects. The team appreciated much of the cross-disciplinary collaboration and effortful communication to make a therapeutic design product, namely the "P-cube", successfully installed in the centres. The users thanked the team to utilise the space in an effective way to integrate rehabilitation elements by setting up the "P-cube" wall for the elderly and young children to interact with. The successful experience has once again strengthened the teamwork and enhanced the "human-centred" approach to solving future problems.

to build the artwork together by putting the blocks in the installation. The children were lured to the dynamic and interactive nature of the installation and found it interesting to co-create the design of the art installation. The designer, Robert Wong, stated that he intended to reflect the meaning of architecture through his work, "Everyone should have been given an equal opportunity to enjoy and access the design of our environment. Architecture is not only about the design solution of a building, it is a process for everyone to understand and interact."

Robert elaborated on the four major elements of making up this artwork. The first element was the tunnel that allowed children to pass through. It was not an ordinary tunnel. It was a tunnel that was built with a spacing wall. The exterior part was lined with void grids, while the interior part was structured with wavy void grids, displaying the relationship between "Solid and Void". The second design feature was that participants were allowed to insert small colourful blocks within the grids, eventually creating a wide array of patterns. All small blocks were painted red, yellow, blue and white. It formed the basis of the three fundamental colours.

The spring lamp that was set up behind the passageway was the third design component. Children enjoyed the moment when they went through the passageway. The lamp was situated at an upper level, and their parents could see their children passing by the passageway from the grids at different angles. Switching the roles, the parents could squat in the passageway and look upward to view their kids from the perspective of a kid. Although the structure of the spring lamp looks simple, it was an aesthetic-oriented design. Moreover, when the children touched the spring lamp, the lamp would create a vibrating effect, radiating rays of light and shadow. The 3D effect was backed up by the pattern created by the bricks input by the participants. The work created a special effect as a dynamic and mobile drawing.

Apart from the spring lamp, there was a set of furniture accompanied by the installation. It was a set of table and chair where children could use their imaginations to create different patterns and forms for their desired tables and chairs. Undoubtedly, the participants found so much fun and accomplishment when they were welcomed and engaged in creating the installation work.

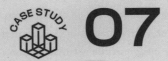

07

People+
Participation+
Play
=Art!

Small play blocks inspire the kids' huge imagination

➡ **When the 2018 Hong Kong-Macao Visual Art Biennale, themed "Urban Touch" took place in Beijing, a large-sized installation artwork "People + Participation + Play = ART!" ostentatiously drew attention from the audience. The installation especially attracted the young kids who have the chance to manipulate the small blocks within the exhibition. This was one of the few interactive artworks that involved the audience's participation.**

Under the theme of "A dialogue with the City Encounters", the Hong Kong chapter showcased eight designers' artworks. All of these designers are architects and artists from Hong Kong. Their artwork expressed the message of the role of spatial design in shaping urban life. The installation work, "People + Participation + Play = Art", was created by children, parents, therapists and designers. The installation work was situated to invite the audience to participate and unleash their creativity

"Without skateboarding, I could never live my life as I currently do. I need to say thank you to my skateboard, the Hangout and Tat Tat. One's influence on someone's life can make a huge difference." Ah Ting showed her gratitude for what she experienced and for whom she met at Hangout.

For the renovation project of the skatepark, Ah Ting never imagined that she would have been able to help recreate the venue even if she was always one of the users. "We can learn different skills in woodworking and try out some new experiences. We do not only play and learn at the same time, but we are also the users of the venue. We really enjoyed the wonderful time in the workshops!"

INFO·BOX

Yobro SkateForGood

Duration
2015–2016
Location
Youth Outreach Jockey Club Building, Sai Wan Ho, Hong Kong
Cooperation Organisations
Youth Outreach
Swire Properties Community Ambassador
Designers
IDEA Hong Kong Project Design Team: Abby Au, Jackie Wong, Robert Wong, Tung Ping Ping, Selina Mak, Vince Cheung and other volunteers
Young skaters
Stakeholders' Participation
25 Skaters in Youth Outreach
20 volunteers from Swire Properties Community Ambassador
Social workers of Youth Outreach
IDEA Project volunteers

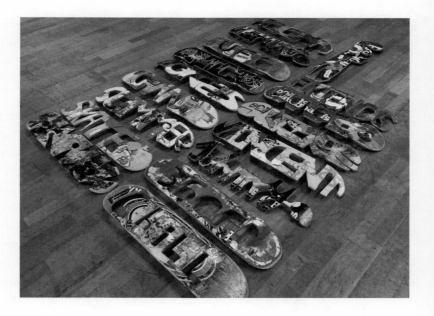

For Ah Ting, the most unforgettable memory about skateboarding is the accident that she fell from a 5-stair-high slope. She was sent to the hospital because of a fracture. "A grade 5 boy showed off to me with a cocky attitude when he was able to do tricks on the ramp. I thought I should have been able to achieve that same trick because relative to him, I was at a higher skill level and had deeper experience. However, I lost control of my legs at the end and the accident happened." The physical injury was a tremendous setback to Ah Ting as skateboarding was her life. After recovering for half a year, she finally had the smile light up her face again when she was able to resume the sport. Meanwhile, she had a personal reflection, "I was a stubborn person before the accident. Even if other people gave me advice, I just ignored them. Now I realize that I need to accept other people's opinions. I should not force myself to do something when I am not ready. I should get myself well-prepared by practising. In the end, my skateboarding technique has greatly improved, and much better than the previous version of me."

Secondly, the end users' involvement will help generate a sense of belonging to the space. Individual skateboarder contributes his insight and creates a mutually supportive culture within the community. "We care about co-creation with our target audience so as to make the change and positive impacts together."

If Hangout is seen as a miniature community, the user's involvement in the creation of space is also a form of empowerment. The value of human beings and the community can only be possibly increased when everyone has a voice in the area in which they live. Value is one of the core elements of the participatory design project. Bobo expressed her opinion, "Participatory design projects that facilitate mutual interactions to engage people in the community should always be promoted. Nowadays we always talk about social capital. If only the rich can contribute to the community and the poor cannot do anything, social capital is always limited. On the other hand, if we can get everyone involved in the community projects, enabling them to leverage their expertise, the social capital will accumulate on an ongoing basis as well as adding value on multiple levels."

Skateboarding changed my life

The establishment of the skatepark at Hangout did not only provide a training venue for ambitious skateboarders but was also a catalyst to change for some people in their lives, such as Ah Ting. In 2014, Ah Ting joined the skateboarding team when she was only 15 and became an employee of Youth Outreach. Now she is operating an online store selling skateboarding equipment, and exploring more possibilities in the sport of skateboarding.

When Ah Ting was young, she was relocated to a hostel due to family problems, which led to her low self-esteem issue. However, by practising skateboarding, she regained her confidence. During her time working at Hangout, it was common to find Ah Ting practising skateboarding more than 9 hours a day, and sometimes she would practise even until midnight. Ah Ting explained, "It was exhausting but I feel thrilled". While overcoming the challenges, skateboarding acts as a means to relieve Ah Ting's tension. Skateboarding has also helped Ah Ting to improve her weakness and face her difficulties.

in Swire Properties assisted in hand-making the bench with old skateboards. Starting in 2011, the Community Ambassador Programme team has been organising projects that address the needs of the neighbourhood, while building friendships, teaching new skills and enriching the well-being of the greater community.

Bobo Leung, the community relationship manager from Swire Properties, remembered that Tat Tat hoped skateboarding would be listed as an Olympic event; and Tat Tat would like to promote skateboarding sport to the public in different ways so that more people would join the league as skateboarder. Bobo was impressed with his vision so she was determined to support the skatepark renovation project. "During our first meeting, the skateboarders mentioned that Hangout can provide a space for them to skateboard freely while skateboarding on streets is bounded by a lot of constraints. If the skatepark in Hangout could be improved, more young people would be motivated to practise there."

Theoretically, even without the skateboarders' involvement, the renovation project could be done by designers and contractors. However, Bobo thought the users' participation was of great significance to the project. First, the users' needs were better considered in the design process and it made the site redesigned into a more stylish and user-friendly venue for skateboarding. For example, there are certain specifications on the radius and weight of the skateboarding facilities in the skatepark, so the routes can be constructed for skaters in a particular way. At this point, the user experience is an indispensable part of refining the final details.

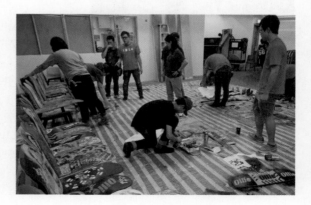

workshops have rules for us to follow which makes us feel constrained and bored. When you are allowed to freely design what you like in the skatepark, you will be inclined to have greater involvement. When I was involved in each step, from sewing and cutting to installing woodwork, I felt much more excited when I saw the end product." Summer was attracted to renovating the skatepark due to its unique approach compared to other general workshops. Tat Tat also agreed that even skateboarders do not decide the vision of the project, they nonetheless have their own ideas on details. "For example, they were given the autonomy to decide the size of the bench, the types of skateboards, the patterns and the quotes they would like to spray paint. That is how they can see their contributions to skatepark recreation in the workshops."

Upon the project's completion, all skatepark users were delighted. The venue is now qualified to be a stylish skatepark. Increasingly more new skaters are flocking over to try the amenities. "The skateboarders find the

venue has more flow now, which means that it is easier getting from one location to the next. A good flow is an essential element in skateboarding. Before the renovation, they needed to stop at a certain spot due to the limitation of the skate structure and equipment. Now, the ride can keep going forward. As the routes for training and practice for competitions become more diversified, it will continue to bring in more skateboarders." Tat Tat explained. With a stylish skatepark, more skateboarders invited their friends to come and Tat Tat was so glad to see a welcoming venue to attract the teenagers to learn.

Participation enriches our social capital

Sponsoring the renovation project, Swire Properties Community Ambassador also invited their corporate staff and technicians as volunteers to lead the design workshops and provide technical support. For instance, the special maintenance crew

design team to highlight the site venue with more features to bring people to recall Hangout and the skatepark. Tat Tat elaborated, "From the designer's perspective, the skatepark might look the best by imitating the dominant style of the skateparks in western countries. Yet, we wanted to highlight the characteristics and culture of Hangout in our place. We might not have the elements which are aesthetically exquisite or splendid, but people will find the pieces that exclusively belong to the skateboarders and Hangout."

In addition to the decoration, there were three newly built structures in the skatepark: a skate platform, a quarter pipe and a curved skate bench. The refurbishment project was supported by Mr Tai Yuen Ming, a construction professional from a social enterprise engineering company. It was a new challenge compared to other renovation projects. The ramp of the quarter pipe and curved skate bench both required precise instruments and a specialized technique to achieve accurate results during the building phase. The requirements of this quarter pipe were up to international standards.

Influenced by the IDEA design team and Tat Tat's passion for this project, Mr Tai also aimed for a higher standard to make the end products perfect. The ramp surface of the quarter pipe was tailor-made with iron, which the more sophisticated technique required because its material is more durable than the previous facilities in the skatepark. It is a hotspot where skateboarders like to perform a drop-in tricks. The curved surface on the skate bench, which allowed skateboarders to do grind and slide tricks, is a rare find in Hong Kong. There is a similar one in Fanling, which has been the closest location to Hangout. Thus, the reconditioned skatepark with these new structures in Hangout was considered great news to the skateboarders in Hong Kong Island East.

Young skateboarders enjoy the participatory design

Looking at these five workshops, the young skateboarders' participation was quite high. Some of them even told the volunteers they would like to stay in the skatepark for decoration beyond the hours in workshops. "These workshops are fun to attend. I was never asked to do things in a certain way such as what colour I can only use and what stickers I should pick. I am free to draw whatever I want. Generally, other

skated was an outstanding reminder of our growth."

During the fourth workshop, old skateboards were made and built into benches and hanging shelves. Inspired by the skateboarders who used to sit on the ground, the IDEA designers suggested combining multiple abandoned skateboards and building them up into benches. Skateboarders were invited to spray paint the skateboards with their favourite patterns and quotes, followed by the eventual grinding, buffing, sawing and toning of the woodwork. The obsolete sports equipment was then transformed into a uniquely designed brand-new bench within the skatepark, and it also became a smoking spot where skaters enjoyed hanging out. Tat Tat commented that the facilities in the skatepark get damaged quickly except for this skateboard bench, which was handmade by the young skaters. Everyone protects the bench well. Sometimes when they had a smoke break together, they talked about the bench and told people it was designed by themselves. "The general skateboarding amenities might exist in other skateparks. However, only this bench is identified as a remarkable, one-of-a-kind signature and iconic piece within our skatepark. The young skateboarders might leave cigarette burn marks everywhere but this bench is always clean. They might not express themselves well by speaking, but their behaviour has underscored the deep respect they have for this bench and its significance."

In the last workshop, volunteers and skateboarders worked together to decorate the wall and facilities in the skatepark by spray painting encouraging quotes such as "Practice Makes Perfect" with masking tape. These quotes were constantly within sight of the skateboarders when they practised skateboarding within the park. Skateboarders not only painted the messages and patterns they loved on the wall, but it also inspired the IDEA

and the old skateboards now have become a part of the skatepark, and brings along a tremendous amount of reminiscent value. Your favourite equipment is now structured within your favourite place." Skateboards are typically made of 7 to 9 layers of maple. There are different colours between the layers. Another skateboarder, Tang Sum Yi (Summer) applied the skills she learned from the workshop to create beautiful necklaces by grinding and polishing the remaining skateboard materials. Creativity sometimes can be sparked in unexpected ways.

Dropped ceiling and spray-painted graffiti

The third workshop was to design the ceiling by spray painting. Fluorescent lighting was selected to improve the poor illumination. To enhance the interior design, the IDEA team suggested that the fluorescent tubes could be hidden above the dropped ceiling, allowing the skateboarders and volunteers to decorate the top by spray painting, as well as maintaining the appropriate brightness indoors. The young skateboarders shared the fact that it was popular to mount remote-controlled spray cans on the bottom of skateboards in foreign countries so that wherever skateboarders would ride, a trail of paint would follow their path. The IDEA team immediately came up with a manual version – to grip tape the spray cans on the skateboards and it would produce the same effect, and the skateboarders found the result astounding. The colour set of the spray cans was intentionally selected by the IDEA design team. Abby Au explained that only the primary and luminous colours were chosen in order to create a sharp contrast. No matter how people skate with spray paint, the trails they made would always form an artistically pleasing pattern on the dropped ceiling. Tat Tat was deeply impressed by the design, "We always fall down when skateboarding. When we pick ourselves up from the ground and glimpse up to the ceiling, seeing the trails we once

how to skateboard from the young skaters. Ah Ting, a 5-foot-tall skateboarder, managed to support another 6-foot-tall volunteer to help her balance on the skateboard. "Tall people find it more difficult balancing themselves. If they have nobody to assist them in the early stages of learning, it can be dangerous. When I found her starting as a new skateboarder who knew nothing regarding the technique, and ended up learning how to skate straight and switch directions on her own, I felt so proud!" recalled Ah Ting. By transferring the skateboarding

skills and knowledge to the volunteers, the young skateboarders certainly leveraged the techniques that they were so proud of and had taken so long to master themselves. On the other hand, learning how to skateboard was also the first stepping stone to understanding the subculture of the IDEA design team. This was an incredible opportunity to enhance mutual understanding and facilitate all communication.

After the ice-breaking session, the design process started in the second workshop. Participants were asked to decorate the wall in the venue with abandoned old skateboards. Skateboarders needed to draw the stencil with their names on it, trim them by tracing the shapes, and finally, smooth the structure with sandpaper. Skateboarders were excited in this session as these old skateboards represented their precious journeys, and all of their "ups and downs" in the learning process symbolically. Before the session, the old skateboards were supposed to be dumped in the landfills, but now these skateboards were reborn after being recycled as a decorative aspect of the skatepark. All participants recalled their fond memories from the past. Ah Ting shared her thoughts on this idea: "I have never imagined that these old skateboards could be refurbished in this way. Although the renewal process made me sweat a lot, it is meaningful

After a discussion with skatepark users, the IDEA design team decided to carry out four design tasks and missions to renovate the skateboarding space for Hangout. The first was to improve the visual appeal of the location, giving the location a great vibe that would exclusively attract young skateboarders. The second was to increase the number of facilities for practising tricks. The third design task would be providing seating for smoke breaks and the fourth mission was to improve the lighting in the skating area. The overarching and most critical mission was to engage young skateboarders in the design and refurbishment project. Skateboarding facilities design were customized and made by professional craftsmen based on the recommendations from the skateboarders and the trainers. To cultivate their sense of belonging, young people were invited to join the 5 design workshops organised by the IDEA team to co-design the venue together.

Old skateboards as part of the skatepark

The renovation work lasted three months. Over 30 teenagers aged 12 to 20 participated in the 5 workshops. They were characterized by being active and lively, and energetic. To capture the young skateboarders' attention, the workshop sessions were organized with a dynamic approach.

Young skateboarders used to watch video clips online. It inspired the IDEA design team to organise a skateboarding-themed micro-movie festival at the first design workshop. Skateboarders were asked to introduce themselves through videos. Jackie, a multimedia designer in the

IDEA team explained, "When I first met them, I was deeply interested in understanding why they loved skateboarding so much. We wanted to immerse our participants into the design project immediately so that they could begin thinking about how an ideal skatepark should be for them."

Interaction between the volunteers and young skateboarders was paramount in the design workshops. Volunteers needed to learn

were insufficient skating facilities. The poor lighting always led to accidents and injuries when skateboarders practised tricks at night. This was shared by an enthusiastic skateboarder in Hangout, Lui Yi Ting (Ah Ting). What skateboarders love most in skateboarding is playing tricks. Previously, they could only practise on basic facilities such as railings and stairs. If they would like to practise higher-level skills, they had to go to other skateparks. Tat Tat said, "Actually, as a skatepark, it's pretty bad. There are only ordinary and fragile wooden props here, which will be soaked in the wind and rain." He admitted that the skatepark in Hangout was a safe and secure place for teenagers, without the risk of being approached by gangsters.

When he learned that the skatepark will be undergoing a major renovation, he was so pleased, "Of course, skateboarding is a trendy sport. We skateboarders all look forward to a new and more trendy image as it will be easier to convey the stylish message and attract other skaters to come and join us."

06

YO BRO! SKATE4GOOD

Radical revitalization of the Skatepark at Youth Outreach, Hangout

Operated by the Youth Outreach, Hangout (a 24-hour drop-in centre) provides teenagers with a platform for "Youth Culture Base, a Unique and Innovative Cultural Platform" through training classes such as skateboarding, e-sports and street dancing. The platform not only helps adolescents boost their self-confidence but also potentially saves high-risk youth from going astray. In 2014, the on-site skateboarding coach Cheung Hang Tat (Tat Tat) in Hangout wanted to form a skateboarding team with the youngsters. Targeting to improve the outlook and facilities of the skatepark, the Youth Outreach partnered with IDEA and Swire Properties Community Ambassador to undertake the "YO BRO! SKATE4GOOD" programme that brought 30 young skateboarders and volunteers to help renovate and transform the skateboarding space into a new "hangout" spot. The skateboarders were all proud of the project and felt that a strong sense of achievement had been reached.

According to Tat Tat, the site was just a small open space for skateboarding, but not a proper skatepark. It was not stylish at all. There

Anthony observed that the participatory design approach applied in Hong Kong was mainly public voting, which may not be considered as a good practice. "Among the architectural projects in the UK, it is quite common to include the participatory design approach in the design contract. The designers are required to organize workshops for public consultations, so as to collect feedback from stakeholders in the area to be developed. Once opinions are gathered, they need to design a fair selection system to sort out stakeholders' opinions. A design cannot simply be a combination of random opinions, but needs to be carefully balanced with different aspects such as the users' opinions, the history and culture, and even the aesthetic concerns. Otherwise, the design might not look satisfactory even if it is an outcome derived from public participation. As a consequence, and over time, the participatory design approach may not be widely accepted as we hope." Anthony further explained. "Participatory design does not mean everything can be determined by the participants. Only when they have a certain degree of understanding of the project and have established their own standpoint on what the project should be, can meaningful discussion be formed." Aron agreed.

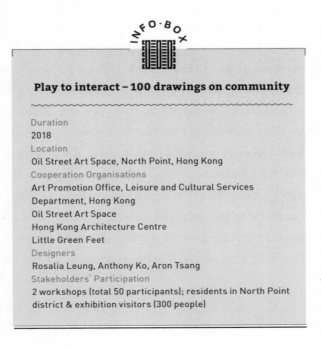

INFO·BOX

Play to interact – 100 drawings on community

Duration
2018
Location
Oil Street Art Space, North Point, Hong Kong
Cooperation Organisations
Art Promotion Office, Leisure and Cultural Services
Department, Hong Kong
Oil Street Art Space
Hong Kong Architecture Centre
Little Green Feet
Designers
Rosalia Leung, Anthony Ko, Aron Tsang
Stakeholders' Participation
2 workshops (total 50 participants); residents in North Point
district & exhibition visitors (300 people)

In Aron's opinion, compared to other participatory design projects, the exhibition was more likely to design a situation for participation. "Participatory design does not necessarily require a productive outcome. It is just as important to challenge the audience's perception by introducing new ways of looking at the environment they are familiar with. So both designers and participants were able to reflect and explore new potentials. For designers, the most challenging, but also the most fun part is how to design different tools such as drawing, writing, modelling or psychology tests to collect the opinions from the participants." Anthony further elaborated, "As long as there are enough opportunities for the participants to express their ideas, our expectations have constantly been surpassed in terms of their ability to understand concepts and redefine space. Of course, how many instructions should be provided or which part of the framework the participants should follow is another question, but this is the designer's job."

The opinions among different stakeholders may vary. For the participatory approach to be adopted in an architectural project, besides establishing a framework to collect stakeholders' opinions, the next critical question is how to consolidate appropriate opinions so as to achieve the best design decision. Although no opinions from the participants needed to be filtered in this exhibition, it is a mandatory process in most architectural projects adopting the participatory approach.

a planter in the park. For some, "Neighbours" was defined by daily life in the wet markets; "Communal" was the scenery at the butcher store.

In general, public engagement workshops may expect the participants to express themselves through verbal communication. Yet, according to Rosalia, drawing as a medium which was suitable to all age groups, could lead to a deeper level of understanding than a pure verbal conversation. "Feelings cannot be easily expressed in a few words. Indeed, drawing is a simple and direct tool which can allow people to express their inner world in a profound manner. For example, the concept of 'communal' may not be easily described in words but can be illustrated through drawings. It does not matter whether the drawings are realistic or beautiful. The most important thing is what one can see." Aron thought that instead of modifying the physical environment, changing the way that people perceive space might bring a different perspective. "100 drawings on community" not only challenges the workshop participants' impression of North Point, but also gives a new perspective to the audiences in the exhibition through the drawings by different individuals.

Design the framework for social participation

Unlike other architectural projects, "100 drawings on community" did not have a predefined problem to solve. In this exhibition, the architects who are also the exhibition designers were not here to solve problems but to raise questions by inviting the public to express their views on our urban development. Rosalia expressed that "This is not a project that has a clearly defined design output. Instead, we need the community's participation to deliver the content. As a designer, our mission is to design and construct a framework for the public to fill up the exhibition space with their own drawings about their own district. The participatory design approach has its own value. It is not necessary for problem-solving, nor simply the means to completing a certain goal. The most important part is that the design outcome is derived from stakeholders' participation. And the outcome of this project is the exhibition itself."

were engaged and fascinated by the local stories, even the young children. After the story sessions were finished, the participants would express their thoughts through sketching a corner of the streetscape.

At the end of the tour, participants were invited by the exhibition team to share their drawings, which consisted of some authentic documentations about North Point, such as the daily human interactions, nature in the urban landscape and traditional stores in the neighbourhood. Even under the same drawing theme, the imaginations that unfolded on paper were broadly diversified. Some drew an under-construction luxurious tower, completely covered with scaffoldings under the themes "Modern" and "Future". Another participant drew the flyover close to North Point Pier under the theme "Sea", while the sea was only a minor part of the drawing. The theme "Sky" was a drawing filled with skyscrapers. Under the theme "elderly", a participant depicted the portrait of a man who sat alone next to

neighbourhood but had built strong ties with the district at some point in their lives. Before the workshop started, the exhibition team showed the participants some fundamental architectural drawing skills, such as perspective drawing and scaled drawing. The team also explained the importance of drawing in regard to the architects.

The participants walked through different North Point landmarks starting with the Oil Street Art Space, along with Boat Street, City Garden, traversing Chun Yeung Street Wet Market, Tong Shui Road and ended at North Point Pier. To deepen the experience of the participants at each location, Little Green Feet (an NGO), was invited to guide the tour to provide information on the district's cultural and historical significance. In parallel, the exhibition team were pushing the wooden cart with the sketching board during the tour so that participants were able to rest and draw at each checkpoint in a mobile setting. The interlocution of marching and drawing gave a ritualistic feeling to the entire process.

Little Green Feet, with the role of a facilitator, was an excellent narrator and could retell history in an absorbing way. The participants

pedestrians, food, modern and romance etc. were selected as drawing titles to invite the public to draw their impression of North Point. Indeed, this drawing exercise also provoked them to reflect on their interpretations of public space. "What makes North Point a distinctively interesting district is its radically ever-changing urban landscape – the new developments are continuously replacing the old buildings. Luxurious private residential towers are being built one after the other, making an interesting contrast with the remaining traditional local stores in the neighbourhood. We found these opposing dynamics so intriguing that it eventually led us to propose these two main themes for our exhibition." explained Anthony.

Drawing enhances emotional expression

The second part was the urban sketching workshop. Led by the exhibition team, more than 30 participants took part in this public event. Some of them joined as an entire family, others were young people, seniors, North Point residents, and even some who were not living in the

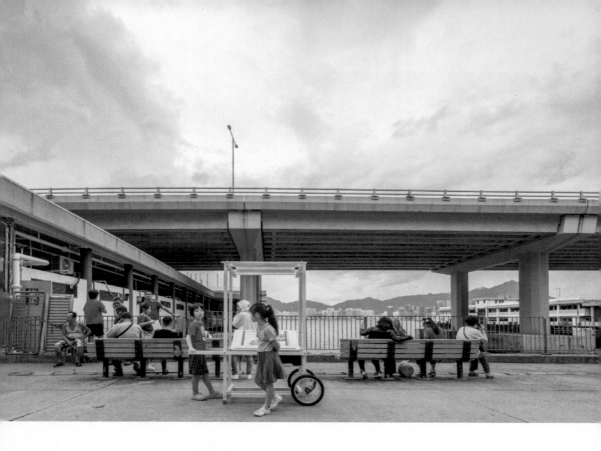

urban sketching in North Point. The artworks completed by the participants eventually became part of the exhibition displayed to the visitors. In addition to the exhibition's defined goal of social participation, it also provided the benefit of showcasing the participants' memories of their city.

The exhibition consisted of two parts. The first part was a progressive drawing archive transformed from the exhibition room at Oil Street Art Space. The walls were initially full of blank drawing papers, as if one were standing within a white gallery space. At the centre of the room, a wooden cart with chairs allowed visitors to sit and draw the North Point in their minds. The drawing papers were carefully designed with grids, dots and perspective lines that facilitated users to draw. Each paper has a unique word printed at the bottom, which was used as a guided drawing theme for the visitors. Under two main themes, "Life and Community" and "Trace and Development", 100 words such as communal, sea, change, noise, love, home,

05

100 Drawings on Community

Reconstructing our city with the power of public imagination

➤ **Without a trace, the landscape of our community silently reshapes itself beyond our recognition, while everyone hectically lives among the hustle and bustle of day-to-day life. However, it is never too late to stop, and recall our memory by pondering the transformation of our city through art. In 2018, Hong Kong Architecture Centre collaborated with Oil Street Art Space for an exhibition "Play to Interact: 100 drawings on community" which invited the public to explore the district of North Point through drawings. The artwork produced by the participants captured the vibrancy and charm of the district and its community.**

From 2017 to 2019, Hong Kong Architecture Centre and Oil Street Art Space co-organized a series of exhibitions and events themed "Play to Change", where "100 Drawings on Community" was a highlighted exhibition. Working as a team, architects Anthony Ko, Aron Tsang and Rosalia Leung, the designers-in-charge of the exhibition, aimed at providing an open platform to interact with the community by inviting them to do

Photo Collection for IDEA Schools in Cambodia

Exploratory & Experiment Stage

 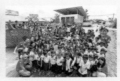 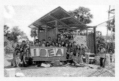

2010　　　　　　　2011　　　　　　　2012　　　　　　　2013

Development & Establishment Stage

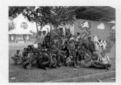 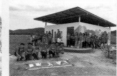

2014　　　　　　　　　　　　　　　　　2015-2017

Scaling Up Stage

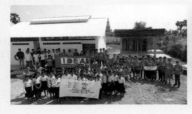 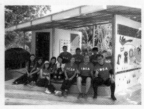

2018　　　　　　　　　　　2019　　　　　　　　　　2020

International Recognitions

Promoting community participation and global development, IDEA has continuously received different recognition in Hong Kong. These include the awardee of the Young Architect Project Fund in the Hong Kong Institute of Architects (HKIA) in 2010 and the Hong Kong Volunteer Award in the Agency for Volunteering Services. In 2017, HKIA nominated the IDEA School Project to represent the institute at the Golden Cube Award organised by the Union of International Architects (UIA).

Globally, IDEA has been widely recognised. In 2015, IDEA Project was selected by United Nations Volunteers as one of the 500 stories worldwide, recognising the role of volunteers in addressing the Millennium Development Goals. In 2010, 2011, 2012, 2016 and 2019, the project team received the certification of recognition and merits from the local government departments in Cambodia, not only appreciating its contribution to the school building construction, but also the implementation of participatory design projects to promote children's involvement in school design and building process.

Village school building projects (15 pre-schools)

Duration
2009-2020
Location
10 different villages in Kampot Province and Kampong Speu, Cambodia
Cooperation Organisations
Cambodian Children's Advocacy Foundation Organization (CCAFO)
Hong Kong Ying Wa College
Design Team
IDEA Cambodia Project Design Team: Anna Yeung, Eddie Chan, Eddie Poon, Gloria Chan, Pam Wan, Robert Wong, Andrew Yu, Angela Lee, Cherry Cheung, Abbie So and other volunteers
Stakeholders' Participation
Cambodian children, teachers and school principals
IDEA project volunteers
CCAFO representatives
Hong Kong Ying Wa College: school principal, teachers and students

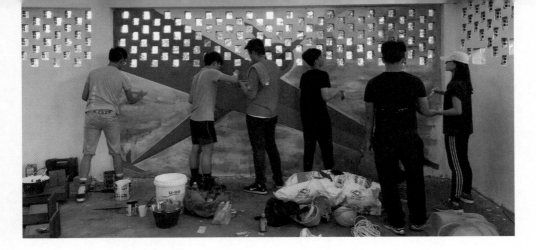

Secondly, the service-learning approach allows students to enhance their understanding of participatory design and user-centred design solutions. Thirdly, it benefits the individual student's personal development and creativity if they are given opportunities to learn to solve problems in an environment with limited resources. Finally, the students had opportunities to interact with the local children and villagers, in which they can enrich their understanding of the challenges that developing countries are facing.

Due to the global pandemic, the last volunteers' visit to Cambodia was in February 2020. To plan the post-COVID school-building activities, the IDEA project team is thinking about online education and remote learning to support the village children in Cambodia in the near future.

Participants

(including 3 school building projects):

140+ IDEA Volunteers (Hong Kong, the United Kingdom & Cambodia), CCAFO, 250+ Cambodia villagers & students, Primary school principals in Cambodia, Cambodian engineers, NTTI students, Contractors in Cambodia, 35 participants from Ying Wa College (principal, teachers & students), 18 participants from the Architectural Studies Subject Group in HKUSPACE (lecturer & students)

From 2018 to now Scaling Up Stage

A theme-based design approach was well adapted to the projects with a positive response and good feedback from children, teachers and volunteers since 2014. The IDEA project team continued this approach at this stage. Also, with CCAFO's active liaison with the Cambodian government, a number of preschools that were previously built by the IDEA project team were passed over to the local government to manage and even supported the teachers' salaries and parts of the school expenses.

While the project development matured, the IDEA team aimed to promote their volunteer service scheme to the students in secondary schools and universities, so that the participants would not be limited to young working professionals only. During this stage, the target members covered students from Ying Wa College and Architectural Studies Subject Group in HKUSPACE. The programme director of Architectural Studies Subject Group in HKUSPACE had listed the school building project as part of their curriculum and was featured in the annual architecture exhibition.

There are three benefits to encouraging Hong Kong students to participate in the school building projects in Cambodia. First, university students can strengthen their practical knowledge of architectural design and its context in the country through direct application. Secondary students had the hands-on experience to work on real school build-up projects to enrich their other learning experiences in secondary school.

TIMELINE

2018

A school compound consisting of 1 classroom, 1 hygiene booth and playground facilities was completed in Oudongk District, Kampong Speu Province, Cambodia

2019

1 English learning centre for children and teenagers and its playground facilities was completed in Krong Svay Rieng, Cambodia.

2020

2 education kiosks and 1 regular classroom were completed in Kampong Speu Province, Cambodia

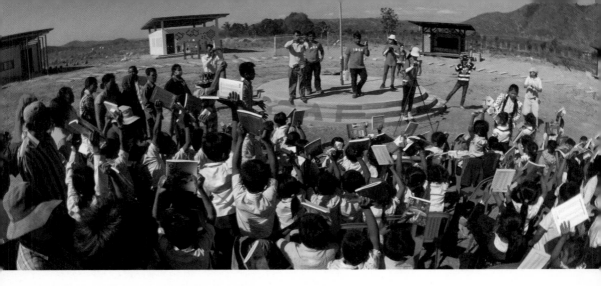

To create a more child-friendly design and learning environment, the IDEA team also invited the children from Caritas Nursery School and Scout Association of Hong Kong to join the design workshops running in Hong Kong before the design service trips to Cambodia. As a service-learning activity, young scouts were invited to brainstorm stories related to theme-based design, while senior scouts volunteered in the schools in Cambodia. In addition to designing schools in developing countries, it was also a great opportunity for the youth in Hong Kong to learn more about children's living and schooling in Cambodia.

In order to encourage volunteers' participation and build up team spirit, the IDEA project team also provided volunteers with training on basic handy crafts, cement works and carpentry skills. This also helped the volunteers to apply them in their real site work in Cambodia during the design service trips.

TIMELINE

2014

2 preschools, 2 education kiosks and playground facilities were completed in Chuuk District and Takeo District, Kampot Province, Cambodia

2015-2017

1 school compound with a comprehensive master plan in circular form (including 4 classroom buildings, 1 education kiosk, 1 hygiene booth and a playground facility) was completed in Chum Kiri District, Kampot Province, Cambodia

2014-2017 Development & Establishment Stage

After working with the local schools and villages in Cambodia for some years, the IDEA project team and CCAFO successfully developed preschool education with more and more children enrolling in the school programmes in Cambodia. With IDEA and CCAFO teams' efforts and local recognition in Cambodia, the school building projects were expanded to cover building necessary primary school education facilities in needy villages, on top of preschools. The government would fund the local teachers teaching in primary school facilities that IDEA built. In the long term, CCAFO and IDEA had been working with the Cambodian government to take over and manage the schools so that the local NGOs could step back as the primary source of funding.

There was no theme in the previous school design and starting in 2014, the IDEA project adopted a theme-based design in building future schools for preschool children. It was a large breakthrough in the design stage. There were two advantages of the theme-based design approach: (1) It was based on storytelling, which lowers the barrier for the participants both volunteers and children, without any design background to partake in the projects. (2) A theme-based design provided more interesting and absorbing elements to children and volunteers in achieving the educational objectives in the school design.

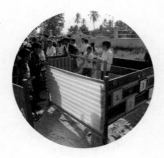

Participants

(4 school building projects):

120+ IDEA volunteers (Hong Kong, the United Kingdom, France & Cambodia), CCAFO, 200+ Cambodia villagers & students, School principals in Cambodia, Cambodian engineers, NTTI students, Contractors in Cambodia, The Hong Kong Institute of Architects (Supported in project promotion & architect volunteers recruitment), Caritas Nursery School, Scout Association of Hong Kong

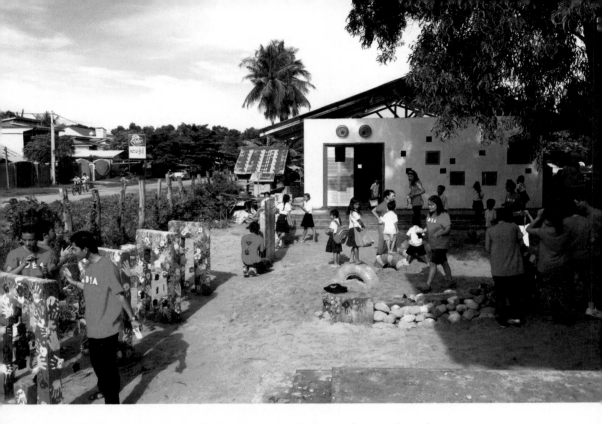

knowledge in engineering and also connect with the rural areas through civic participation. This also aroused their awareness towards improving the quality of Cambodia's education in villages. Eventually, some students were determined to influence the local society and became teachers in the preschools after they had completed their volunteer service.

Participants
(including 4 school building projects) :
120+ IDEA volunteers (from Hong Kong, the United Kingdom, Australia, France & Cambodia), CCAFO, NTTI students, 200 Cambodian villagers and students, Primary school principals in Cambodia, Contractors in Cambodia, The Hong Kong Institute of Architects (Supported in project promotion & architect volunteers recruitment)

To develop further, IDEA had the intention to engage more local Cambodian people in school-building projects. Starting in 2011, the IDEA team invited the National Technical Training Institute (NTTI) in Cambodia to collaborate in the preschool building construction. Supported by NTTI lecturer, Panha Hem, who once volunteered in the IDEA Project, the engineering students from NTTI joined the project and became volunteers to help their children and villagers in rural areas.

Together with NTTI students, IDEA volunteers organised local consultations with the children, parents and teachers to introduce the design of future schools. All of them had opportunities to ask different questions about the design and share their feedback with the design team. NTTI students acted as a strong connection between local people and overseas volunteers, not only as translators but also as design facilitators.

With backgrounds coming from Phnom Penh, the national capital, NTTI students did not know much about the rural villages. The volunteering opportunity not only enabled them to practically apply their professional

TIMELINE

2010

1 preschool and playground facility were completed in Kampot, Cam. To support the IDEA Project, both senior government officers and military members attended the opening ceremony. The project encouraged the local students to partake in and invest in their education, and provide a sense of pride in going to the local school.

2011

1 preschool, 1 library and playground facilities were completed in Kampot Provincial Town, Cambodia

2012

A two-storey-preschool and playground facilities were completed in Kampot Provincial Town, Cambodia. The upper floor was built for the classroom. The ground floor was constructed as a playground and bike parking area. The building represented a landmark to the local town and province, as it was the first two-storey school to ever be built within the region. There were more than 40 students and they were split into morning and afternoon class sessions to take lessons.

2013

3 education kiosks, 1 library and playground facilities were completed in different villages (Prey Krala Khang Ket Village, Sreprey Village & Damnak Chambak Village) in Kampot, Cambodia.

● 2009-2013 Exploratory & Experiment Stage

To launch a school building project, the important step was to build trust with the villagers and agree on the location of the school building. The IDEA design team, along with CCAFO, got in touch with the principals at the local primary schools. As CCAFO suggested, if the community agreed to build preschools within the campus of the primary schools, the local villagers would be more willing to send their children to the newly built preschools. It was because the parents and villagers would be more confident that the preschools would be well-managed and used properly.

In addition to building the schools, the IDEA programme team also facilitated the knowledge exchange between overseas volunteers and the local communities in Cambodia. Since 2009, the IDEA team had worked with CCAFO, local teachers and school principals in three distinct aspects:

1. The Design team organized design workshops with volunteers, teachers and students to encourage them to brainstorm on how to improve the campus's physical environment, adopting a participatory design approach.

2. The Education team introduced teaching methodologies that were applied in developed countries, such as interactive learning in small class sizes, to the local Cambodian school teachers. A teaching manual about activity-based learning and teaching methods was also produced to share with local teachers.

3. The Global Citizenship team focused on promoting the concept of global citizenship and equality to the students and led the volunteers to visit the schools in person, to better connect and enrich their understanding of the challenges that developing countries are facing.

In 2010, the IDEA project team was selected as the awardee of the Young Architect Project Fund in the Hong Kong Institute of Architects, recognising its innovative participatory design concept and its social impacts on the Cambodian community. The first school building project was proved to be successful.

● 2007-2009 Research & Inspection Stage

To organise and implement volunteer service in a new country, it is important to build a good relationship with a trustworthy local non-governmental organisation (NGO). In 2007, the IDEA team successfully reached out to the Cambodian Children's Advocacy Foundation Organization (CCAFO), which is an organization dedicated to developing preschool and English education for teenagers based in rural areas in Cambodia. CCAFO has been a long-standing collaboration partner organization to IDEA.

In order to demonstrate an example of the participatory design project, IDEA took the initiative to co-create school signage with the children in an informal school in Cambodian villages, when IDEA volunteers were invited by CCAFO to refurbish the informal school, build a chicken farm and water well. CCAFO and the local villagers appreciated this participatory approach.

Participants
60+ IDEA volunteers,
CCAFO, 80+ Cambodian
villagers & children,
A building contractor
in Cambodia

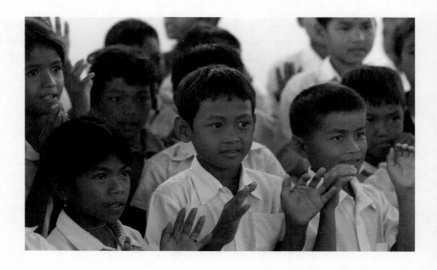

Creating Space for Participation – Participatory Design in Architecture

changes emerged and encouraged more volunteers and participants to be engaged. These were the keys that kept the project running and drove its success.

The school building projects in Cambodia were structured through 4 developmental stages: (1) Research & Inspection Stage; (2) Exploratory & Experiment Stage, (3) Development & Establishment Stage and (4) Scaling Up Stage.

Preschool education is not mandatory in Cambodia, and there are no subsidies provided by the government. All preschool nurseries (or kindergartens) in the rural area used to be located under the teachers' stilt houses or big trees. In schooling, students attend classes by sitting on mats together, where the indoor environment is lacking adequate ventilation and daylight. Given the lack of physical spaces and poor learning environments in the classrooms, the parents had little motivation to send their kids to school. They preferred their kids to stay with them to take care of the farm or earn a living. As such, the IDEA design team saw the urgency to improve the situation.

Since 2009, IDEA school building projects have supported the design of school facilities, including indoor classrooms, education kiosks, library corners, hygiene booths and playground facilities. The classrooms were designed up to appropriate design standards: the classrooms with a capacity of 40 preschool students at an area of 50 to 80 square metres; and IDEA fund-raised the building cost within the range from US$8,000 to US$10,000 (approximately HK$62,400 to HK$78,000). The education kiosk cost about US$3,000 (HK$23,400) and had a capacity of 15 students.

04

—

Participatory Design of Village Schools in Cambodia

—

Reflection from a decade long of Socially Engaged Design practice

When the founder of the IDEA Foundation (IDEA), Robert Wong, paid his first visit to Cambodia in 2007, he found that young children in rural areas were out of school. With his passion for using architecture to help the needy, he decided to partner with the local NGO in the country to build schools. In 2009, IDEA organised the first village school-building project in Cambodia. Since then, IDEA has brought more than 500 volunteers from around the globe to Cambodia, organised participatory design workshops with the local children and completed a total of 11 school building projects to build over 20 architectures that benefit over 5,000 children.

With the strong commitment to promote villages' participation, the school building projects had been evolving and developing, in terms of volunteers (including those from Hong Kong and Cambodia) participation, project planning and the details of design programmes. While new elements and ideas were implemented into the school building projects, gradual

On the other hand, there is always an unbalanced power dynamic among the NGO, professionals and villagers, which is prone to conflicts. The professionals need to put themselves in the shoes of the villagers. "The villagers would feel shy or do not find their own opinions worth voicing out when talking to the professionals. Therefore, these experts need to change their attitude and the way they communicate with the villagers, by listening more to the residents for their thoughts and way of doing things. This is the only way to encourage increased participation in the project."

The more engaged the villagers can be, the more confidence they can build. Christie shared a story about a villager who was a building team leader who had much more confidence in the earthquake-resistant houses he constructed after the project was done. The leader was deeply involved in the processes from laying the foundation and assembling the steel frame to the final interior decoration. By learning the principle of aseismic houses with continuous communication with the engineers, his knowledge was enriched and he was more ascertained on his skills and judgement. "Their knowledge of building houses was improved. Before, they did not think too much and only built their houses according to their past experience. Now they also learn and start to take other factors such as foundation depth, materials, and the risk of landslides into consideration. They became more careful than before and this can be seen as a learning process."

Christie also asked the villagers who got more involved in the project a question, "If you come across a bigger challenge in the future, will you be confident to overcome it?" Some villagers responded and expressed their confidence proudly. "It was a painful experience for the villagers to rebuild their houses at the very beginning as there were many struggles. However, when they were successfully overcome, the villagers rebuilt their resilience. This is also our initiative for the project. We would like to prove that it is possible to cope with adversity so long as you are determined to work on it on your own. When there is a risk, there is an opportunity. Of course, I would say there is still a lot of room for improvement for this project but overall, it was a positive experience for the villagers."

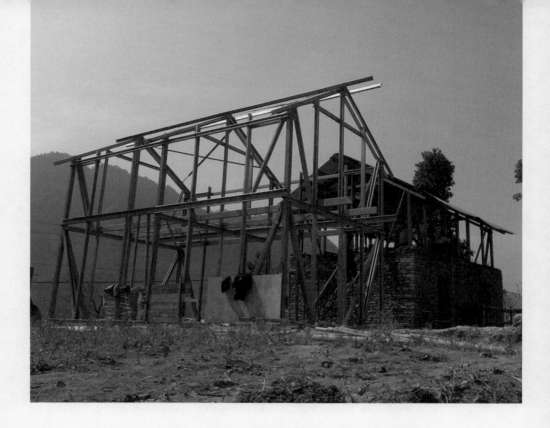

Although Christie wants to allow the villagers to rebuild their homes one step at a time, many problems came from donors, who hoped to see immediate outcomes and asked why the building project had not been completed. Or some donors might ask why the newly-built houses looked so crude despite their monetary contributions. They seemed to have high expectations of the villagers and also anticipated what should have been done in the project. Christie was frustrated, "We are not the users. Only the users know how much time they need to settle their houses and with the appropriate resources. No matter what, they will be able to improve their environment as this is their home. They will make it look nice and comfortable. However, when it is imposed upon them to do the work in a certain way, it will reduce the degree of their autonomy. It is important to trust the villagers."

Future Village: Listening and patience as a foundation for empowerment

For years, Future Village has been improving the livelihood of the farmers and their families in remote rural areas in Nepal by providing better education, medical care and agriculture. Their services range from sponsoring more than 100 children in the village to attend school, sending outstanding students to study in the city, hiring 6 full-time teachers in the village, providing free tutorial classes on a regular basis, supporting the redevelopment and upgrade of the village school, constructing the pipelines for clean water for more than 700 villagers living in remote locations, supplying free medical checkup and dental services. There was no administration fee charged and all helpers in Future Village are volunteers.

Emphasizing the villagers' participation and contribution to their own community, Future Village does not want them to have an over-reliance on donations from NGOs and other parties. It was the reason that they fully supported the concept of participatory design.

Christie pointed out that there are important factors to achieve the goals when Future Village encourage villagers and engage them in community affairs through their participation in the projects. She further explained, "First of all, it depends on the extent to which the villagers can get involved in the project. Taking house building as an example, do you allow them to make all the decisions ranging from designing to material selection? Or if you only let them construct the house by following the established guidelines? These are two different stories. The real empowerment is to allow the audience to express their opinions and make decisions on their own with confidence, to build greater autonomy. That means we have to maximize their participation in every process, which requires time and patience. This is the most challenging part of every development project."

Every time when there were visiting volunteers, the children seemed excited to show them the patterns and words on the wall in the classroom. These materials inspired the volunteers to design their teaching plans based on the kids' interests and lives, and that created an excellent interaction between both parties.

In addition to building up a stronger sense of belonging for the kids, Jenny thought what IDEA would like to achieve in the workshop was an even grander objective. "Our team hoped to be the memorable spark in the children's lives and make them feel like they can create something impactful in their lives. That is the true meaning behind the workshop."

INFO-BOX

Earthquake-resistant building with steel-frame structure
25 Houses (for families in housing needs)
2 classrooms (Future Village School for Nepalese children's schooling)

Duration
2015-2018
Location
Ward 9, Katunge Village, Dhading region (100 kilometers north of Kathmandu), Nepal
Cooperation Organisations
Future Village (Nepalese NGO)
IDEA Foundation
Design Team
Architect Heish Ying Chun
Design For People Co. Ltd.
IDEA Nepal Project Design Team: Edgar Yu, Gigi Poon, Jenny Chin, Robert Wong and other volunteers
Stakeholders' Participation
Nepalese villagers and children
IDEA volunteers
Future Village representatives

another key focus. The bulletin board on the interior wall was filled with pictures taken by the children with their cameras when the volunteer team visited the village. Children were also allowed to write down their future wishes on the notices. As the children did not have any telephone, a pigeonhole mailbox made of plastic bottles decorated by them was set up on the external wall to receive and deliver the messages on paper to each other. It was a way of communication to bond and strengthen their relationships.

Memorable sparks in the young kids' lives

Jenny shared that the children enjoyed the activities very much. They even crossed over the bumpy hill roads in the early morning to make sure they could attend the workshop which was held early in the morning (6:30 am to 8:30 am) before school started. After the lessons, they came back to the education and learning centre to decorate the classroom. They placed a high value on joining the activities. Kids were tearful and reluctant to part with the volunteers when the workshop had run its course. As Gigi recalled, "A kid is with tears rolling down her cheeks and putting a letter in my hands before I leave. She shared that she would definitely miss me." Gigi was deeply touched by the design service trip.

After all the workshops, a new education and learning centre was also completed. This was the centre that was designed and decorated by the children themselves. They were proud of what they had done for the centre. Children started pointing to the colourful pictures on the wall and proudly telling people, "This is my drawing!". Through participation in designing the interior, the children felt that they had been a vested part of the creation and felt a greater sense of belonging. Also, the art craftworks made by the kids were a good tool to learn daily English vocabulary.

The decoration elements, unexpectedly, also benefited and helped the volunteers. Future Village used to invite international volunteers to stay in the village to teach. As volunteers do not speak the same language as the students, the teaching materials prepared cannot be fully applied due to the cultural gap. Using the cultural elements surrounding the kids to conduct the classes was the only solution. The drawings on the wall and ceiling in the learning centre were a bridge to connect the volunteers and the kids.

The workshop consisted of three parts. The first was about purchasing supplies such as blackboards, chalk and bookshelves for the education and learning centre. The second part was to introduce new knowledge to the children through activity-based learning. For example, card games allowed children to learn the concept of time, measurement and calculation, while board games, combined with the physical activity of hopscotching, were used to create quizzes for them to answer questions related to the classroom material in a fun and interactive way. Flash cards featuring key English vocabulary were also produced to facilitate and catalyze the learning process within the workshop.

The third part was that volunteers decorated the education and learning centre with the children by handcrafting the artwork. The crafts were eventually placed in the interior and exterior wall, classroom and ceiling in the centre. These activities not only encouraged the children to be creative but also helped them engage in experiential learning. "Ceiling with the weather" was a good example. Hanging up the stars, the moon, the sun and the rainbow made by the ribbons, plastic cards, banners and fluorescent stickers on the top of the classroom, provided the context necessary for children to learn words in the English vocabulary. They also learned about the knowledge of wind power by making paper windmills which were posted on the wall. On the external wall, the use of polygons to draw animals functioned as teaching materials for the children to learn both the English terms for geometric shapes and animals. Edgar Yu, a volunteer of the IDEA design team, highlighted that the chosen animals were commonly seen in Nepal because they wanted to create an environment close to the native culture.

In addition to education and learning, building up community networks was

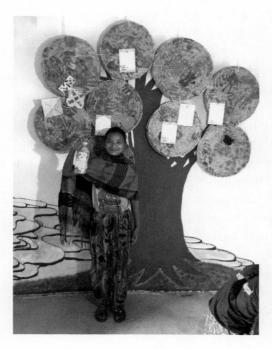

Creating Space for Participation – Participatory Design in Architecture

each step during the rebuilding process when there were opportunities. In particular, they also applied their creativity to address their housing needs. For example, the villagers had their own idea to build a step at the entrance of the house to prevent flooding, and it also served as a seating area for them to socialize with their friends. In addition, the villagers separated the toilet area from the bathroom, relocated the stairs from indoors to outdoors and moved the kitchen stove out of the house, in order to spare more space for grain storage. Overseas people generally think that it is always good to have a high ceiling; nonetheless, it was not considered necessary to the local residents in the village as it increased the construction cost.

"If you really adopt a participatory design approach in the project, you need to double the time to complete the process. What the meaning behind the end product is to the users, depends on your objective. Do you want to only rebuild the houses for the villagers? Or do you want to help them rebuild their confidence and enhance their knowledge by constructing a house? If the latter is your true motivation, it's necessary to change your attitude. Besides, you should not always ask the villagers for their opinions. They do not have many ideas, and you are actually the one to inspire them in different ways during the process so that they can try it out." Christie explained.

Plant the seeds to change the world with creativity

During the design service trip, IDEA organized a participatory design workshop for 50 children in the village to decorate the kids' education and learning centre at Future Village. The team believed that the workshop would enable children to learn how to explore and express themselves, planting the seeds in their hearts to inspire them to change the world with their creativity. In addition to fundraising to support the programme, the volunteers joined weekly workshops before the service trip to brainstorm how to integrate the children's design ideas and learning elements into the centre design. To immerse the local cultural characteristics into the workshop, they also invited the local residents to review the drafted design and provide feedback.

First of all, the villagers were confident in reading the floor plan and instruction manuals to assemble the steel frame. Meanwhile, they could not communicate well with the construction professionals. The local engineers, who perceived the villagers' way of building the house as not up to standard, gave professional advice to villagers on the construction accuracy in terms of work steps and specifications. On the other hand, the villagers felt criticized but reluctant to share their views, even though they were not convinced by the engineers' comments.

"Why do you think the way we lay the foundation on the ground is not good enough? We have been working the same way for over 20 years!" were some common arguments from villagers. The lack of mutual trust and tension between both parties created an unpleasant atmosphere in the village. Christie elaborated, "Mr Hsieh envisaged that the local villagers were allowed to build their own homes with their skills. However, the cultural difference did exist in reality. Villagers found that the methodology did not fit their traditional expectations. They also needed to build their capacity to perform the task as they might not have been confident enough to participate in our reconstruction project right away. We had to encourage them to express their opinions." The local NGO in Nepal played a vital role in facilitating communication among the stakeholders, especially when the project involved specialized knowledge and skills. Future Village's co-founder, Dambar, helped in translating and interpreting the messages between the construction professionals and the villagers, played a key

role in bridging differences in culture and smoothed the project execution.

The team suggested the building professionals not pinpoint the methodology proposed by the villagers. Instead, they should leave the process off their hands to the villagers to try it out first and provide feedback for improvement later on. Based on Christie's observation, although the villagers might not have been able to express their opinions clearly, their creativity was unleashed. It reflected in

Creating Space for Participation – Participatory Design in Architecture

if the labour cost was taken into account. Yet, the project team still respected the decision made by the villagers.

"Unfortunately, the villagers who opted to accept the housing grants from the government could only receive their first instalment a year and a half later." Christie further elaborated, "While the whole country was undertaking the redevelopment that caused a deficiency of workers and construction materials, the labour cost had risen 40%. An earthquake-proof house with the standard approved by the government cost up to US$7,000 to complete. And it left most villagers in significant debt." Compared to the reconstruction project with the labour reciprocity practice assisted by IDEA and Future Village, the villagers only needed to contribute their own time and physical labour, and not pay for the high labour cost.

During the second phase of the project, IDEA recruited over 30 volunteers from Hong Kong to join the serving learning trip to Nepal at the end-2016. Volunteers flew to Nepal and helped the Katunge villagers rebuild their houses. During the service trip, the volunteering team sorted unorganized steel frames according to the construction manuals to facilitate the structural frame assembly on the site. Villagers and IDEA volunteers worked together to join, assemble and build up the steel frame structure one by one, piece by piece. As a good memory to local villagers, it was also a valuable experience to work with oversea volunteers to build a house from scratch and in a collaborative way. Truly, it was an immersive experience for all involved.

There is no doubt that starting something new always comes with difficulties and obstacles. In comparison to the architect and contractor designing and building the homes "for" the villagers, it required more time and patience to build the houses "with" the villagers.

needed to spend around US$2,300 for their houses. Unlike those who offered a full subsidy to the people, the team emphasized teamwork and self-reliance among the villagers during the rebuilding process. Under such circumstances, 30% of the material cost and expense of material delivery were borne by the villagers, and the remaining 70% was fund-raised by IDEA and Future Village. The cost of labour could be saved by the villagers' collective effort in the building process.

Labour Reciprocity Practice had long existed in Katunge Village. It was a traditional way of mutual benefit in sharing human resources in rice growing, farm plowing and even house repairing. They all rely on the labour shared by their neighbours to complete the tasks. The benefited families would also repay the manpower by returning the favour through other tasks and engagements. Such a mutual support system not only utilizes the labour resources available but also strengthens human relationships and builds up community connections. The more the villagers contributed to rebuilding the houses, the more direct costs were saved.

At the start, the villagers showed great interest in rebuilding the houses together when the reconstruction plan was announced. Nevertheless, the biggest obstacle that the project team came across was when the Nepalese government set up a post-disaster cash subsidy of US$3,000 programme distributed in three phases. These government initiatives encouraged the affected people to construct government-approved designs that would withstand future seismic shocks.

Many villagers chose the government's cash subsidy. In the end, only 30 families participated in the "Build the Home, Build the Future" reconstruction project. "A subsidy of US$3,000 at that time was irresistibly attractive to many villagers at that moment as this amount is much more than many families' annual incomes." Christie shared, "This government scheme was not community-based and it does not have any contribution from the local residents. We worried if the villagers could gain confidence and learn new skills during the rebuilding process. More importantly, it was an opportunity for them to mutually support each other."

Based on the calculation, both the government's cash subsidy programme and "Build the Home, Build the Future" had similar project costs

of the steel frame build-up in the village. First, Robert, Jackie and Naga set the ground level of the house by using a rubber tube with water. Furthermore, they measured the size of the truck to plan for the material delivery on site. After collecting detailed information from the site, the team finally decided to refine the design and adjust the length of the steel frames in response to the geographical constricts on the road along the mountain, and to facilitate the ease of transportation and material delivery.

During the trip, the IDEA team introduced the initial housing design solution to the villagers. Using his smartphone with conceptual design drawings prepared by Design for People, Robert shared with the villagers about the architectural design of the house, steel structure, wall partitions and room layout. Villagers had opportunities to express their views on housing design. After the earthquake, most men in the village went to work in Kathmandu to gain more income for reconstruction. Showing the design of the future houses brought hope to the old people, women and children who were staying in the village.

Building Community Bonding through Labour Reciprocity Practice

In the project, the team adopted the house model of "collaborative construction" with lightweight steel frames, which was developed by Hsieh Ying Chun, a Taiwanese architect. These houses were low-cost, highly earthquake-resistant and easy to assemble. Similar to building up toy

bricks, no welding would be required. Steel columns, beams and other components were ready to be installed to form the building structure of the house. Villagers could team up and build their own houses in a collaborative way. The wall could also be built up by villagers after the structure was assembled.

Using the easy-assembly structure, rebuilding 100 homes in the village cost about US$250,000 and each family

confidence after the disaster and build up their resilience in facing future struggles and challenges in their lives. (3) To encourage social participation in the decision-making process during the reconstruction project, so as to build up the social capital and community network in the village. (4) To build up a strong mutual trust and support network in the community.

Starting from October 2015, the project ran in three phases. During the first phase, the project team visited Katunge Village and worked with the villagers to listen to their wishes and expectations regarding their new houses. Then, the team explored the appropriate and participatory design approach to the housing reconstruction project. In phase two, the project team recruited volunteers from Hong Kong to join design service trips to go to the village in 2016 and 2017. In the service trips, volunteers worked with villagers and families in preparing building materials, organized participatory design workshops, and built the education and learning centre in the village which would be run by the Future Village. In the final phase, the team helped the villagers rebuild their homes.

For the construction, the team worked with Design for People Co. Limited (Design for People) and Heish Ying Chun Architects on the steel frame structure. In November 2015, five project team members from IDEA and Future Village travelled to Chengdu, China to meet with the Design for People architectural design team and the steel manufacturer to understand more about the steel frame structure and its detailed specifications. They further explored with the architectural team the logistics of the material delivery and construction method in the village. To understand more about Design for People's "collaborative construction" concept, the team tried to build the steel frame structure together on the ground. Experienced engineers, Gigi Poon and Jenny Chin shared, "This is the first time we've built the metal frame structure by ourselves in our professional career. What an unforgettable experience for us. It is a different and contrasting experience than sketching the structural design on paper."

After the exploratory trip to Chengdu, the IDEA team visited Katunge Village from December 2015 to January 2016. Robert Wong, an architect, travelled with Jackie Wong, a multimedia designer to the village to meet with the Design for People's site engineer, Naga Venkata Sai Kumar Manapragada, to understand the site condition and inspect the practicality

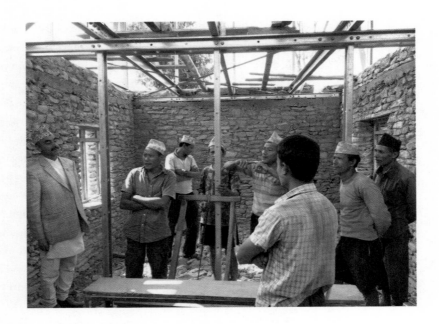

Village also helped in other reconstruction works, including rebuilding the community centre and repairing mountain roads.

After the emergency relief stage, Future Village began to plan ahead on the restoration and rebuilding programme in the 9th region of Katunge Village, where about 100 families lived. Using the limited resources found in the neighbourhood, these families built up their temporary accommodation by using corrugated metal sheets one month after the earthquake. In the long run, the villagers needed stronger and seismic-resistant houses to prevent them from damage caused by earthquakes. They also believed that a stable shelter would give them a good foundation to plan for their future. Future Village shared the same vision with the villagers and started the "Build the Home, Build the Future" in October 2015 with IDEA.

As the earthquake broke down the local network, Future Village and IDEA agreed to rebuild villagers' hope through community participation and social empowerment. There were four objectives set in the "Build the Home, Build the Future" project: (1) To transform the villagers from aided victims, and become initiators of the house reconstruction through a participatory design approach and joint financial commitment. (2) To restore the villagers'

The epicenter of the earthquake was 80 kilometers northwest of Kathmandu, which was considered a shallow quake, and therefore caused more damage. Even worse, another major earthquake of 7.3 magnitudes followed by a series of aftershocks hit Nepal within the same month. International organizations responded quickly by offering immediate humanitarian aid deliveries to the affected regions in the big cities. However, the rural villages in the mountain which were close to the epicenter, did not receive as much concern as the urban area, even though they were also hard-hit locations. Katunge Village, within Dhading region and 100 kilometers north of Kathmandu, was entirely turned into rubble and debris by the disaster, where all residents suffered the loss of their homes.

A community-based reconstruction programme

Future Village was a local NGO located in the 9th region of Katunge Village in Dhading. It was co-founded by Dr Christie Lam, an anthropologist from Hong Kong, and Dambar Adhikari, a local Nepalese villager in the region, in 2004. In 2015, Christie was teaching at Osaka University in Japan. She went back to Katunge Village to help and coordinate the recovery work after the earthquake hit in April 2015. As she recalled in the visit, most villagers had never experienced any earthquake before. They were all insecure about their future, and they found themselves helpless in rebuilding their homes in the villages.

Adopting a community-based approach to restoration, Future Village worked closely with the local residents to ensure that the limited resources were distributed to the people most in need. Christie shared that one of the pressing needs was to make raincoats available to the villagers, but this puzzled many aid organizations. She further explained, "Starting in May and June, the villagers start preparation to farm between June and July, which is the only wet season for growing rice in the region. A raincoat enables them to catch the most important period in the year to work on the farm, not to wait for any year. They hence need not solely depend on the food assistance from others over the following year." It sounded minor to some people, but it truly highlighted the importance of accommodating and responding to the local residents' needs. In addition to raincoats, Future

Creating Space for Participation – Participatory Design in Architecture

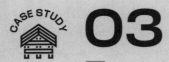

03

"Build the Home, Build the Future" – Building earthquake-resistant homes

—

Rebuilding hope in times of crisis

On April 25, 2015, Nepal was struck by a 7.8 magnitude earthquake which was recorded as the country's most devastating since 1934, killing nearly 9,000 people and injuring more than 22,000. Most of the buildings in Nepal were not aseismic structures. In Kathmandu, the capital city of Nepal, 90% of the buildings were severely destroyed. Thousands of houses were destroyed across many districts of the country, with entire villages flattened, especially those near the epicenter. The majority of the people became homeless. Collaborated with Future Village, a Nepal-based NGO, IDEA organised a post-earthquake reconstruction programme in Nepal, namely "Build the Home, Build the Future", to help villagers to rebuild their homes with earthquake-proof houses. The project was set as a model for other villages and communities to work on, and also as a reference for future resettlement and reconstruction plans. It also filled the gap to help those people in the villages who were left behind by the government and other international organizations after the emergency relief. However, long-term redevelopment efforts and the assistance of re-housing victims were initiatives that were missing.

talents and which is beneficial to their future. We should act and promote participatory design to empower more people."

When the design journey was towards the end, the team experienced one of the strongest hurricanes in Pondicherry's history. There was significant damage to the city. The Telecom network was disconnected. Due to flooding, the team had to relocate to another safe accommodation at midnight. The entire city underwent a power outage. There was almost no food supplied for 3-4 days. Thanks to Dinesh, the local Indian volunteer in the project, who helped in looking for food under the adverse weather and bad living conditions. "As a volunteer, we came to support the local people in Pondicherry. However, this is not always the case. Facing these challenges, we are all fragile. We also need help from them. All lives are equal. It is important for us to help each other out." Calvin shared his reflection on his hurricane experience in India.

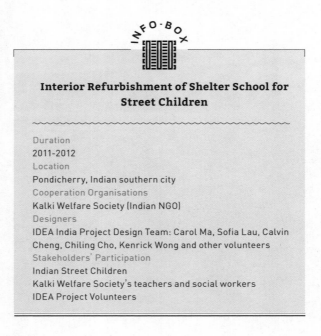

Interior Refurbishment of Shelter School for Street Children

Duration
2011-2012
Location
Pondicherry, Indian southern city
Cooperation Organisations
Kalki Welfare Society (Indian NGO)
Designers
IDEA India Project Design Team: Carol Ma, Sofia Lau, Calvin Cheng, Chiling Cho, Kenrick Wong and other volunteers
Stakeholders' Participation
Indian Street Children
Kalki Welfare Society's teachers and social workers
IDEA Project Volunteers

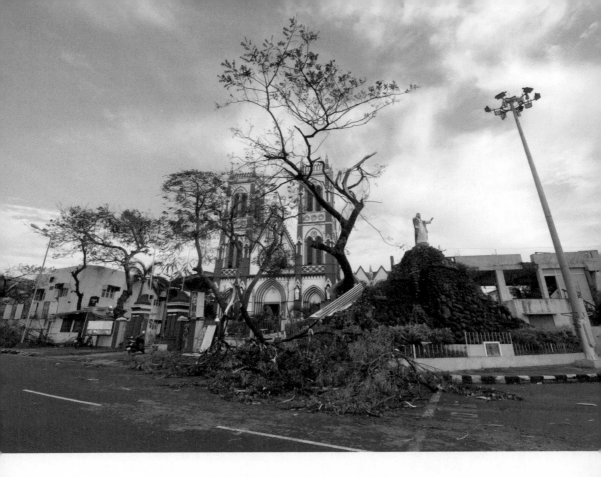

the interactions with volunteers and the skills gained in the design workshops helped the children in building up their confidence. Carol further elaborated, "It is an example of what we called design empowerment. We would help them to resolve the problems in their daily lives first to build their sense of belonging within their community and living environment. They would also be able to build up their self-esteem."

Sofia echoed that the co-design project created memories and impacts on the participants. It was just like a seed being planted. "The kids are the less privileged group in society. But our programme allows them to taste and experience design. The 7-day design experience may not be long enough to change someone's life, but the kids might be able to discover their design

techniques and opportunities to express their ideas. I am only a facilitator to help them complete the process." Chiling smiled and reminded us to appreciate the kids' participation and their effort, regardless of the outcome.

Building confidence in children through workshops

The street children in the Kalki Shelter School were coming from the lowest class under the caste system. Usually, they were born poor with few opportunities in society. The caste system, as a notoriously traditional social norm in India, ranked people into different social groups by family name and kinship. Even though the caste system had been legally abolished today, it was still rooted implicitly in India's culture, leaving an adverse impact on the people's discrimination.

"The Caste system created a barrier for the street children to access the resources to improve their lives, in particular to the natural disasters, such as hurricanes. Their lives would be in danger without a shelter centre." As an oversea volunteer, Carol Ma had a sense of powerlessness after talking to the social workers in Pondicherry. "Our volunteer programme might not be able to resolve this issue. However, we volunteers can help to share our valuable experiences to promote social justice around the globe."

Although the programme and design workshop might not bring any political and material changes to the street children, it brought them hope by seeing that people from different parts of the world also shared a similar vision and care about people's well-being with them. In addition,

and stone seats. IDEA volunteers cleaned the site, did the site setting out, cut the rocks, painted the seats in three different colours; and finally built up outdoor seats for school activities and performances.

Some may have a question about involving small kids in the co-design process. Are they capable of completing the design tasks?

"The answer is definitely YES! The kids are capable of designing and creating something special." The design leader, Chiling Cho shared. He further elaborated that the design facilitators had to give out clear instructions to the kids in a simple framework. "The programme designer has to break down the design into small tasks based on the kids' capability. The merit of participatory design is not only the design outcome but the process of engagement and people's interactions. Kids are exposed to the creative process and they can learn new knowledge through play."

"They are the real designers of their products, who only need the hints,

Creating Space for Participation – Participatory Design in Architecture

their friends. The older girls with good sewing skills began to teach the younger ones the techniques and craftsmanship. These girls enjoyed very much in this design process and finally joined the small cloths into a colourful hanging curtain for the counselling room.

Sofia was so touched after receiving a special design ornament, which was made from the leftover materials in the design workshop, from the girls. "The children treated us as their close friends. We enjoyed it very much in the process. Despite the communication barrier of speaking in different languages, I can feel their trust and love."

Multi-purpose playground created by our little designers

In front of the patio at the school's main entrance, there was an open space that can house 40 kids on the other side of the performance stage. As agreed with the teachers to create a multi-purpose seating area for school activities and assembly, the IDEA design team collaborated with the children aged 3 to 6 to redesign this outdoor space.

Each kid was given cardboard and 15 wooden sticks to create a different layout for the outdoor seating area. It was the first time for the kids to design graphics patterns. Designers then consolidated the kids' design and formulated the landscape plan for the outdoor area with benches

in the most visible and accessible school corner. Children were exposed to the aesthetics of photography. This might arouse the kids' interest in photography, but it certainly opened their eyes to see the world from a different angle and providing a precious sensory learning experience.

Build our counselling room with "needle and thread"

Teachers and social workers shared with the IDEA design team their needs in a private room to address the teenagers' needs for counselling in their adolescence. After the building survey and site measurement, the team agreed with Kalki to rearrange the room layout and convert the existing store room into a new counselling room.

The existing store room was next to a common room with a sewing machine. In order to create a counselling room with better privacy, the IDEA design team designed a hanging shelf and curtain at the entrance. Specially designed boxes were placed inside the counselling room. These boxes were used to store the therapeutic tools and equipment; also, they can be stuck up to combine into desks and seats. A leaf-shaped feature was designed to create a calm interior environment in the counselling room.

In the co-design process, young people aged 12 to 16 were invited to decorate the storage boxes and design a new curtain for the counselling room. Each teenager was asked to sketch and draft the patterns on paper, then cut them out on the coloured cloth accordingly. In the last step, they sew the cloth by needle and thread and combine all cloths into a large curtain.

At the start of the co-design process, the youth did not have many ideas about how to sketch the patterns and design the curtain. Sofia Lau, the architect volunteer, facilitated the design process by breaking it down into small design tasks. Also, she shared with the youth design works in school to encourage their participation to create a comfortable and casual atmosphere to talk about design concepts and creative ideas. After the warm-up, the teenagers started to chat and share different design ideas with

Most street children in the school were passive and shy. They were not confident to meet with people outside of the school. The photo-shooting and outreach activity encouraged the children to interact with people in the district and learn

more about their community. At the same time, it was a great opportunity to let the neighbours and residents better understand the street children. Calvin Cheng, IDEA global citizenship team leader, shared, "We are all equal. The street children do not have much difference from other kids in the city. The objective of the photo-shooting activity is to connect children with their neighbourhood. Though it is not easy to kick start and build up the friendship and bonding, it is the first step to create an impact on an individual's empowerment." He further elaborated that through the lens of a camera, the marginalised group of street children in the city were able to find alternative ways to engage themselves within the community and build their collective memory.

Films were processed and hard-copy photos were printed out. The children began to post their artwork on the interior walls of the school and make the hall into a photo gallery. Walking around the hall, the children were so excited to show their work to the teachers and social workers. They started to share the stories behind the photos with their classmates and friends. A child proudly shared, "That is the photo that I took at the street corner. It is my good design, isn't it?" Some children pointed to the photos that they took and explained to the IDEA volunteers the good memories of the photo-shooting activity and the unique moment they had spotted at the event. Together with a cluster of children's photos, the layout was finely articulated with wooden boards and beautiful handy messages by the IDEA design team. The art wall emerged as a professional miniature exhibition

Connect people in the community through photography

In the school refurbishment project, the team would like to bring the shelter school children connected with the community. Kenrick Wong, a volunteer photographer, suggested the kids to walk around the city and take pictures to record their lives and activities in the community. First, each child was given a cardboard photo frame and they started to learn the fundamental concept of photography and the composition of images. When they walked around the city, the children used film cameras to record the scenery and interesting activities on the street. They perceived the city from another angle and appreciated the streetscape, the livelihood and the beauty of the community.

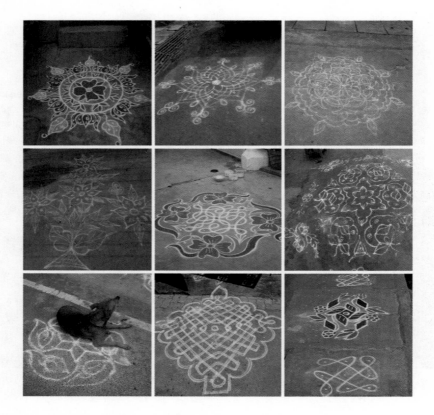

blind. The workshop was filled with a cheerful vibe and energy. Students became the "teachers of drawing Kolam" for the IDEA volunteers. Indian children not only designed the basic patterns and shapes of Kolam but also thought outside of the box by recreating a unique graphic of a quarter Kolam on the wooden blind.

As a participatory design process, Indian children were given single-lined paper to design and sketch the patterns. The papers were then folded into paper blinds, which became a model one-tenth of the real wooden blinds at the school entrance. The paper models were a way to connect children and designers, and the children enjoyed the design process. They shared their paper model design products with their friends.

30 volunteers from Hong Kong arrived at Pondicherry. IDEA Project team members quickly reached out to Kalki and agreed to shift their project to another shelter school for street children as an alternative plan.

The new targeted shelter school consisted of two buildings: (1) an activity and learning block for classes; and (2) a dormitory for street children.

Before the site work, the team conducted a conditional survey and detailed site measurements. After talking to the teachers and social workers to understand how they used the site, the IDEA Project team finally came up with 4 design items in the school compound to create a better learning environment for the students. They include: (1) creating a new performance stage on the patio; (2) decorating the interior walls with children's photos; (3) transforming the workroom into a counselling room; (4) building an outdoor seating area for performance.

When window blinds were revitalised by Kolam design

The IDEA Design team aimed to create an eye-catching and visually iconic element in the shelter school refurbishment project to attract more children to attend the classes. At the west-facing patio at the school entrance, the students had always been exposed to the strong sunshine in the afternoon. The design team proposed to install wooden blinds to block out the afternoon sunshine, but it also helps to serve as a curtain that converts the patio into a performance stage.

Kolam is an old conventional art in southern India with a strong cultural character. It is named "Rangoli" in the northern part of the country. Every morning, women draw the symmetrical Kolam using rice and flour on the ground in front of the main entrance of their house every day, attracting insects and birds to eat, which symbolises the prosperity of their home. In the festivals, the coloured grains are used to draw flamboyant patterns to welcome the goddess, wish for health and wealth, and prevent evil spirits from approaching the family. This form of art is strongly tied to the identity of Indian people and also strongly represents their cultural beliefs.

Inspired by Indian cultural features, the design team encouraged the students in the shelter school to design the Kolam pattern on the wooden

Founded in 2008, the Kalki Welfare Society (Kalki) aims at helping street children in the city. A street children's centre was set up to provide urgent assistance to homeless kids. Kalki provided basic healthcare, food and education for the street children. Currently, there are over 100 street children, aged 3 to 17, staying in the shelter centre.

In this project, IDEA was split into 3 working teams: (1) Design team organised design workshops with the local children and volunteers from Hong Kong to renovate the shelter school. (2) Education team developed activity-based learning materials and teaching manuals and shared them with the local teachers on interactive teaching methodology. (3) Global citizenship team brought the volunteers to visit the informal settlement and slum areas in the city to understand the local context and its challenges in the developing country.

Organising community development projects in developing countries often comes along with some unexpected circumstances. Six months before the IDEA India service trip, the organising committee members of the IDEA Project visited the site in Pondicherry and discussed with the Kalki team the design and service scopes of the project. Without any prior notice to the team, it was shocking that the Kalki school had been shut down when

02

Co-designing the school with street children in India

When traditional elements become a creative source for renovation

The street children issue has been a deteriorating social problem in India. Over 18 million children are living on the streets. The nation has the largest number of such cases among other countries in the world. Wandering the streets in India, one can see the underprivileged kids make ends meet by being street performers, street vendors and beggars. At their young age, street children are struggling and exposed to dangers and are prone to going astray. In 2012, IDEA Project collaborated with Kalki Welfare Society, an NGO rooted in an Indian southern city – Pondicherry, and renovated a shelter school with the children. The shelter school provided learning opportunities and emergency assistance to the street children.

amount of time was left for the purposes of the design project. The design team always has to make a balance between the users' involvement and the outcome.

5. Collaborate with government departments

The design project in Morse Park required approval from different government departments, including the Leisure & Cultural Services Department (LCSD) and the Architectural Services Department (ArchSD). With strong support from the Art Promotion Office, approval from LCSD and ArchSD was finally obtained. The programme organisers and project designers would need patience in the liaison and collaboration under the government bureaucracy, and allow sufficient time in the programme planning. In this project, thanks to LCSD's adjustment to its operations and accommodation to the project request in displaying the 1-to-1 mock-up on-site to showcase the creative design work, the design project was successfully completed in Morse Park.

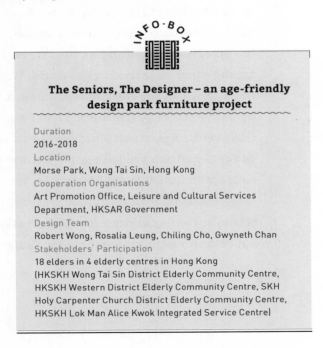

The Seniors, The Designer – an age-friendly design park furniture project

Duration
2016-2018
Location
Morse Park, Wong Tai Sin, Hong Kong
Cooperation Organisations
Art Promotion Office, Leisure and Cultural Services Department, HKSAR Government
Design Team
Robert Wong, Rosalia Leung, Chiling Cho, Gwyneth Chan
Stakeholders' Participation
18 elders in 4 elderly centres in Hong Kong
(HKSKH Wong Tai Sin District Elderly Community Centre, HKSKH Western District Elderly Community Centre, SKH Holy Carpenter Church District Elderly Community Centre, HKSKH Lok Man Alice Kwok Integrated Service Centre)

number of participants who were invited from the elderly centres was a point of concern. If all the elders were selected from only one elderly centre, it would be rather difficult to convince the social worker and service-in-charge. Instead, elderly participants coming from a number of elderly centres could reduce the risk. Close collaboration between the elderly centres and the design team is required. For the elderly recruitment, the social workers helped look for active elders who are enthusiastic about community projects. Before the project implementation, the design team and social workers would need to meet up to plan the programme details.

2. Enhance familiarity by integrating the design project into a casual day trip

Although the elderly members of the concern group were invited to the project, they were not always familiar with the design work. "Design" is a vague concept in their daily lives. Instead of naming it as a design project, the elders were invited to partake in a day trip called "Exploration to age-friendly space". Through the trip, it was anticipated that the elderly participants became familiar with the space and environment around them. The elderly had the chance to understand design concepts and how design could be applied to their daily lives.

3. Trust building: Social workers as friends

Social workers in the elderly centres played an irreplaceable role in the design project. They built up trust with the elders and served as a bridge to connect the design team with the elderly participants. As a facilitator, the social workers helped both parties exchange their opinions. They also encouraged the group members to express themselves when they felt hesitant to present their own design ideas in front of everyone.

4. Empathise the elders' needs and understand their daily schedule

After the project's completion, the official project celebration was originally scheduled in July 2017. However, the social workers shared that summer was not ideal for the elderly to go out for site visits due to the hot and humid weather. Taking care of the elders' health and physical conditions, the celebration was postponed to winter in December 2017. Also, long-duration activities on the day trip were not encouraged. As a thoughtful and caring programme organiser, it was vital to respect every stakeholder. For example, the elderly usually followed a regular schedule, such as lunch at 12 noon and dining at 5 pm. This meant that only a limited

Robert's team was invited by the World Health Organisation, the United Nations Human Settlements Programme (UN-Habitat) and the American Institute of Architects (AIA) New York Chapter to share with international professionals, scholars and policymakers about the participatory design experience with the elderly in the age-friendly design forum. The project was highlighted as an exemplar of the integration and involvement of the ageing population within the community. Robert suggested: "Forum attendants were surprised at the fact that we were able to carry out this project and deliver it successfully. They are all seeking an approach that encourages and engages their community's senior citizens to get involved with the community. In my opinion, if the government were to leave more space for us to conduct these types of social experiments for similar projects, more possibilities would be explored and discovered."

5 critical factors facilitating a successful participatory design project

Since 2005, the World Health Organization had developed the Global Age-Friendly Cities project across multiple cities and subsequently. The "Global Age-Friendly Cities and Network", a concept established in 2010 defined the eight aspects of significance to the well-being of older people: outdoor spaces and buildings; transportation; housing; social participation; respect and social inclusion; civic participation and employment; communication and information; and community support and health services. This participatory design project served as a pioneer work to use design as a medium to focus on the aspects of "outdoor space and building" and "social participation" in solving ageing problems.

To engage the elders in participatory design, there are multiple determining factors:

1. Target the right audience

Leading the elders for a site visit involved a variety of preparation works beforehand such as programme planning, purchasing the appropriate insurance, rental of the shuttle bus, and risk assessment. Besides, the

had to measure the size and positions of the new seats by laying the papers on the ground and building up the seating model with the prefabricated corrugated cardboard within a limited period.

During the mock-up visit, the design team prepared the elders a rainbow-like array of colours to determine the seat colour, but unfortunately, none of the colours was selected. Robert smiled and recalled that "We did not hear a word to complain about the choices of colour but some rambling such as 'Oh my gosh! These seem like the colours the kindergarten children would like!'." He continued, "In the end, we discovered the elders' preference of the natural wood colour, so the light wood colour was applied to the final design." Also, the design team designed children's chairs with blue and yellow, where they could sit back-to-back and play with each other. With a limited design background, our elderly participants did not make judgement of the colour only based on their own preferences but rather based on the users' need. This is considered one of the impacts of participatory design on the users.

At the opening ceremony, a mini party took place in the seating area in the park. Everyone tried out the facilities in a real-life setting. As Gwyneth remembered, a grandmother came to her excitedly when she arrived in the park. "This was designed by me!" She screamed while pointing her finger at the hooks installed on the handles on the tables and seats. "With such simple words, we knew we had attained the original goal of the project."

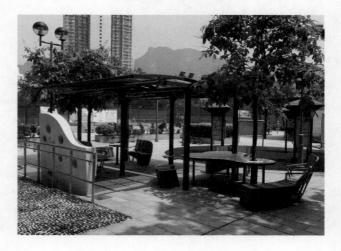

Creating Space for Participation – Participatory Design in Architecture

After the presentation, the design team summarized and integrated all the thoughts into a "Design Brief" and started to prepare the conceptual design drawings. There were two essential design features: (1) a creative aerodynamic design, and (2) the park furniture should be friendly to allow activities for both kids and elderly users.

Creative ideas stimulated innovations to inspire new artwork. The curvilinear and wavy seat of the bench allowed the grandparents and their grandchildren to sit on either side. A large table, with two tree trunks protruding from its centre, provides face-to-face seating and a comfortable environment for the elderly and their family to enjoy meals together in the shade, a perfect location for a picnic. This was a wholly different setting compared to the traditional seats we usually found in the park.

During the workshop, elders shared that they used to hang their belongings on the backrest of the seat, but frequently forgot about them. The design team paid a lot of attention to the design of seating to address the elders' concerns. In the new design, a small hole with a fixed hook installed at the front of the seat and the armrest, not only reminded the

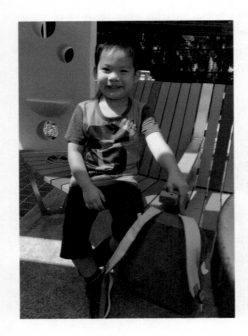

elderly to put their frequently carried items; an S-shaped hook, umbrella, pole and grocery bag but was obvious enough for them to be aware of their own belongings, due to its immediate visibility.

To respond to the elders' design concept of promoting interaction between children and elders, the design team also designed a wavy-shaped check-in wall with multiple holes that allowed kids to show their faces. Elders would take pictures with the children. It would bring a lot of fun to both grandparents and their grandkids.

To let the elders visualise the design idea, Rosalia and Chiling spent two weeks preparing a 1-to-1 ratio mock-up on-site. LCSD agreed with the design team to take down the existing seats in the morning and to reset the venue back to its original setting before 6 pm every day so as to minimize disruption to the park operation. They

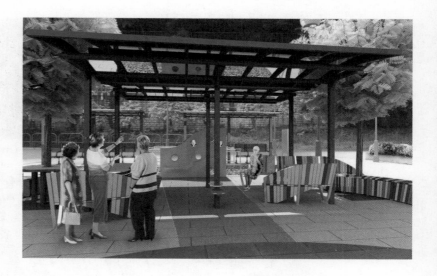

Elderly-friendly design features: a small hook and a recess in the chair armrest

While the design team expected the elderly designers to prefer the seats with a more conservative style – plain and regular shape, their creativity went beyond the team's expectations. As Gwyneth recalled, an elderly design team sketched and designed a rainbow seat that allowed users to place their electronic products such as an iPad or a laptop. "People used to have the impression that senior citizens only play chess for leisure at parks, but it is untrue. Rather than staying with this traditional form of entertainment, they also wish for a cosy spot to enjoy surfing the internet with their mobile phones in public, as well as taking pictures with their grandchildren at the check-in points whenever possible."

When the elders' sketches and presentation materials were finished, the senior designers were invited to present their design ideas in front of the government officials, as if it was being presented to a real professional designer. Prior to the 3-hour workshop, the concept of "design" sounded completely foreign to them. Without a doubt, this came up as a huge challenge for them to explain their design ideas.

Creating Space for Participation – Participatory Design in Architecture

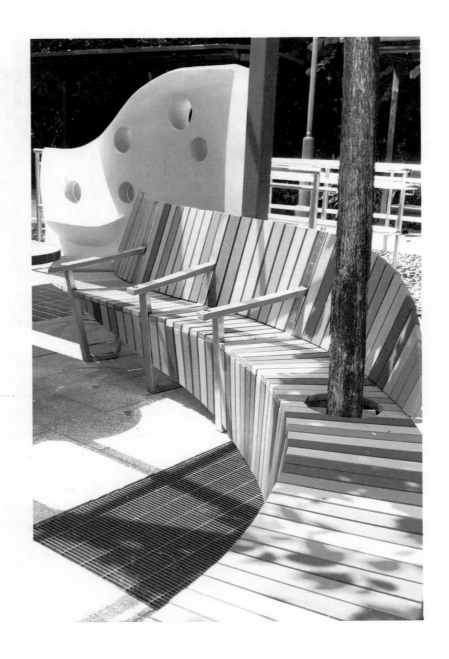

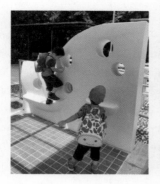

knowledge gap between the professionals and the public in terms of design experience and perception of design materials.

Nonetheless, by spending time interacting with the elderly group and explaining to them the usage of tracing paper and other materials, the participants eventually were willing to give it a try, sketched their design idea on the tracing paper and prepared the design presentation drawings. The whole process of involving the elderly in the design clearly strengthened the communication and understanding between the elderly and the designers.

Regarding the existing park furniture in LCSD, the senior citizens had long been thinking about opportunities for improvement. The elders shared that they were not satisfied with the monotonic and standard design of the seats with their limited functionality. They expected the seats could be used in multiple and diverse ways. "The elderly would want to enjoy the time with their families in the parks," Rosalia described, "But, the facilities in the LCSD parks are usually categorised by age group. The seniors stay in the elderly exercise area, while the kids would do their activities in another zone. When the elderly take care of their grandchildren in the kid zone, there are no facilities available for their personal needs." Most of the elderly expressed their wish to hang out with their family members closely in the parks such as having picnics, chit-chatting and gathering.

In the afternoon session, the elderly were divided into 3 groups. Referring to the printed images of creative benches in different parks in the world, the elders were invited to brainstorm and explore innovative design options. At the same time, this design process also allowed the team to understand more about the senior members' preferences regarding the type and materials of the benches. "These photos show the most beautiful extraordinary design of the benches in the world." Robert commented, "Why can it happen in other countries, but not in Hong Kong? This also gives a great opportunity for our senior citizens without any art background to appreciate the artwork. After the workshop, the elders became more open-minded to these designs. We realized that everyone loves good and creative design. No one is an exception."

In the workshop, the design team also provided the participants with mini models to visualize their desired space in the parks. At the first instance, the participants were not quite familiar with tools for design, such as yellow tracing paper, and craft materials for designers. When the team invited the elders using yellow tracing paper to draft their design ideas; instead, they asked the social workers for some white paper to sketch. The elders thought that the yellow tracing paper was expensive and could only be used by professional designers. At that moment, the designers felt the

(NGOs) in Hong Kong at that time, Robert had extensive experience working with the elderly and coming up with user-friendly and creative design ideas for renovation projects of elderly centres and residential care homes. Hence, the "Seats • Together" project just appeared as another opportunity for Robert's team to bring the elderly into the community, listen to their voice, integrate their creativities and co-create age- and child-friendly park facilities in Morse Park.

A total of 18 seniors were invited from the elderly centres, which were managed by the Welfare Council, to participate in "The Senior • The Designer" project. All of them came from the elderly concern groups at the elderly centres located in Western District, Wong Tai Sin, To Kwa Wan and Hung Hom. With the assistance from the social workers, the elders had been promoting an age-friendly environment by reaching out to the community, looking for good practices and sharing their findings and opinions with the district councillors. Although they had the experience getting involved in community improvement projects, it was their first time designing public facilities for the community.

Starting from sketch to experience as a designer

There were two design workshops organised in the project and aimed at guiding the elderly participants to become user experience designers. The first workshop was scheduled into 2 parts on the same day. In the morning, the design team gave a briefing session about the project to all participants and brought them to Morse Park for a site visit. The elderly were guided by questions such as what the size of the chair would be, what types of outdoor chairs were considered comfy, and what was considered an adequate outdoor space, the participants were all excited to further brainstorm their ideas. They even did the site measurement, and pencil down all the relevant details.

of the Leisure and Cultural Services Department (LCSD) organized an event called "City Dress Up: Seats • Together". This public art project was introduced to twenty venues managed by LCSD: parks, waterfront promenades, leisure areas and playgrounds across 18 districts in Hong Kong. These 20 sets of innovative and artistic furniture were set up to enrich the cityscape and beautify the city.

Joshua Lau, one of the art project curators at APO, invited Robert to revitalise the Morse Park elderly exercise zone and re-design 12 existing benches there with the theme of "Public Furniture for senior citizens". As the former assistant director of Hong Kong Sheng Kung Hui Welfare Council (Welfare Council), one of the largest non-government organisations

01

The Senior · The Designer

Co-designing a friendly park furniture for
children and elders

**↘ In Hong Kong, seniors used to be stereotyped as a group
that needed to be taken care of in our society. However,
if they are given an opportunity, they are able to play an active
role in improving our community. The co-design projects
done by the seniors and a group of designers at Morse Park
in 2017 were a good example to showcase the elderly's active
participation. 18 senior citizens were invited to brainstorm
ideas for designing public furniture which was friendly to
kids and the elderly in the parks. Featured with aerodynamic
design, the bench and other public furniture not only
aesthetically looked beautiful but also facilitated interaction
with the users. The members of the design team, Robert Wong,
Rosalia Leung, Chiling Cho and Gwyneth Chan were glad to
share the story and experience about the project with us.**

The genesis of this project began in 2017, which was the 20th
anniversary of the establishment of the Hong Kong Special Administrative
Region (HKSAR). To celebrate the event, the Art Promotion Office (APO)

psychologists, therapists) who have been working closely with the local community acts as a great facilitator between the designer and the community in public projects.

With the help of social service practitioners, designers and architects can have a better understanding of the community beforehand and during design workshops social service provider can act as a bridge to facilitate the interaction between designers and users.

In the following chapters, we will introduce why different stakeholders have a vested interest in the participatory design approach and highlight case studies which demonstrate how different stakeholders can work together for a participatory outcome.

01 Susanne Hofmann, Susie Hondl, and Inez Templeton. *Architecture Is Participation : Die Baupiloten – Methods and Projects*, Translated by Susie Hondl and Inez Templeton, Berlin: Jovis, 2014, p.11-12.

02 Horst W. J. Rittel, and Melvin M. Webber, "Dilemmas in a General Theory of Planning." *Policy Sciences* 4, no. 2 (1973): 155-169.

03 "Design Thinking Defined", IDEO, accessed 29 Nov 2022. https://designthinking.ideo. com

04 Clay Spinuzzi, "The Methodology of Participatory Design." *Technical Communication* (Washington) 52, no. 2 (2005): 163-174.

05 Paul Jenkins, and Leslie Forsyth, *Architecture, Participation and Society*. London: Routledge, 2010, 9-22.

A possible collaboration with social service practitioners to facilitate communication between designers and users

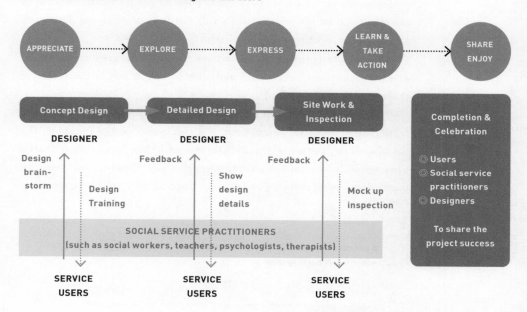

Creating Space for Participation – Participatory Design in Architecture

In a wider social participation model, the architects and other professionals work together to facilitate effective communication with both the client and building users, while still fulfilling professional duties and satisfying the regulatory requirements.

While the training of an architect mainly focuses on technical knowledge, communication skills and other soft skills may be overlooked in traditional design education.

Since the interaction between the design professionals and the layperson is a crucial component of a successful design outcome, the collaboration between the architect and other human-orientated professionals is vital for a comprehensive participatory outcome. In most cases, social service practitioners (such as social workers, teachers,

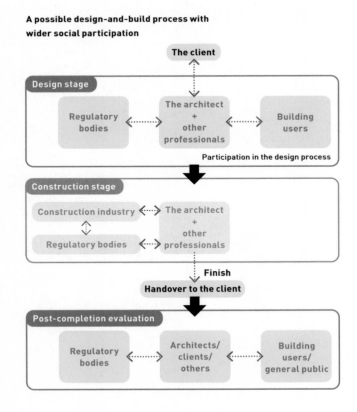

A possible design-and-build process with wider social participation

The role of facilitator: Collaboration between architect and human-orientated professionals

In the book *Architecture, Participation and Society*, Jenkins and Forsyth discuss about the architectural design process and the relationship of architects with different stakeholders. Apart from typical architectural production, the authors suggest a possible design-and-build process with wider social participation. [05]

In a typical architectural process, architects are pitted as the key coordinator. Their responsibilities include working with other building professionals to develop a design proposal which can fulfil the client's needs in addition to the regulatory bodies' requirement.

The typical architectural process

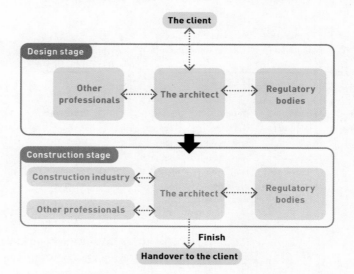

Beyond the streamline of production, Architecture is co-creation

Despite of the highly technical nature of architecture, the end user's engagement can still occur within various stages of architectural production using various methods such as the early design stage and post completion stage. While architects continue to develop the project, engagement exercises in each phase can act as a check point to verify the design.

The workflow diagram below summarize how architecture production, participatory design and design thinking can be streamlined and correlated with each other.

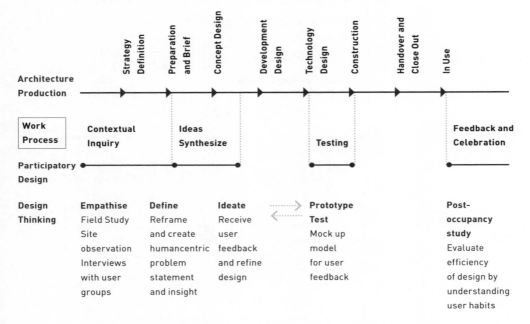

This integration of action research method in design provides positive change for both the architects and users. While architects can learn from users on their tacit knowledge within their respective communities to design a better built environment, users can learn from the architects' professional and technical expertise.

Thus, architecture can go beyond problem-solving and service, and instead empower both designers and users.

Participatory Design work stages and methods

The five basic stages are present in almost all participatory design research and their methods are grouped by stage:

Work Stage	Possible Methods
◎ Stage 1: **Initial exploration of work** Designers meet the users and familiarize themselves with the ways in which the users are situated.	This stage involves contextual enquiries. Ethnographic methods such as field observations, interviews, surveys, walkthroughs and examinations of artefacts will be useful to understand users' behaviour and their situated context.
◎ Stage 2: **Discovery process** Designers and users employ various techniques to understand and clarify goals and envision the desired outcome.	Different than traditional ethnographies, this stage requires designers and users to interact heavily. Group interactions, polling, role-play games, which allow users to envision their preferences and motivations will be the goal.
◎ Stage 3: **Prototyping** Designers and users iteratively develop design prototypes to fit into the goals developed in stage 2.	This stage involves a variety of techniques for iteratively shaping the design. Draft, mock up, scale model, paper prototyping will be useful to enhance user feedback.
◎ Stage 4: **Site work and inspection** During the construction phase, under appropriate safety precautions, the designers can consider to do site visit with the users who have participated in the previous design phases and to explain to them some key features in the construction site.	Designers should explain clearly to the users' representative the objectives and limitations of the site visit, so as to avoid any miscommunication and false expectation.
◎ Stage 5: **Completion and celebration** After the construction is completed, designers can invite the end users who have participated in the previous stages to come and celebrate the fruit with their friends and community.	The users who have participated in the design stage can take the role of "designer" to introduce the design concept and design features to other users.

2.2 Principles of implementing participatory design into a project

Participatory Design is design research

Similar to Design Thinking, Participatory Design's many methods ensure that participants' interpretations are taken into account in the process.

In Spinuzzi's "The Methodology of Participatory Design", he describes Participatory Design as research, although it has sometimes been seen merely as a design approach.

He argues that the approach is just as much about design – producing artefacts, systems, organizations, and practical or tacit knowledge – as it is about research.

Adopting tools from ethnographic research such as field observations, interviews, analysis of artifacts and also protocol analysis, these methods are always used to iteratively construct the emerging design, which itself simultaneously constitutes and elicits the research results as co-interpreted by the designer-researchers and the participants who will use the design. [04]

Alternating between practical work to support change (such as design activities) and systematic data collection and analysis on the other hand, the design outcome of a participatory design project is not a pre-determined task, but a collaborative research output between the designer-researchers and participants.

While Design Thinking focuses less on the hardware but more on the software and user experience, it is generally framed in the following steps in order to help the designer understand their end users' needs:

Design thinking stages	Typical design stages
Empathise	Discover
Define	Define
Ideate	Conceptual design
Prototype	Design development
Test	Deliver

❶ Empathise
❷ Define
❸ Ideate
❹ Prototype
❺ Test
❻ Start all over and iterate the flow as much as possible

Table: correlation between design thinking work flow and typical design work flow

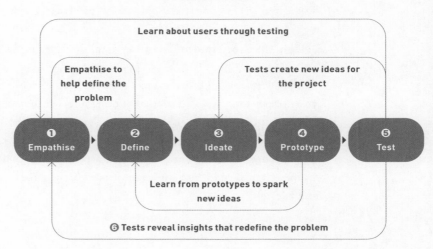

DESIGN THINKING

early 1960s, the "Design Methods Movement" was an important attempt to start the integration of participation in a systematic planning process.

While criticizing against the earlier approach of pure rationality in developing design methods, Rittel raised the notion of "wicked problems"[02] – problems which are complex, open-ended, ambiguous and could not lead to simple and easy judgements of "right" or "wrong". This criticism turned some in the movement away from the rationalized approach and embraced the desire to integrate users' needs in the design, in which designers work in partnership with the problem stakeholders (client, customers, users, the community).

This human-centric problem solving approach led to participatory design, user centred design and later Design Thinking.

In 1991 the design company IDEO was formed and showcased their design process, which drew heavily on the Stanford curriculum.[03] They are widely accepted as one of the companies that brought Design Thinking to the mainstream. Then in 2005 Stanford's d.school began teaching design thinking as a formal method.

Nowadays, Design Thinking has become a popular method for creative problem solving. It has been widely adopted beyond the traditional design industry, but to many other industries notably the business and government sector.

Developed upon ways on how designers design, Design Thinking serves as a bridge for people who are not design trained but still able to apply design methods for innovative solutions in their respective fields.

Design Thinking methods and typical design methods

The development of design methods has been closely associated with prescriptions for a systemic process of designing, which mainly consists of four stages: Discover (insight into the problem), Define (the area of focus), Develop (potential solutions), Deliver (resolution of the solution); and can reference to the work stages in architecture and engineering projects or any design fields which are conceptual design, schematic design and detail design.

02

Participatory Design is about Understanding and Communication

↘ There were debates driven by the question on how a design methodology could be made accessible to members of the public through a process of systematization between the late 1960s and early 1970s. [01]

2.1 Design Thinking and Architectural Design – Correlation and Connection

From design transparency to design thinking

The attempts were to make design more 'scientific', to strive for objectivity and high rationality of thought and to defy subjective, emotional, and intuitive factors in order to make design more comprehensible to outsiders.

The first books on rational design methods and on creative methods also appeared in this period, including Christopher Alexander's *Pattern Language Method*, John Chris Jones's *Design Methods* and later Peter Rowe's *Design Thinking*.

Founded by British and American architects Christopher Alexander, Bruce Archer, John Chris Jones and German design theorist Horst Rittel in

01 Rachael Luck, "Dialogue in Participatory Design." *Design Studies* 24, no. 6 (2003): 523-535.

02 "#Envision 2030 Goal 11: Sustainable Cities and Communities", United Nations, Department of Economic and Social Affairs, Disability, accessed 29 Nov 2022.

https://www.un.org/development/desa/disabilities/envision2030-goal11.html

03 Charles Jencks, *The Language of Post-modern Architecture*. 6th ed. London: Academy Editions, 1991.

04 Nan Ellin, *Postmodern Urbanism*. Cambridge, Mass: Blackwell Publisher, 1996, p.1-8.

05 Jane Jacobs, *The Death and Life of Great American Cities*, Harmondsworth: Penguin in association with Cape, 1964.

06 Henry Sanoff, *Community Participation Methods in Design and Planning*, New York: J. Wiley & Sons, 2000, p.1-3.

07 Ibid.

08 Nan Ellin, *Postmodern Urbanism*. Cambridge, Mass: Blackwell Publisher, 1996, p.44, 48-54.

09 Ibid. p.9-10, 26.

10 Natasha Vall, "Social Engineering and Participation in Anglo-Swedish Housing 1945-1976: Ralph Erskine's Vernacular Plan." *Planning Perspectives* 28, no. 2 (2013): 223-245.

11 Mateusz Gierszon, "Architect-Activist. The Socio-Political Attitude Based on the Works of Walter Segal." *Journal of Architecture and Urbanism* 38, no. 1 (2014): 54-62.

12 Paul Jenkins and Leslie Forsyth, *Architecture, Participation and Society*, London: Routledge, 2010, p.14.

13 Sherry R. Arnstein, "A Ladder of Citizen Participation." *Journal of the American Planning Association* 85, no. 1 (2019): 24-34.

14 Sarah C. White, "Depoliticising Development: The Uses and Abuses of Participation." *Development in Practice* 6, no. 1 (1996): 6-15.

15 Paul Jenkins and Leslie Forsyth, *Architecture, Participation and Society*. London: Routledge, 2010, p.9-22.

16 Nishat Awan, Tatjana Schneider, and Jeremy Till. *Spatial Agency : Other Ways of Doing Architecture*. Abingdon, Oxon [England]: Routledge, 2011, p.38.

17 Giancarlo De Carlo. "Architecture's public" (1969). Peter Blundell Jones, Jeremy Till, and Doina Petrescu. *Architecture and Participation*. Taylor and Francis, 2013: chapter 1.

18 Ibid.

19 Vitruvius Pollio, Frank Granger, and Vitruvius Pollio, *On Architecture*, Translated by Frank Granger, Cambridge, MA: Harvard University Press, 1931.

20 Susanne Hofmann, Susie Hondl, and Inez Templeton, *Architecture Is Participation : Die Baupiloten – Methods and Projects*, Translated by Susie Hondl and Inez Templeton, Berlin: Jovis, 2014, p.11.

21 Paulo Freire, *Pedagogy of the Oppressed*, London: Penguin Books, 1972.

The essence of participatory design is to acknowledge the user's knowledge and to empower them to build up new knowledge alongside the researchers.

Hence, according to De Carlo, architects identify with the users' needs does not mean designing "for" them, but designing "with" them.

Instead of treating the public as an empty vessel, an architect's professional knowledge and users' tacit knowledge should work together to discuss both spatial and organisational hypotheses before jumping into design conclusion.

This parallel relationship between the architect and public is the fundamental bases of an effective participatory design.

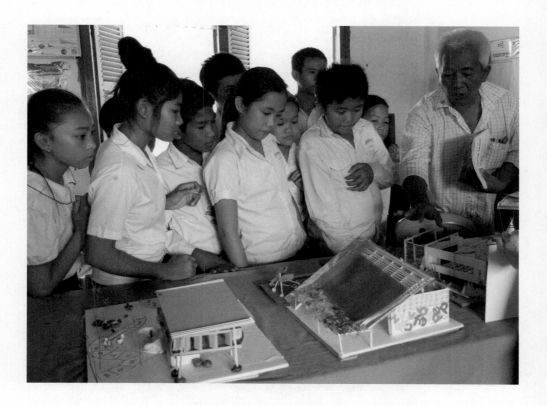

Creating Space for Participation – Participatory Design in Architecture

But how could architecture be truly useful if the architect identifies the client's needs over the user's real need?

Also, the principle of usefulness, at any rate, is undermined when the communication process between architect and client or users is dysfunctional, and architects believe they know what users need better than the users themselves. [20]

Establish a parallel relationship for better understanding: a balance between user's knowledge and professional's knowledge

Referring to the idea of Brazilian educator Paulo Freire, Pedagogy of the Oppressed (1968) that pedagogy should instead treat the learner as a co-creator of knowledge. [21]

Freire calls traditional pedagogy the "banking model of education" because it treats the student as an empty vessel to be filled with knowledge, like a piggy bank. He argues that pedagogy should instead treat the learner as a co-creator of knowledge.

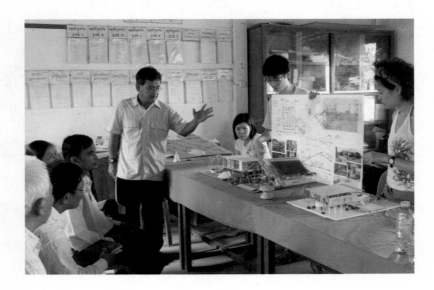

Due to the nature of each project, the issue of "How" will be discussed in the section 2.2 "Principles of implementing participatory design into a project".

Together with the previous framework established by White, we arrive to a taxonomy of participatory design in architecture, where the architect and the client (initiator or developer) can decide the form and degree of participation during the different stages of the design process.

Indeed, the interaction between the design professional and members of the public is a crucial component of the successful outcome of today's work in urban planning and design.

1.4 Architects and the public

Architecture is immanently political because it is part of spatial production, and this is political in the way that it clearly influences social relations. [16]

Giancario De Carlo's Architecture's public (1969) [17] has remained a remarkably relevant statement about the political nature of architecture and the need for participation to empower the user. He criticized that in all epochs, whatever the importance of his role, the architect has been subject to the world view of those in power.

De Carlo criticized, "With the rise of bourgeois professionalism, architecture was driven into the realm of specialisation, where only the problems of 'how' are important, because the problem of 'why' are considered solved once and for all." [18]

Modern architects aligned with the economic and political powers and distanced themselves from the general public. This left them in closer proximity to the client, rather than the users.

The emphasis of an expert agent has been accompanied with a suppression of a sense of social duty. Hence, design is often considered a field of subordinate aesthetic choice.

For centuries, architects have been taught according to Vitruvius's principles of good architecture (Vitruvius, *De architectura*, 30-15BC), which are strength, utility and beauty. [19]

Referring to Sarah White's Typology of Interest (1995), we can identify the following forms and incentives of participation: [14]

This distinction between forms of participation is equally important because it requires careful consideration of communication behaviour throughout the process to bring about knowledge sharing and learning on the part of all participants.

Besides different various forms of participation, conceptualizing the issues also means asking questions of who, what, where, how and when.

In "Concepts of participation in architecture", Paul Jenkins created a 3D matrix to illustrate a wider participation framework in architecture production, which includes: [15]

- **Who** The nature of participant
 (client, users and wider public);
- **How** The form of participation
 (information, consultation and decision-making);
- **When** Stages of the architectural process
 (design, construction and post-completion)

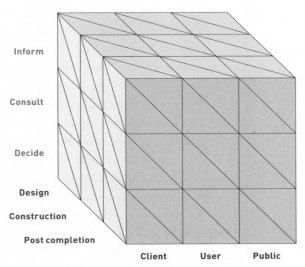

Jenkins & Forsyth's 3D analytical framework of participation in architecture (2010)

Forms and levels of participation

The first theoretical framework of participation was proposed by Arnstein's Ladder of Participation (1969), in which she measured level of participation in terms of the degree of citizen power. For Arnstein, the optimum level of participation is emancipation, in which the public has complete control of their community. [13]

According to other frameworks developed by academics, we can categorize participation into two general distinct types: Where control of the project rests with administrators is pseudo-participation, genuine participation occurs when people are empowered to control the action taken.

However, since participation is contextual and a two-way relationship, it bears different meaning to each actor according to different situations. Furthermore, different actors prefer to participate in different ways according to the situation.

Form of participation	From implementing agency's interest	From receiving end's interest	Function of participation
Nominal	Legitimation	Inclusion	Display – this involves informing, therapy and manipulation
Instrumental	Efficiency	Cost	A means towards a stated end – often the efficient use of the skills and knowledge of community members in project implementation.
Representative	Sustainability	Leverage	Giving community members a voice in the decision-making and implementation process of projects or policies that affect them.
Transformative	Empowerment	Empowerment	Both as a means and an end, a continuing dynamic

White's Typology of Interest (1995)

Creating Space for Participation – Participatory Design in Architecture

1.3 The legitimacy of participation

Since the idea of "active citizenship" has become more widespread since the 1960s, participation has been normalized both as a responsibility as well as a right in the development of our city.

There are two different philosophical bases for participation: the position which assumes that participation is a fundamental right for those who are affected in some way by a process and the position which sees value in participation for instrumental reasons. The first does not exclude the second, but the second does not entail the first position. [12]

From the perspective of management or administration, participation reduces the feeling of anonymity and communicates to the user a greater degree of concern. While users are actively involved in the development process; there will be a better-maintained physical environment, greater public spirit, more user satisfaction and significant financial savings.

Nowadays, it has become more commonplace for public and private interests to seek community involvement and support from the outset of a project. Yet what exactly 'participation' means to different actors can vary enormously.

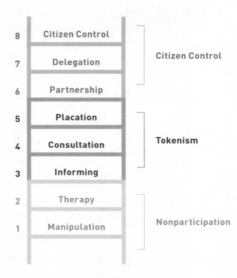

Arnstein's Ladder (1969)
Degrees of Citizen Participation

powers in the design of buildings they use or inhabit, by developing a modular building system which anticipates the essential technical design, and based on the system, leaves the final design to the users.

Similar ideas were formed, albeit in a less radical manner, by Dutch architect Herman Hertzberger, whose idea was on the design of "polyvalent space", which provided prototypes to allow individual interpretations and appropriation. He realized this intent in his Centraal Beheer insurance office building in 1974.

This goal of encouraging inhabitant intervention has further resulted in the co-housing movement and alternative forms of social housing.

Ralph Erskine's redevelopment of Byker Wall estate in Newcastle upon Tyne in 1968 is a pioneer in the English community architecture movement. In order to preserve the community bonding during the redevelopment, user participation was initially channelled through the architect's office, which operated an open-door policy to allow residents to have open dialogue with the architect. Formal organizations, liaison committees and community development projects were established to facilitate discussion along with municipal support. [10]

Another ambitious attempt to empower the users was Walter Segal's self-build instruction for social housing in London's Lewisham district (1960s-70s). The Segal method was to simplify the design and construction of buildings into a manual so that inexperienced constructors and residents could also build houses themselves in a cost-effective manner.[11]

Unlike the grassroots activism of the community architecture movement, Erskine and Segal both demonstrate a possibility to combine social engineering and democratic participation within the government led social housing and planning projects.

While the Post-war period generated tremendous debate regarding where society should go, it was also a period in which the design profession reflected on their own role and purpose within the society. Having made mistakes and learnt numerous hard lessons, participatory design provided an alternative method where the professionals emphasized listening and understanding the public's voice in the making of an open society, instead of taking a more authoritarian approach to decide the best interests of the public.

Creating Space for Participation – Participatory Design in Architecture

groups and persons, and shall urge the alteration of policies, institutions, and decisions which militate against such objectives". [07]

Advocacy planning began as civic groups resisted the development of the first form of public participation, which connected the design and planning professionals to the public. Community Design Centers became the staging ground for professionals to represent the interests of disenfranchised community groups.

Efforts have been made from the Institutes to revise their professional responsibilities. In 1967, the American Institute of Planners revised their statement of purpose to enlarge the purview of planners beyond mere physical planning, to include social, economic and environmental issues as well.

Hand in hand with other efforts and interdisciplinary development – post-occupancy studies, environmental psychology, environmentalism and feminist urban design theory – there was a reflexive turn within the profession – a self-critique. The role of urban designers, according to this self-critique, should be less authoritarian and more overtly political, with the goal of empowering people to improve their communities and their environment. [08]

From rigid to open

While participation started from advocacy in America, there was a parallel trend in western Europe where architects attempted to find ways to engage with users by allowing design to be more transparent and open-ended.

Besides the streams of neo-classism and neo-rationalism, which tended to find pre-industrial townscape for inspiration and legitimation, a different breed of European architect and planner reacted to the alienation produced by modernist solutions by opposing the rigidity of both the architectural mode of production and its end product.

Open architecture is an approach that includes the prospective users in the design process or provides them structures that could be easily transformed to their own needs and tastes. [09]

Belgian architect Lucien Kroll was one of the pioneers, with his most well-known participatory work – the design of the medical school faculty at Louvain-la-Neuve, Belgium in 1969. Kroll granted users wide-ranging

From elitism to activism

Referring to Nan Ellin's Postmodern urbanism, architecture theory since the 1960s might be understood as a series of efforts to resolve the practical, artistic, and ethical dilemmas architects have been facing.

The 1960s was a period highlighted by the civil rights movement, with the rise of the liberation of women, the anti-war movement, the May 68 student protests and the challenges of alternative cultures, all of which represented an upheaval of civil society.

Under the context of the acceleration of globalization after the Second World War, there was a pervasive sense of placelessness registered in many critiques of the western society and a deep nostalgia for the "world we have lost". In the field of built environment, it was manifested as a general dissatisfaction with the products of modern architecture and city planning, namely the destruction of existing urban fabrics and the building of isolated structures surrounded by open space and mass-produced tract housing throughout the world.[04]

The beginnings of a grassroots democracy in America were tied to the community-based struggles in the 1960s, triggered by the disruptive efforts of urban renewal.

Jane Jacobs's *The Death and Life of Great American Cities* was an attack on orthodox city planning and rebuilding. Jacobs analysed the notion of what constituted a neighbourhood and proposed a return to the essence of everyday human interaction and the active citizen involvement. [05]

The failure of mass-social housing projects, notably the demolition of Pruitt-Igoe in 1972, brought into questiond the elitist assumptions of professions.

Saul David Alinsky, the American community activist and political theorist believed that the main problem with the system was the insensitivity of political institutions to the people, who were excluded because of bureaucratization, centralization, and manipulation of information. [06]

Paul Davidoff's "Advocacy and Puralism in Planning" (1965) was a call for planners to promote participatory democracy and positive social change. "A planner shall seek to expand choice and opportunity for all persons, recognizing a social responsibility to plan for the needs of disadvantaged

peripheral to it – are also recognized as legitimate stakeholders and should therefore be involved in the design process.

This democratic philosophy that encourages the participation of individuals in the urban development process has become widely recognized, as more research has shown that a user's direct involvement in the design and decision makings has a positive influence and that its investigation generates continued insight and knowledge.[01]

In 2015, the United Nations stated to "Make cities and human settlements inclusive, safe, resilient and sustainable" as one of its 17 Sustainable Development Goals (SDGs).

"By 2030, enhance inclusive and sustainable urbanization and capacity for participatory, integrated and sustainable human settlement planning and management in all countries"
#Envision2030 Goal 11: Sustainable Cities and Communities[02]

Instead of merely treating design as a one-way professional service, the participatory design approach extends the power of architecture and planning as social engineering and empowerment. The result is a collaboration between the professional and the public.

1.2 Participatory Design in architecture – an overview

"Modern Architecture died in St. Louis, Missouri on July 15, 1972 at 3:32 p.m. (or thereabouts), when the infamous Pruitt-Igoe scheme, or rather several of its slab blocks, were given the final coup de grâce by dynamite." Architectural critic Charles Jencks' famous quote marks the beginning of post-modernism in architecture. [03]

Participatory discourse in architecture developed due to the criticism towards modern architecture has become one of the parallel streams in the postmodern period; in the hopes of finding an alternative way to create architecture which can fulfill the needs of all stakeholders, regardless of social status.

01

Architecture and Civic Participation

Public participation for a better
living environment

⬊ **Participatory design, or in other terms, co-creation
or co-design, is a design approach which attempts to
actively involve all stakeholders in the design process to better
address issues and create greater value for the public.**

1.1 What is participatory design?

Participatory design originated from the civil rights movement in the
1960s, which fought for an egalitarian and democratic society. This design
was developed from advocacy to a research methodology applicable to
various disciplines, with notable applications in the field of architecture and
urban planning.

The idea of participatory design in this book is associated with the idea
of involving the local community during the process of architecture and
urban design.

Traditionally, the architect is considered a service provider, whose
primary responsibility is to fulfil the needs and expectations of his or her
client. In participatory design, members of the broader community – from
the end users who are directly impacted by the project to the public who are

The first project that I experimented with participatory design in Hong Kong was an interior refurbishment of the Hong Chi Cafe at the Aberdeen Tennis and Squash Centre in Hong Kong. The most impressive and rewarding moment I got was when an individual with intellectual disabilities proudly told his parents and friends about his design for part of the cafe. From then on, I truly understood the great power to let the users feel and get hands-on experience in design.

All the cases in this book are about the co-creation effort from both the designers and the users. The users vary from children, young people, old persons, and across people from different parts of the world, including India, Cambodia, Nepal and Hong Kong. Throughout these cases, it is hoped that the readers can understand the treasure of using participatory design to connect people from all walks of life. It is also a means for architects or designers to transform difficult professional languages into easier meanings for people to understand and participate in.

I hope that the readers can always reflect on the space surrounding us and co-design an environment which represents our identity, culture and history.

Enjoy this wonderful participatory design journey!

Robert Wong

Reimagining People and Design

"A design is a plan or specification for the construction of an object or system or for the implementation of an activity or process or the result of that plan or specification in the form of a prototype, product, or process. The verb to design expresses the process of developing a design." (Wikipedia)

Is design only about making an object or a house?

What is the value of design?

How can people best use design to connect people?

Who are the designers?

As an architect and social entrepreneur, I always believe in the power of a user-centred approach in the design process. In 2004, I had the chance to study urban development planning at the Bartlett School at University College London (UCL) and the experience was certainly an eye-widening opportunity for me. I was amazed by the community participation being employed in the whole design and planning process. Participatory design is a process involving users and designers to co-create the products, a space, and even architecture. After graduating from UCL, I had been actively involved in promoting the concept of participatory design since 2006.

Contents

CREATING SPACE FOR PARTICIPATION

Participatory Design in Architecture

Robert Wong
Rosalia Leung
Liza Luk